IN OPEN
CONTEMPT

IN OPEN CONTEMPT

Confronting White Supremacy
in Art and Public Space

Irvin Weathersby Jr.

VIKING

VIKING
An imprint of Penguin Random House LLC
penguinrandomhouse.com

Grateful acknowledgment is made for permission
to reprint excerpts from the following:

"Bullet Points" from *The Tradition* by Jericho Brown. Copyright © 2019 by
Jericho Brown. Reprinted with the permission of the Permissions Company,
LLC on behalf of Copper Canyon Press, coppercanyonpress.org.

"Praise Song for the Day: A Poem for Barack Obama's
Presidential Inauguration January 20, 2009" from *Crave Radiance:
New and Selected Poems 1990–2010* by Elizabeth Alexander. Copyright ©
2009 by Elizabeth Alexander. Reprinted with the permission of the Permissions
Company, LLC on behalf of Graywolf Press (Minneapolis, Minnesota,
graywolfpress.org), and with the permission of the poet.

All photographs © 2025 by Irvin Weathersby Jr. except for
"2139 Andry St." on p. 38 © 2025 by Javon Blue

Designed by Nerylsa Dijol

LIBRARY OF CONGRESS CATALOGING-IN-PUBLICATION DATA
Names: Weathersby, Irvin, Jr., author.
Title: In open contempt : confronting White supremacy
in art and public space / Irvin Weathersby Jr.
Description: [New York] : Viking, [2025]
Identifiers: LCCN 2024016803 (print) I LCCN 2024016804 (ebook) I
ISBN 9780593299159 (hardcover) I ISBN 9780593299166 (ebook)
Subjects: LCSH: Racism and the arts—United States. I Arts and
society--United States. I White supremacy (Social structure)—United States.
Classification: LCC NX180.R3 W43 2025 (print) I LCC NX180.R3 (ebook) I
DDC 306.4/70973—dc23/eng/20240926
LC record available at https://lccn.loc.gov/2024016803
LC ebook record available at https://lccn.loc.gov/2024016804

Printed in the United States of America
1st Printing

For Annie

What is always needed in the appreciation of art, or life, is the larger perspective. Connections made, or at least attempted, where none existed before, the straining to encompass in one's glance at the varied world the common thread, the unifying theme through immense diversity, a fearlessness of growth, of search, of looking, that enlarges the private and the public world. And yet, in our particular society, it is the narrowed and narrowing view of life that often wins.

—Alice Walker

CONTENTS

IN OPEN
CONTEMPT

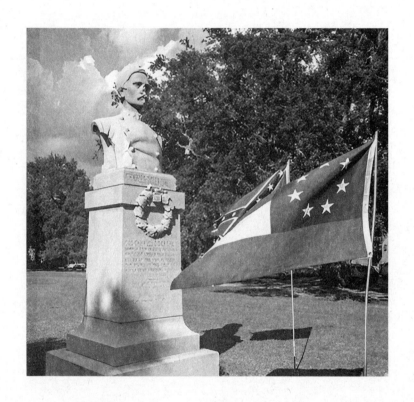

Jefferson Davis Parkway, New Orleans, Louisiana, 2017

LOSERS
AND TROPHIES

We possess two basic versions of American history: one which is written and as neatly stylized as ancient myth, and the other unwritten and as chaotic and full of contradictions, changes of pace, and surprises as life itself.

—Ralph Ellison

Three miles west of the Mississippi, on the vast patch of grass called the "neutral ground" that lies in the middle of our streets, I met a group of white supremacists lounging under a tent, three of them stationed there like sentinels guarding the bust of Charles Didier Dreux. As I pulled up, I couldn't see much beyond a fortress of flags. Confederate flags, American flags, MAGA flags, and black-and-white American flags with a single red stripe.

As was their purpose, they scared the shit out of me. I had driven there to see the razed monument of Jefferson Davis at the center of the neutral ground on the south side of Canal Street, but the ring of flags on the north side compelled my approach.

Two oversize banners faced the street and were even harder to ignore. One read:

MITCH LIED

$2.1 MILLION MONUMENT REMOVAL

OVER MURDER RATE!

Another headline read "MITCH'S 2017 SCORE BOARD" and tallied eighty-eight murders and over three hundred shootings. "WORST IN AMERICA!" summarized the count at the bottom in red cursive script.

Mitch was Mitch Landrieu, then mayor of New Orleans.

It was a humid Friday afternoon, and I stood on the corner sweating, processing the scene. If I was going to do this, I thought it wise to make my presence known, so I lingered in the green space between the tent and banners to let them see me before I proceeded. I didn't know what to expect and fixed my gaze on the statue as I walked slowly around the perimeter, afraid to meet their eyes. Shaking, my adrenaline pumping, I settled on the lawn off to the side so that I could still see them in my periphery.

I had never met white supremacists face-to-face, at least none who were so shameless, and I knew my stunt, the exercise of my right to occupy any public space, had the potential to further enshrine the memorial with my blood. I should tell you that this happened two months before Charlottesville, when Heather Heyer was run over by a car in August 2017. I should also tell you that her murder wouldn't have turned me around, at least not then. I couldn't just retreat after everything I had already

seen, after every one of us they had killed, so I took a deep breath and collected myself. I had to figure out why Dreux was so important.

The inscription etched on the face of his pedestal read:

Col. Charles Didier Dreux

Born in New Orleans, May 11, 1832, First Conf.

Officer from Louisiana Killed in the War

Between the States on the Field of Honor

Near Newport News, VA on July 5, 1861

———

His Last Words Were "Boys Steady"

Nobler Braver Never Lived

Had I been there a day or so earlier, the words would have been obscured by a messy anarchist symbol, striking and full of color when it was first sprayed but now faintly visible like a red watermark hiding behind the text.

Dreux's nose, blasted off like Napoleon had allegedly defaced the Sphinx, ruined his rather handsome, boyish depiction, his mustache thick and droopy, the crown of his hair carefully combed to his right temple. Four pairs of decorative buttons finished his double-breasted uniform and rose to a mock collar where stars were pinned. A wreath just above the inscription punctuated the mournful sentiment.

As I stood there inspecting it, my chest pounding with anxiety,

the youngest of the three approached me slowly, as if to suggest his benign intentions.

"How are you today, sir?" he said, smiling under a dingy trucker hat, his face scruffy and sincere.

"Good. How are you folks doing today?" I returned with a half-smile and sought each pair of eyes. A heavyset woman was in a folding chair to the right, and in the back, a man with a weathered face and stained, dusty clothes lounged in a beach chair next to a cooler.

"What brings you down here?" the young man asked.

"I came to see the monuments and get a feel for the city after all the controversy," I said uneasily.

"Well, I'm happy that folks from out of town are starting to see that we have a problem," said the older man.

"I'm from here, actually, but I live in Brooklyn," I confessed before regretting it, wondering if my outsider status might keep me safe.

"That's why we're here," said the young man. "A buddy of mine called and said that he needed some protection."

"For what?" I asked.

"The desecration of public property," said the young man.

"There were some folks who were just being nasty," added the woman. "Things were getting physical, and we're here to show them that we won't be pushed around."

"But doesn't everyone have a right to express how they feel, just like you folks?" I said, my voice cracking. "I mean, you're sitting here surrounded by Confederate flags."

"This is our heritage," she responded with more force.

"Look, you seem like a sensible guy," the young man said, inching closer to me. "Can I ask you what caused the Civil War?"

I paused to find the right words. "There were many reasons, but let's say economics," I responded.

"Right, the North had all the money and wanted to keep the South poor," the woman added quickly.

"Well," I said, "the South had all of its wealth in enslaved Africans."

Silence.

"You can't just erase history," the woman finally shot back. "You know, I used to enjoy looking up at Beauregard's statue, how beautiful it was at night under the lights, him looking so powerful on that big ole horse, and I would be proud of where I lived. But now that's gone!" She was nearly screaming by this point, her face reddening. "And the man built the streetcars and designed the sewer system. He was important to this city. He fought for his country and became an American hero."

"I tell you what: Mitch will never get another job in the state of Louisiana," said the man in the lounge chair.

"I doubt he wants to stay," I said with a smile, surprising myself. I could now sense their pain, each of them too wounded to harm me.

"He was just grandstanding, motivated by his own political agenda." The man opened the cooler and cracked a beer before continuing. "He's the only mayor in America who wants to be in the White House."

He had a point. Mitch Landrieu had done the unthinkable when he authorized the removal of four statues, citing how these

symbols had inspired a white supremacist to kill nine parishio-ners in South Carolina at Mother Emanuel AME Church in 2015. The musician and hometown hero Wynton Marsalis had urged Landrieu to remove the Robert E. Lee monument, and in the months that followed Landrieu began researching the site's history and soliciting support from leaders throughout the com-munity.

The first to fall was the Battle of Liberty Place monument, an obelisk that had been situated steps away from the riverfront that honored an attack on the city's police force by white su-premacists. Jefferson Davis's bronze statue was second; then went the statue of P. G. T. Beauregard, the general who had won the first battle for the Confederacy in the Civil War. Finally, the defiant arms-crossed image of Robert E. Lee was removed from its sixty-foot pedestal at the center of a roundabout that divides the Central Business District from Uptown. After each had fallen, one protest after another threatened to erupt into tragedy, and the tipping point was a speech from Landrieu that seemed to promise more, the force of revolution in his words shocking me beyond belief:

> New Orleans was America's largest slave market: a port where hundreds of thousands of souls were brought, sold, and shipped up the Mississippi River to lives of forced la-bor, of misery, of rape, of torture. America was the place where nearly 4,000 of our fellow citizens were lynched, 540 alone in Louisiana; where the courts enshrined "sepa-rate but equal"; where Freedom Riders coming to New Or-leans were beaten to a bloody pulp.

So, when people say to me that the monuments in question are history, well, what I just described is real history as well, and it is the searing truth. And it immediately begs the questions, why there are no slave ship monuments, no prominent markers on public land to remember the lynchings or the slave blocks; nothing to remember this long chapter of our lives; the pain, the sacrifice, the shame . . . all of it happening on the soil of New Orleans.

As if refuting the truth, the woman screamed, "This is New Orleans! He's taking money from our firefighters and police officers to erase history. You can't erase history!"

"He's letting this city run wild," the man in the beach chair added. "There are murders every night."

"Can I ask you folks a question?" I interjected. "How would you feel if the money to remove the monuments came from somewhere else?"

Silence.

They didn't care that the people dying in the streets were Black, that the murders were caused by centuries of injustice, that half the money used to remove the monuments came from private donors.

"I'll tell you what," I said after a moment. "I really appreciate y'all's right to believe what y'all believe, but your heroes were devils. I hope they take 'em all down. See this flag?" I asked, pointing to the Confederate flag. "It reminds me of the time when my ancestors were property, and I don't like it."

"It's our heritage," said the woman.

"I don't value that heritage. I believe in this one," I said,

pointing now to the American flag, shaking with nervous rage. "This one replaced yours. Losers don't get trophies."

Silence.

"I really appreciate y'all taking the time to talk with me," I finally said and offered my hand to the surprised young man who hesitated before extending his own. I squeezed it firmly but not aggressively as a sour, defeated expression emerged on his face.

The woman picked up her phone and walked away.

"You take care now," said the man in the beach chair, his tone absent of anger.

I then turned toward the statue and took pictures as if they weren't there, unbothered, feeling like I had won something, the sentiment a relief from how I had felt earlier in the day when the police officer who murdered Philando Castile was cleared on all charges. It was a feeling I had felt before, of course, the denial of justice so common that the grief becomes ritual. The anger eventually gives way to sadness and we place our beloved's memory in the company of all those we've lost without redress.

I'll never forget Castile's traffic stop, how his last moments were broadcast live via his girlfriend's Facebook feed. I'll never forget how he was shot seven times in forty seconds. I'll never forget who he was, because months before his murder I was almost a victim in a similar scene with the police that made me fear for my life. I can accept that Castile's death may never be honored and commemorated like Dreux's, but in that moment, I relished the wins still left to count. We were catching white supremacy slipping, and soon, I hoped, we would conquer the beast, one memorialized nose at a time.

In the near future, I would make room for others: Laquan

McDonald. Elijah McClain. Breonna Taylor. Ahmaud Arbery. George Floyd. Daunte Wright. Tyre Nichols. Jordan Neely. Sonya Massey. Each of these souls would find residence in my mind's temple for grief.

But in this same future, I would also celebrate guilty verdicts, Juneteenth as a federal holiday, and the fall of racist symbols across the country. Street names would honor us. Professional teams would reconsider their mascots and rebrand. The world would appear changed.

I would walk this same stretch and call it Norman C. Francis Parkway in honor of the longtime president of Xavier University, the historically Black college that sits along the street. Dreux and the other racist statues that composed one of the city's most prominent galleries to white supremacy would linger like apparitions, removed from the public eye save for their impressions, the remnants of their stone pedestals left like scars on the land to remind us of unfinished work. In unison, in voices tinged with reconciliation, they would say *Remember to repair*, as in the root of "reparations."

But in that moment, after spitting in the face of white supremacists, I was riding high on retribution and crossed the street to inspect the remains of Jefferson Davis's monument. Only the foundation was left, a graduated set of concrete steps that looked like a ziggurat, its surface stained and oxidized. Grooves of dried mortar rose and dipped along the top tier, and I climbed the steps to take Jefferson's place.

While he had his upturned hand extended to passersby, as if to say *Welcome to New Orleans* or *Behold our vast empire*, I extended my arms from my sides and raised my head to the

heavens, feeling like I had toppled the Confederacy. I stood there for a while, reclaiming the space as my own, until a Black man walking his dog snapped me out of my reverie. He had walked up beside the pedestal and paused, which made me realize that I must have looked ridiculous.

"Wanted to see if my dog would piss on it," he said, and we shared a laugh before he moved on.

If you keep walking north along Norman C. Francis, the street eventually turns into Moss Street, which, if you continue farther, leads you directly to the site where Beauregard's statue once lived. There, you'll see unobstructed views of the grandeur of Esplanade Avenue toward the Mississippi River and the French Quarter in one direction, and the sculpture gardens at the entrance of the New Orleans Museum of Art in the other. Each perspective along the wheel is florid, rich, and tropical, with a canopy of live oaks and palm trees shading the landscape. From every turn, the views are arresting, the site so central to the beauty and birth of New Orleans. Just past the museum, a path leads into City Park, the largest public space in the city, its breadth spanning thirteen hundred acres of gardens and wildlife barely visible from the grassy roundabout.

My mind wandered as kayakers paddled along Bayou St. John. There were no protesters or sympathizers crowding the base of Beauregard's former pedestal, and the only signs of their presence from a few weeks prior were washed-out posters tangled in the undergrowth of flowers and freshly cut grass. An American flag laid there askew in an overturned vase of withered stems and brackish water. It felt like I was viewing Beauregard's defamed sarcophagus, its face burned out in an inferno

that charred the brick underbelly hiding beneath the stone slabs. Never had I seen it in such a state, and the sight evoked a mix of glee and trepidation. I was happy that another one of their heroes had fallen, but I still sensed danger lurking in the air, the void emanating from the remains convincing me that someone or something had died there. In the evenings, the inscription of Beauregard's lifespan would normally be bathed in the glow of spotlights, but now it was expunged. All that remained was an anxious tableau, waiting for words and imagery to say something else.

Erected just south of the roundabout on Moss, a plaque offered an opaque story about the city's origins along the bayou:

THE OLD PORTAGE

Short trail from Lake Pontchartrain to River shown by Indians to Iberville and Bienville, 1699. Winding trail used by early travelers to city. From Bayou St. John it led to N. Broad, Bayou Roads, Vieux Carre to Mississippi River at site between Dumaine and Gov. Nicholls Sts.

The words read like a creation myth without a god, the prime mover muffled, the storyteller offering no depth or sense of setting. To translate: The Indians were Choctaw, the brothers Iberville and Bienville, Canadian-born emissaries of the French empire. The portage was where Bienville settled because the lo-

cation provided easier entry into the Mississippi River from the Gulf. The travelers were wealthy white men who established plantations along the river's watershed to traffic Africans.

By 1860, New Orleans was the largest and most cosmopolitan city in the South, serving as the way station for countless goods, second only to New York as the country's busiest port. Often called the "northernmost Caribbean city," it functioned as a significant conduit for the transatlantic slave trade and the country's wealth during the height of its rise. During this period, over one million enslaved Africans were transported to the markets of New Orleans, making the city an essential engine of chattel slavery.

At the end of the seventeenth century, a few years before the first enslaved Africans were brought here, approximately seventy thousand Natives lived in Louisiana. When the Louisiana Purchase was signed, it stipulated that all agreements previously held between the French and Spanish settlers of the region and the Native nations of Louisiana would remain intact. But by 1835, Natives were forced to give up one million acres of their ancestral land and resettle in present-day Oklahoma. What the Choctaw once called "Bulbancha," meaning "Land of Many Tongues" to recognize the Caddo, Quapaw, Chickasaw, Houma, Chitimacha, Biloxi, and other Native nations that hunted and traded in the region for millennia, became scores of cotton and sugar plantations. Twenty-two thousand slaveowners eventually lived in Louisiana and were among the wealthiest in the country, second only to their Mississippi neighbors. Before the start of the Civil War, John Burnside, Louisiana's richest slaveowner,

was worth $2,186,000, or roughly $78 million today. He enslaved nearly a thousand people.

CREATION MYTHS OFTEN BEGIN by describing the land and animals before the arrival of humans who came to subjugate. Some depict us in concert with the natural order but not atop the biological hierarchy. Others speak of the times before, when worlds were destroyed by natural disasters due to our ill behavior, or they speak of a void, an unformed darkness in the cosmos that would later become what we call home. Each positions sacred animals and plants and trees at the center of the universe from which all life springs. Turtles, sweetgrass, acacias, serpents, spiders, elephants, lotuses, and others rise in the collective imagination to become symbols of our creation.

The myth of New Orleans began in 1681, when French Canadians led by René-Robert Cavelier, Sieur de La Salle, traveled down most of the 2,340 miles that define the Mississippi River. With a few dozen Frenchmen and Natives, La Salle stopped along the way and established posts where the group exchanged goods until they reached the mouth of the river, just south of New Orleans. There, in a ceremony that included a salute of arms, festive songs, and chants of "Vive Le Roi," or "Long Live the King," they erected a cross and a column affixed with the name of Louis XIV. All the land along the Mississippi—its tributaries, natural resources, and all the people who inhabited the land—were now the possession of the French as established by La Salle's declaration.

This is the tale told of fur traders from foreign lands who founded New Orleans—a tale that underscores their bravery with the pillage of Native nations obscured. It's a tale marked by the excitement of discovery as they planted flags and claimed possession of space that rejects ownership. The flags now stand as bronze statues in our squares to signal the worst of what we've done.

Often, I think about these origins, of New Orleans and America, when I stand along the riverfront at the water's edge while Black folks perform songs for sustenance. Blowing a trombone in sweltering humidity may not qualify as the American dream, though it offers something dreamy to the tourist, who, if possessed by gratitude and enough powdered sugar, drops a few bills in the donation buckets before carrying tales of food and liquor back to his place in the world. *The beignets were the best*, he'll say.

When I look out onto these totems to the myths ascribed to New Orleans, I see the oldest Catholic cathedral in the country, which honors a king who waged war against Muslim and Jewish ideologies, next to a building where the Louisiana Purchase was commemorated, a document imbued by a mysticism that transferred the unknown to the undeserving. Now it lives as a museum detailing the exploits of Andrew Jackson in the Battle of New Orleans, a fight that was settled before it began, a foregone victory that pitted a ragtag band of troops against a flank of British men who died without learning of their country's concession. The legend of Jackson only rose and thrust him into the White House as a hero of the new world, one who secured a utopian vision for us all, save for the savages. Fronting the build-

ings, Jackson's equestrian statue seems caught in a victory lap, his posture relaxed and cap tipped to onlookers as if to say *You're welcome* or *Just doing my job* or as the prelude to his next trick—the not-so-magical Indian Removal Act.

Try as I might to worship at this altar, I find it hard to focus because I see something else. I know what happened along River Road when we fought for freedom. The fiction is fractured as I see the heads of Black men on pikes planted in front of the church to remind us that we lost the 1811 uprising. Like young trees planted on scorched land, they stood to remind the slavers that order was restored. Life would carry on as it had before—until Jackson came along to save slavery and the city again.

Then it would become the New Orleans you know, the postcard image disseminated throughout the world to evoke the sublime experience conveyed by the city's motto: *"Laissez les bon temps rouler,"* or "Let the good times roll." Later, President George W. Bush would use it as a backdrop to talk about recovering from a storm, like that time President Andrew Johnson did the same in the neighborhood where my origin story begins.

Somewhere along the river, an illiterate Black man from Mississippi worked on a wharf to feed his family in the Lower Ninth Ward, though he would only be paid if he was one of the lucky stevedores selected to risk his life loading and unloading cargo from ships docked at the Port of New Orleans. His fifth child became my father, and when I stand there, along the river's edge, I think of my ancestors, my grandfather's grandfather who may have found work along the river too, although *he* was probably the work transported to the markets that lined its banks, his labor valued more than his humanity.

———

I HAVE LEARNED ENOUGH to know that I'm called to testify, to elucidate the complexities of space and time through language as a practice of study and expression of art. To this end, I've been a teacher for more than two decades, learning as much as I've taught, born of the tribe that is aware of its design and feels compelled to say something when it needs to be said, to do what needs to be done, to face the fear of bearing witness when a soul is trapped in a choke hold or the space beneath a knee. Some call us writers, activists, or preachers, but such titles are shortsighted. Each of us is capable. None of us can do everything, but we can all do something, and sometimes, this something means meeting the eye of the devil to tell him that his hatred won't go unnoticed. If called upon, if your goings about life are interrupted by the abuse of your kind, it's your responsibility to make the murderers see you, to hold them accountable for their deeds and take up as much space as possible. It might mean holding up a phone to livestream an arrest, or resisting a protest organized to impede your rights, or passing out stacks of banned books to children. It might mean something more benign, like walking through a museum as the only Black person in sight. But even this invites danger. Who knows what you may see hanging in the galleries? Who knows how your psyche will respond? To be clear, I'm not saying you should put yourself in harm's way or arm yourself with weapons so you can shoot the antagonists or break any laws that don't deserve to be broken, but I'm also not telling you to shy away from what needs to be done when the stakes are life and death—which is to say, every day.

I didn't come to this journey to uncover the disturbing truths concealed in our art and public spaces lightly. My ancestors were the guides. They've taught me to teach what I've learned, to shepherd toward safety when required, and to strike when our foes are vulnerable, when their hatred falters and makes space for correction. This isn't to say I've figured anything out, save for the value of opening my eyes to the world and sitting in silence so that it slows down and reveals what I'm seeking. The blessings, which I might call lagniappe, are the unexpected, the invaluable understandings that emerge without warning. I'm here to tell you that the mediations work, that the significance of these silences has been reinforced time and again throughout the course of my life across continents.

So, when the monuments started to fall after the murder of George Floyd in May 2020, I recognized the opportunity to deepen my understanding of how these streets and statues have shaped our times. I had traveled throughout North America, the Caribbean, and Europe searching, gazing upon statues, staring at frescoes, strolling through parks, listening for voices, on the hunt for validation of theories I had already proven: to reimagine our world, we must recognize how our past lies in the symbols we see every day. But my frame was off. I was looking anywhere and everywhere except the place where I first came to understand the world, the place that just so happens to be the epicenter of American slavery.

Understanding that symbols are not static must be our guiding premise. They can't be reduced to mere shapes and signs, colors and shades. They live in our minds as much as they appear on the wall fronting the Cup Foods store where Floyd was

killed. They occupy a large space in our conscious and subconscious understandings of each other and the world. They remain significant sources of our actions, more so than we realize. How we see and treat each other is the domain of symbols and stereotypes and misconceptions. Only when we engage each other do we see things we can't physically and reinterpret the symbols. The same holds true for monuments. We need to spend time with them and learn their stories to determine their value. But if we overlook the task, if we dismiss it as an insignificant act, racism will continue to infect society, and I'll have to find more space in my head for lawless executions.

One

PLANTATION
VISITATIONS

When children used to get a whipping, they was taught to
turn 'round and say, "Thank you, ma'am, for whipping me"
and bow. That was mighty hard to do, but we were never
allowed to pout. If we did, we got another.

—Francis Lewis, formerly enslaved in Louisiana

I first became convinced of the power of museums when I
toured the plantation home of Thomas Jefferson. I had
traveled to Monticello as a curious fourth grader with my
classmates after a tour of Washington, D.C., not yet aware of
Jefferson's legacy as a founding father. I hadn't heard of Sally
Hemings either. We had walked the mall and seen the Lincoln
Memorial and gazed up at the Washington Monument, but
much of the experience, I admit, remains a blur. But the dun-
geons, the chains, I will never forget. Even now, I can't paint an
exact image of the scene. I mainly remember how I felt: con-
fused and injured, cramped in the closed air of the hole, ques-
tioning who would want to see this, vaguely aware that the

people once chained where I stood were somehow connected to me. Maybe I was too young to experience such things, my language and understanding of the world too fragile, but I was certainly changed by it.

Years later, after reading and learning and probing what it means to be Black in this time and the times before, I would come to expect the pain and distress that accompanies the exposure to trauma passed down through generations. It has taken me a while, and I won't pretend to have mastered the moment when you're met with despair, but if you force yourself to evoke the sensation frequently enough, eventually you come to welcome it, and in the visitation, you exercise a level of control that helps you endure. The courage is in the looking, you see. If we can examine with clear eyes the ways in which we respond when thrust into such vulnerability, there exists a chance to heal and become empowered. The dare is to see and be seen, to witness and be witnessed, to move through the world like a living, breathing installation that demands dignity.

If you can rise to this state, nature will take care of itself. That's the thing with museums and art and public space, how they tend to overlap in purpose and symbolism, how art, when executed in concert with the natural world, raises the stakes and evokes sensations more powerful than can be felt in isolation. This is the force of monuments: they exist equally within the laws of location, time, and imagination. This is why they command our attention, if only we pause long enough to appreciate the experience.

Consider the space art has occupied in human history, how it has marked our ability to imagine and create symbols that we

use to interpret and document the meaning of life. Evidence of this higher consciousness has been found on every continent in the paintings and carvings etched on the walls of prehistoric caves. These spaces were our first museums, where we were inspired by nature to alter its physical and psychic properties. Since then, the human mind has expanded its capacity for imagination, and we've created works of art that continue to defy what was previously thought possible. We've built pyramids for tombs, erected towering spires and temples to worship gods, and sculpted our idealized image in stone. The use of paint and material and subject matter has evolved in kind. Today, art and artifacts and architecture coexist more than ever to the degree that not only are our lives subject to rendering via portraiture, sculpture, and photography, but also how and where we live has risen in importance and our homes and habitats have become monumental; in time, they may become museums. Now everything can be classified as art, however base or transcendent, irrespective of form and function, which explains how I found myself in a "museum" that once functioned as a site of oppression.

I know now that my experience at Monticello contributed to my awareness of my unresolved place in America, the source of my most significant trauma. I was born free in New Orleans, recipient of all the liberties earned in the Civil Rights Movement, but still aware, albeit vaguely, that my freedoms were insecure. This is the nature of white supremacy. It acts upon us as early as it can to establish its unnatural order.

While I can't be certain of the first experience that introduced it—when the recognition of my Blackness first confounded me—

I do know that I never stop asking why. I never stop trying to expose the lie, to subject my understanding and life experience to examination so that I might fashion a way to live free of its burdens.

So, when the nation began to reckon with these sites of racial trauma, I returned home with the burdens ready to be released. I recognized the moment as one along the continuum of our fight for civil rights, and my nature sent me seeking.

MY QUEST LED ME to another plantation. The day after I explored the monuments erected along Jeff Davis, now Norman C. Francis, I drove to Wallace, Louisiana, to take part in the Juneteenth festivities at the Whitney Plantation. There, I hoped to be moved by commemorations honoring the day Union troops descended on Galveston, Texas, to inform our ancestors that they were free as declared two years earlier by the Emancipation Proclamation. They could discard their chains forever, but that moment—the delayed exercise of our ancestors' freedom—celebrates an event that hasn't come to pass. Slavery ended in name, yet our freedoms remain insecure, which is why I hoped there would be all sorts of activism swirling the grounds. I wanted to feel the energy of protest that had partly inspired Landrieu to reimagine New Orleans and take down the monuments.

I was met with African dancers, drum circles, and food trucks selling gumbo and jambalaya. The force of Negro spirituals rose in my ears through a chorus of singers who brought me back to church, to Morehouse, and to all the scenes of free labor that I

had stored from my studies. Sadly, I was underwhelmed. Instead of throngs crowding the exhibits, there were only a few dozen people moving throughout the space. A boy, pushed into action by his mother, had even delivered a monologue that spoke of the denigration of the race due to "gay boys" and "intellectual acrobats" who failed to actualize the true teachings of Imhotep. I had been there before, and each experience had uplifted me, but this time I left disappointed.

Years earlier, shortly after the museum had first opened to the public, I arrived before the start of a guided walking tour and spent a moment inspecting a lanyard given to me as proof of admission. Mine bore the image of Albert Patterson, an enslaved child cast in bronze. Shoeless and clad in overalls cut just below the knee, his hands were stuffed into his pockets, his face squinched in bemusement. When I flipped the lanyard, I heard his voice:

> I remember our plantation was sold twice befo' de war. It was sheriff's sale, de white peoples dey stand up on de porch an' de black men an' women an' children stand on de ground, an' de man he shout, "How much am I offered fo' plantation an' fine men an' women?" Somebody would say so many thousand . . . an' after while one man buy it all.

How fitting and ironic that Patterson had detailed the acquisition of a plantation, considering that my presence was the product of a wealthy lawyer's purchase. John Cummings, the museum's founder, had amassed millions from litigating class-action lawsuits, which he parlayed into a vast real estate portfolio

that now included the Whitney. More than $8 million of his money was allocated toward restoring the plantation—but why would an Irishman with no direct connection to slavery give so much? Guilt is the easy answer, which he conceded, but something more had to be at play. Something obsessive must have forced him further, to do all he could to understand how his life in Louisiana had been shaped by the transatlantic slave trade. His actions speak to a need to show up, and he did, so that everyone who desired to see us would hear our unfiltered stories.

At the first stop on the tour, I learned more about Patterson's life in a beautifully restored Baptist church constructed of white fish-scale shingles that gleamed in the April afternoon sun, situated steps beyond the welcome center in front of a large pond and several gardens. When I crossed the threshold of the church, originally erected by freed Black men and transported here as an exhibit for the museum, I was struck by statues of children cast in bronze, like Patterson, scattered around the pews and pulpit.

After a brief introduction, we settled into the pews to watch a video that explained the statues' significance, each embodying someone formerly enslaved who was interviewed in the twilight of their lives as part of the Federal Writers' Project of the Works Progress Administration. Famous Black actors animated their voices, and when I heard Samuel L. Jackson's voice resound through the chapel, I looked at my lanyard again and realized that Patterson was ninety years old at the time of his interview. I wondered what Patterson had looked like in old age, as I attempted to reconstruct the circumstances of his life.

The other statues capture girls seated with their legs crossed, wearing sackcloths that lay folded across their laps, some with

neatly braided plaits, others with loose, flowing curls. They are dressed in their Sunday best with ribboned cloche hats and sleeveless dresses, the boys in denim overalls. Their clothes are warm, earthy hues, but every square inch of their bodies seems dusted in dirt and grime, signifying their destitution. Even more impressive are their hollowed-out eyes, which created an effect so ghastly, it seemed they were peering into my soul, as sunlight refracting through the stained-glass windows produced bursts of angular spotlights and corresponding shadows.

These children reappeared in my imagination when we walked past two canals, each lime green with algae and clusters of verdant leaves, to the Field of Angels, where a memorial honors children who died while enslaved in St. John the Baptist Parish from the 1820s through the 1860s. The installation is positioned behind the welcome center in a clearing all its own where, in the center of a brick-paved square, behind a ring of rusted chains, the image of an angel kneels on a pedestal as she holds a newborn.

The statue is cast in bronze, and the message it conveys blew me away. She is clearly Black, with a face of full lips, wide nostrils, and big, protruding eyes. Plaits part neatly from the crown of her bowed head, and jutting from her back, her wings almost stretch the diameter of the ring. Her breasts are exposed and her tunic drapes in countless folds to her ankle. I couldn't tell if she is about to take flight or if she had just landed, but her expression doesn't suggest joy, and I realized she is ready to lift the child to heaven. Her blank gaze fixes on a spot beyond the child and creates a dissonance between the task before her and all the promise that new life signifies. My eyes welled in recognition.

Children, we can agree, should be spared the evils of the world, and it seemed the museum wanted to underscore the suggestion. I understood the purity children symbolize, but maybe my interpretation was too simplistic. By definition, the image of a child evokes a before-and-after comparison, a growth chart, and a hope that one day, God willing, they will rise into adulthood without a recollection of racism. But rarely is the child's or baby's image seen as a site of death, and the associations of Cupid, Jesus in the manger, and a young Siddhartha are upended. *What about the mythology of Black babies?* the statue seems to ask.

Around the perimeter of the square, a brick wall lists the name of each child along with their death date, their age at the time of their death, and their mother's name if it was known. The wall rose to my shin, and I squatted to inspect each marker until I came across two whose lives had expired 147 years before my birth. Zenon and Annette had only been a year and eight months when they passed, and I wondered how Rose, Annette's mother, had managed her death, how any of their kin had labored on.

I hadn't expected the pain to hurt so severely, but it was as if I were reading my own tombstone, and I pinched my tear ducts to stop the flow of mourning. I could literally see myself reflected in the granite slabs, but what I felt transcended the physical, like I sensed in my soul the hunger and untreated illness that had taken their lives. Is this the function of memorials, where ghosts are summoned to shake you into tears? Was I supposed to trace my life to theirs and experience catharsis? What are tears beyond deflections?

These thoughts, I fear, were too selfish, driven by ego and a

relentless need to see myself somewhere along the grounds. But time and how we measure it are our greatest sources of reflection, so maybe I was justified in my approach. Wasn't that why I had come? To understand my history—our history—from a formerly silenced perspective. Like rewriting lines from a speller to learn a language, wouldn't history become mine if I found a way to insert myself, if I pored over it again and again until I emerged?

I lingered in this uncertain state and jogged past other installations and both canals to rejoin the group on a pathway along the great lawn where a line of cast-iron cauldrons extended to the cane fields that, after centuries, still produce what we crave.

There, the docent explained the process of refining sugar, which was one of the most dangerous jobs on the plantation, and as I investigated the rusted relics, each massive and curved cauldron like an upturned suction cup, I imagined how severely the splatter from the roiling liquid would burn, how much I would sweat through the task. I was already dripping from the noonday sun and couldn't fathom the insufferable temperatures they had to endure. I thought of the times my father had come home with chunks of sugar stalks and taught me how to chew them slowly to yield the syrupy juice. I wondered from what fields they had come and who had potentially suffered on my behalf.

From there we moved to the slave cabins, each positioned a few yards beyond the pathway. The meager clapboard dwellings were discolored with flaky paint chips, and when I climbed the rickety steps and peered into the living areas, I felt the weight of

history like a sudden loss of air, its omnipresence overwhelming and suffocating. Everywhere I looked, I could see evidence of the past—in the splintered floorboards, in the dust mites dancing on the windowsills, in the subtle impressions on the walls where our ancestors had left their DNA.

Settling my gaze on the bed frame, my anxiety intensified. The frame was a crude construction of pine planks threaded with hemp to support a burlap sack filled with a thin layer of goose feathers, which served as a mattress. An entire family would sleep in the one-room cabins, the children on the floor or in the attic, and the ghostly presence of their lives unmoored me.

I left the room and finally exhaled.

In the center of the great lawn, we moved to a structure that impeded a clear view of the big house from the fields. It looked like a misplaced storage container, one you might find stacked with others at a port. The structure was old and empty, corroded with coarse layers of rust, seemingly missing its contents. Three iron doors, cross-stitched in a pattern of bars, were propped open, and in the center of each, a metal square had been cut away. This structure, explained the docent, was a slave jail.

At her suggestion, I entered one of the cells and looked through the floor-to-ceiling bars from the other side of the cage. I didn't know if the effect was coincidental or intended, but I felt a current of chills as the view of the big house emerged behind the bars, evidence of the incredible wealth stolen via slavery displayed behind a superimposed symbol of the oppression that had necessitated its growth. The unfettered freedom of the masters' daily activities was just out of reach but situated squarely in

my line of sight to taunt me. Granted, the jail wouldn't have been placed here when it was in use, but the museum's primary goal was to expose the lives of those who toiled here, and I let myself slip into their skin. I let myself embrace the optical illusion and imagine. The curators succeeded here, as I had never been to jail—at least not then—but I had no trouble seeing the men and women who had suffered in the space.

Afterward, we explored the building situated closest to the big house, the oldest detached kitchen in Louisiana, a brick structure lined with ovens and pots and cauldrons dangling from roasting rods. But our tour would end prematurely: the big house was closed for the filming of a Disney movie about witches that sought to capture the mystical beauty of the plantation. I let the group move ahead to the church where the tour began, thinking if I walked with purpose toward the big house, maybe I could blend in with the film crew. But the inconvenience of capitalism prevailed, and I hardly made it a few feet before I was called back.

The trade-off is implied with museums: You can witness moving works of art and artifacts for a fee offset by wealthy donors, and as long as you don't think about the transaction, you are free to roam re-created worlds without interruption. Money is pliable in that way, capable of insulating you from the truth and disrupting it at once. Often, through means we may be better off not knowing, museums exist and are funded by people and institutions that would seem to undercut their aims.

Take, for example, the barn, a structure original to the plantation that still smelled of labor, a musky mix of sweat, grime,

and hay, where an enslaved African named Robin had used its kiln to forge all the plantation's horseshoes, tools, and kitchen supplies, and where a scene from *Django Unchained* was filmed. This knowledge was strange: the antebellum past, I thought, shouldn't be tread upon to make a farcical spaghetti western about slavery, especially as imagined by Quentin Tarantino, who has an odd penchant for creating racist characters. There is Black victory in the end, though, which I guess redeems it, although this, too, seems ahistorical.

When I returned a year later, I went straight for the big house. This time my guide was older and more confident, her words carefully ordered and imbued with an unapologetic force. Like Elaine Brown or Fannie Lou Hamer, she described the structure's architectural style with dramatic flair. Drawing influences from French and Spanish estates, the creole cottage was built with every nail driven by an enslaved African. The guide paused for emphasis before repeating the assertion and had me fired up in all the ways I desired.

From there we climbed the stairs to the second-floor veranda where a series of storm doors opened into bedrooms. By contemporary standards the rooms were small and populated with simple dressers and four-poster beds. As we paced the rooms, the docent pointed to spots on the floor where servants would sleep to attend to their masters' needs, which often included sex, a fact she punctuated with silence. White men, she explained, raped enslaved women without compunction or regard for their wives. As I scanned the faces of those assembled, I wondered how the group received this revelation. Where did their minds travel?

This is how I came to be called Weathersby, I know. Somewhere in the story of my lineage, a Scottish man owned and raped my ancestor, giving her my name and a trauma that often resurfaces when I enunciate its syllables for strangers. The looks I get vary, and rarely does anyone hear the echo of slavery like I hear the echo of "Hemings" in "Jefferson." Sometimes I explain that my family was owned centuries ago to remind them of the obvious. Usually, not always, I say it with a smile to absolve the listener from the crime.

THE LAST TIME I visited the Whitney, during the Juneteenth celebration, I saw an installation just beyond the Field of Angels, in the far corner of the plantation closest to the fields. I fixed my gaze on a series of miniature heads resting on metal rods that rise from a bed of rust-colored mulch. There are roughly fifty on display, each stratified in rows so that none of them obscures the other. Fronting them all, positioned on his own stone, is the likeness of Charles Deslondes, the leader of the 1811 rebellion. None bear the signs of trauma, and the only indication of the savagery enacted upon their bodies is the varied angles at which they rest. Some heads look straight on while others are tilted slightly, turned askew.

I would have liked to see them portrayed more realistically, with more evidence of decapitation, their eyes eaten away by crows, their skin mask-like, wrinkled, and leathery from exposure to the sun. Cummings had expressed the same desire. He had wanted to make them life-size and position them along the road in front of the plantation to show people what really

happened to them. But thinking the heads would be too much to see, he yielded to caution, and I'm not sure that I agree. Imagine the reckoning their heads would inspire, the undeniable truths they would teach because we couldn't look away. Imagine what they would mean to a curious fourth grader on a tour with his classmates.

Two

1811 STREET

As long as I'm in New Orleans, I'm not away from home.

—Fats Domino

On January 8, 1811, at the end of the harvest season and the beginning of Carnival, while slavers along the German Coast celebrated their success at decadent balls and drank into the wee hours of the morning, a group of enslaved Africans led by Charles Deslondes—a mixed-race slave driver from a nearby plantation—initiated an insurrection that would reveal the insecure sovereignty of New Orleans and the newly acquired territory of Louisiana. After Deslondes and others killed his master's son, they marched up River Road toward New Orleans, setting fire to every plantation in their path. Eventually the group swelled to more than two hundred men—some accounts indicate a number as high as five hundred—each equipped with muskets, sabers, cane knives, and any weapons they could steal from their masters' supply. Inspired by the Haitian Revolution, they wore the military uniforms of their enslavers as they

rode on horseback and marched on foot with the express goal of conquering New Orleans.

The plot was thwarted, however, by the disloyalty of some of their brothers in bondage who had forewarned their masters of the revolt, allowing some of them to flee before facing the wrath of the rebel army. Among them was Manuel Andry, Deslondes's master, who paddled across the river and alerted the men from the major slaveholding families.

The new militia of slavers came upon the rebels and caught them by surprise. Fifteen or twenty of the rebels were killed, fifty were taken as prisoners, and the rest fled to the swamps. In the days that followed, they were tried and sentenced to death. The ruling of the court read: "The heads of the executed shall be cut off and placed atop a pole on the spot where all can see the punishment meted out for such crimes, also as a terrible example to all who would disturb the public tranquility in the future."

The decision was executed in the space between the German Coast and New Orleans, from the heart of the plantation district to the commercial center of the city at the Place d'Armes, where roughly a hundred heads and dismembered bodies lined the landscape, where for months their bodies rotted on display, and where the image of Andrew Jackson astride a horse stands today.

My father's family grew up in the Lower Ninth Ward on Andry Street, the namesake of Manuel Andry. We didn't know who he was when we lived there, and I didn't find out until years later.

Today, when I reflect on my memories of Andry Street, I feel the place slipping away just as the aftermath of rebellion rises in

my imagination. I have no new memories there since Katrina, save for the times I've ridden to where my family's house used to be. My father and four of his siblings remain. One has passed. So have both my grandparents, with my grandmother surviving the longest, though many of her final years were filled with darkness, her Alzheimer's advancing to bouts of confusion and circular conversation. The person we once knew only emerged in flashes. After her house floated away, it seemed that her old self began to wither. She was dead ten years later.

OUR HOUSE WAS one building removed from the corner and Richard Lee Park, where we became local legends in sports, but the park was unrecognizable when I last visited, the fence and fields and covered basketball court replaced by a construction site with backhoes and mounds of dirt. Even the street sign was gone. The large oak tree that stood in front of the house was wrapped in orange netting, and this is how I knew where to direct my gaze.

The lot was overgrown with fallen branches and patches of grass that had sprouted like bushes. Through a thicket of dead weeds, I could see the street and house that remained behind the lot. A fire had burned the house on the right; on the other side, only the concrete slab of the neighbor's house remained. I paused for a while, trying to re-create the neighborhood. I remembered my grandmother, Georgia-Lee, a housemaid who had composed a life with Sb, an illiterate longshoreman. They met through family in Mississippi, as his cousin was married to her sister.

When they married, they moved their family to New Orleans, where they raised six children in a three-room shotgun.

The last time my grandmother saw her house, it had floated off its foundation, the upstairs addition dislodged from the structure and hanging precariously off to the side like a building block ready to tumble. My aunt and uncle had stood there with her as a demolition crew prepared to reduce it to rubble. My aunt remembers surveying the scene from an open window upstairs, how the clothes in the closet seemed fine and the towels hanging in the bathroom had remained in place, as if no storm had passed. She says she doesn't remember much else. Yes, she was crying, and she was sure Mama was too, but the pain must have blunted everything else.

My uncle Marvin claims that Mama never broke down. She might have mumbled a few words, but mostly she suffered in silence, never turning her eyes away. She was a praying woman, always ready with a scripture, so she probably was reciting a prayer. "I wasn't sad that she had lost her house," he said, his voice cracking. "I was sad that she lost her home."

It took twenty minutes for a bulldozer to flatten the house. In the aftermath, a china cabinet somehow stood intact, propped up against the roof. One of the workers clawed an opening to it so they could retrieve its contents. Someone had stolen the silver, but the plates remained, albeit caked in grime. "That was the only thing she saved from her old life," my uncle said of my grandmother, choking up again.

In a photo my cousin took of the demolition scene, the white siding of the house is stained a dingy brown-gray, marking the

water's ascent. The screened-in porch is collapsed on itself and leans to the right. At the base of the screen door, the spray-painted X indicates that a FEMA crew had searched the house for survivors. The gate in the front yard is mangled and barely supports a set of wood planks propped against its posts. Along the ground, a pattern of caked mud resembles uneven stucco tiles or snakeskin. Sheets of metal that once formed the carport lay atop my grandmother's car. The second floor gleams white in the sun, and the only signs of disaster are a few strips of siding blown from its face.

The last time I visited, the gas station that I had always driven by on my approach to the house was an apocalyptic scene. The windows were busted out, the walls sprayed with graffiti, and the pumps replaced by weeds as tall as the building. It seemed like Katrina had just passed, although it had been seventeen years. The street itself was split open with large concrete pipes raised on pylons waiting to be lowered into the ground.

As I slowly pulled up to the lot, maneuvering around orange cones and gaping holes, a neighbor across the street emerged from behind his screen door.

"Hey there!" he screamed.

"Hey, how you doing? Just wanted to stop by and see my family's old house, at least where it used to be."

"Oh, alright."

"Everything looks different with all the construction."

"Yeah, they finally gon' fix the Ninth Ward. Cantrell and the news were out here couple weeks ago to kick it off."

"Crazy that they doing it now."

"Well, you know, they ain't doing it for us. Them white folks starting to move back here, and you know how that go," he said before retreating inside.

I stood there in front of the lot, inspecting the site of my family's fallen monument, looking for my place, trying to situate myself in the forgotten, listening for stories that I have never heard but have always felt coded in my experience. In a way, monuments accelerate forgetting, a dementia of sorts that gradually worsens as the years pass until the before eludes all recollection. They may appear to underscore the past—and they do this too—but in the process, they suppress other events and stories that shaped the commemorated life and space. Rarely are they found with enough context to leave us with a comprehensive image of what life meant then and what it means today.

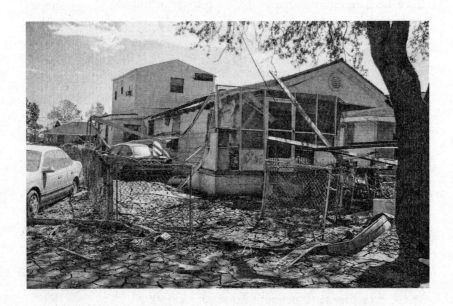

Family home, Andry Street, New Orleans, 2005

This is why I return. I want to remember what was lost even as I learn more in the passing years. Now I ask the survivors—my father and his siblings—what they remember most about the house and the neighborhood and their parents as often as I can so that when I return, I can pull from their repositories to erect our own signposts.

When I ask my aunt Dora about the day they moved in—the aunt who was standing next to my grandmother when the house was demolished—I hear her voice swelling with glee. "I think I was a rising eighth grader, and we lived a block over on Choctaw Alley. Mama and Daddy were at work, and we took it upon ourselves to move everything before they got home. I can still see the scene of what seemed like the whole neighborhood carrying boxes and couches and beds into our new home. We were just kids, but it was fun. We were excited. Moving from a one-bedroom to a two-bedroom house made a big difference."

But less than a year later the then most destructive hurricane in American history came churning in from the Gulf.

My father remembers evacuating from Hurricane Betsy in 1965, driving through the storm to higher ground uptown, as the most scared he's ever been. Rooftops flew away. Trees toppled over. Live wires dangled from electric poles. He was young and doesn't recall most of the details, but the eldest, my aunt Esteen, remembers it vividly.

"It was the first day of twelfth grade, and it was a bright and sunny day. But it got dark quick that night, and that's when Daddy got us into the car and drove to our uncle's house.

"Afterward, Daddy went back to the neighborhood to help. With Mr. RT, Daddy's friend, they got a boat and saved as many

people as they could. They even saved a baby floating in the water."

Scores drowned in the flood that swallowed the neighborhood for ten days. When they returned to the house, my aunt Dora says the refrigerator met Daddy at the door. The water rose to three feet in the house and the parquet floors were damaged. "They were beautiful," she remembers, "but because they buckled, they had to be pulled up. Daddy redid the house, but the mold kept coming back until one of his friends who worked in commercial laundry gave him something to spray on the wood."

My father's fear of storms didn't extend to the violence that sometimes engulfed the community. I have heard the story of the time Bad Dick shot Pitt so often that I feel like I was standing there on the corner like my father was moments before it happened. My father missed the shot, but when he heard it clap, he ran outside from the house and saw Pitt splayed out as Bad Dick retreated to his house next door, now a slab of concrete.

"Everybody knew Bad Dick was a gangster, his whole family were gangsters, but I wasn't afraid of him. And I told him, 'If I would have seen it, I would have told on you.'"

"Why'd he kill him?" I asked once.

"He said he didn't mean to do it, said he tried to hit him in the head and the gun went off. I told him he was lying, because I was standing right there as he waited on him. Pitt was strung out and owed him money for drugs. Shame, too, because Pitt was one of the best players to come out of the Ninth Ward."

My most vivid memory of my time at our house on Andry

was when I was six years old. It was Christmas Day, and I was huddled around a floor-model television with the men of my family and an aunt or two and a few female cousins as we watched the Lakers take on the Celtics. I remember I was just falling in love with professional sports and learning our family tradition of debating the merits of one player's skill over another and the strength of various teams, when, in an attempt to join the banter and argumentative spirit, I interjected, with all the conviction I could muster, "I want the Celtics to win," and everyone, and I mean every voice present, seemed to exclaim "Nooo!" in the next beat, some laughing harder than was probably necessary.

"You root for the Black team," I can still hear my uncle Bebe saying to me, smiling just enough to preserve my feelings. I was sorely embarrassed and didn't say a thing for the rest of the game, silencing the questions that would have clarified my confusion. Didn't the Celtics have Dennis Johnson and Robert Parish and other Black players?

What my family had attempted to teach me then was bigger than the players. The Lakers, I would come to understand, embodied Black excellence and all its potential, led by three of the game's all-time greats who had lifted the team to a hallowed place in the Black imagination, where it became our identity as much as any other symbol. Each of us was Magic and Worthy and Kareem.

But Blackness as a feature of skin color does not equate to shared values. It must cohere with the dominant symbolism of the time to register, which isn't to say there is one symbol that

represents us universally. Blackness evolves with our ever-expanding understandings of self. That's why it can coexist as the suited and booted upright air of the church folk *and* the militant defiance of today's activists in their fatigues and bandannas. I would be hard-pressed to distill it into one or one hundred images. There exists a graceful fluidity to what constitutes "Black," and what's most important is the ability to read how the symbols work to represent us.

The task then becomes maintaining your proximity to self and the symbols collectively accepted, knowing that as time passes, so do the symbols that are further complicated by the complexity of discerning kinfolk and allies.

When I told my father and aunts and uncles about the namesake of Andry Street and asked each how it made them feel, how knowing who Andry was might change the perception of their experience, all expressed disbelief and shock. But none said it would have changed much.

I'm not so sure. I'm not saying that Bad Dick wouldn't have shot Pitt. I'm not saying that my uncle wouldn't have traded firefighting for a crack pipe. I'm not saying that the concerts on the park would have been any less exciting for my aunt who fondly remembers her times on the porch as the bands played into the night.

I just wonder about the effect of living on a street that represents the best of you, how a conscious or subconscious shift in your self-worth can alter your life outcomes, how the allegiance and sometimes spiritual importance we tie to our addresses matter. The neighborhood becomes your team, and one of the

most important roles you assume is to protect its members. My uncle Marvin says it best: "I don't believe there is a neighborhood anywhere in America where the people loved each other the way we did."

But this hyperlocal connection to the spaces that raised us can also lead to overcompensation, a conscious or subconscious response to the absence of a space we can return to in Nigeria or Ghana, where DNA says my family has family, long-separated cousins and aunts and generations. Due to this dislocation, it makes sense that our relationship to our homes can be so corrupted.

When someone asks where I'm from, I'll probably say the city at the mouth of the Mississippi that the French, Americans, and others have convinced me was home. But is it still? My parents were dislocated again after Katrina and now live in a Dallas suburb, which means there are fewer reasons for me to visit. My grandparents are ancestors. My extended family still lives in New Orleans, but I only visit once a year, twice if I'm lucky. Now, when I return and cruise my old neighborhoods, down avenues with new names, our former homes and schools vacant, I feel my image of home slipping away.

STREET NAMES IN NEW ORLEANS were officially labeled in 1721 and were confined to the French Quarter. Each honored the royal court, their families, and their baptismal names. As the city expanded, wealthy slaveowners established faubourgs around the quarter, what we would call suburbs today, and they

chose to name them as they saw fit. When the Americans came, so did the street names in their honor. This was also the case during the period of Spanish control.

The names have undergone periods of sweeping change beginning in 1852 through 1924, when the city council established uniformity and got rid of duplications, fragmented stretches, and unseemly appellations by integrating the faubourgs into the grid we know today. Since then, they have been altered periodically at the behest of the city's leadership.

The change of Jeff Davis, one of the city's longest and most recognizable streets, came as the first of many with the establishment of the City Council Street Renaming Commission, which was formed weeks after the murder of George Floyd in May 2020 and was tasked with "renaming certain streets, parks, and public places in New Orleans that honor white supremacists." Change was long overdue but likely wouldn't have occurred without Floyd's murder. The catalysts for change often stir when a Black man, woman, or child is killed, and we keep asking ourselves, must this always be the case? How many more must be killed before we remove all evidence of terror from the public eye?

The commission's goals were to provide "a list of streets, parks, and places that should be renamed, accompanied by a detailed explanation; a proposed list of replacement names for each recommended street, park, or place, accompanied by a detailed explanation; [and] a process to facilitate both educating residents and receiving public feedback on the proposed changes." With the support of historians, experts, academics, students, the New Orleans Public Library, and suggestions from the public,

the commission compiled a 172-page document that is nothing short of amazing. The website articulates the success of the commission succinctly: "While other U.S. cities have made similar efforts to re-examine historical symbols that have come under new scrutiny in the wake of the police brutality and racial protests, the recommendations outlined in this report represent the most comprehensive set of changes proposed by any other municipality in the country at this time." What's most impressive is the interactive map that allows you to toggle over the streets under reconsideration and learn about the namesakes and the figures who should take their place, each name and proposed replacement offering an incredible lesson on the city's history.

To date, however, only a handful of changes have been made. The chief of staff for a councilmember told me about the constraints facing the newly elected commission. Assuming a seat on the city council is like drinking from a fire hose, he said. There are so many to needs to address—*that is, until another Black person is publicly killed,* I wanted to say.

Who will die next? Who else will be sacrificed before all symbols of white supremacy vanish before our eyes? This, more than potholes and power lines, seems to be the pressing issue of our time. Racism versus infrastructure has always been a rigged comparison because racism has always influenced the decisions made about infrastructure. Although there isn't evidence to corroborate their claims, locals believe Betsy didn't inundate the city because officials decided to direct the flow of water to one community, the community that sits along the Industrial Canal: the Lower Ninth Ward. Sacrificing the Blacks to save the wealth

of the plantation homes uptown was an easy choice. Even when we achieved the freedom to own our homes, we were still subject to the whims of white supremacy and how it manipulates geography to its benefit. Worse than redlining, which designated where we could live and devalued our homes, we believe the architects and engineers of hatred in New Orleans wanted to see us drown. There isn't evidence to disprove these claims either.

"Explain the changes made without the commission's approval." I pressed the staffer further. How were some street names so odious that they were changed without debate? This was progress, he insisted, and he referred me to the proposed name changes that would appear before the council. But when I scrolled through the names in question, I didn't see a proposal for the street that mattered to me most.

Clearly people care, and when I say "people," I include those who used to live there. The school that sat on Andry a few blocks from our house, where my family studied, had its name changed to Martin Luther King Jr. in a show of progress. This change seemed understandable in a historically Black neighborhood, except its residents, both past and present, protested. King was an incredible icon, undoubtedly our most visible, honored on the National Mall for good reason, but they wanted it changed back to what it used to be, to honor Alfred E. Lawless, a Black educator who advocated for the rights of Black students in the early twentieth century. He was also the founder of Beecher Memorial United Church of Christ, the church I attended every Sunday of my youth. Because Lawless was the only Black high school in the Lower Ninth Ward, its alumni constitute a

vast network of Black professionals throughout the city who joined efforts to successfully change it back.

The reports that detailed their arguments illustrate an incredible sense of pride for the Lower Ninth and their school, a pride that still drips from their tongues. It seems that the names do matter. They always will.

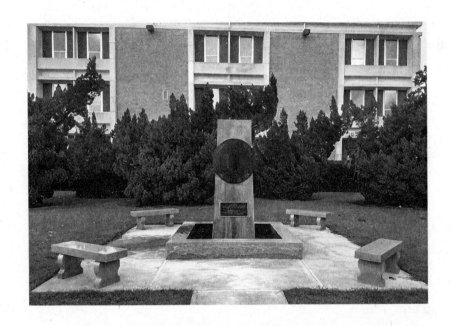

Cypress trees and Katrina Memorial,
University of New Orleans, 2017

A LESSON
BEFORE DYING

Whatever we do, there is always an active enemy who is doing his sowing at the same time, and for this reason we must humble ourselves and pray that the Lord of the Harvest may protect our child's mind from the sower of evil; for in spite of all you may do, you will find things in that child's mind which you never taught him, and which you cannot account for.

—Fanny Jackson Coppin

In a lawn along the western edge of Milneburg Hall on the campus of the University of New Orleans, a row of bald cypresses is thrust sidelong, almost touching the ground, each tree huge and fluffy, tipped over like massive pears in a still life of Louisiana's state tree. Noted for their ability to thrive in multiple ecosystems—in wet, salty, dry, or swampy soils—these trees endured a scale of trauma that is hard to appreciate from one perspective. From behind, I came upon them and moved slowly around each, taking in their tenacious beauty before walking toward a plaque fronting the space:

THESE TREES ONCE STOOD ERECT. THEIR CURRENT STATE
IS A VIVID REMINDER OF THE INCREDIBLE FORCE OF NATURE
THAT CHANGED NEW ORLEANS FOREVER. INSTALLED ON
THE 5TH ANNIVERSARY OF KATRINA BY THE 2009-2010
UNO STUDENT GOVERNMENT.

A path from the plaque leads to a square where small benches
are angled toward a circular disc affixed to a stone column, the
disc the shape of a cyclone. Beneath it another plaque reads:

IN MEMORY OF ALL THOSE WHOSE LIVES
WERE AFFECTED BY HURRICANE KATRINA.

I found myself there in the path of the places where I've stud-
ied to remember who I was. In the process, I hoped to see some-
thing I hadn't before or at least see the familiar anew to further
my understanding of self. This exercise, however, was not in-
tended to suggest some fabulist, predestined understanding of
the world in which meaning is imbued in the details of every
formative location in my life. But if you go looking, if you be-
lieve in the magic of moments past and present aligning to create
a future that provides answers to your life's questions, you might
find them. That's our goal.

UNO was the last school I attended in Louisiana, but before I
tell you what it meant to me, let's begin at the beginning. John
A. Shaw was the name of my elementary school, a two-block
walk away from my maternal grandmother's house. John Angier
Shaw, a white minister and schoolteacher from Massachusetts,
was appointed the superintendent of the New Orleans public

school system in 1841, and he is credited with creating the city's first free library system. The story of his life wasn't taught to me as a child, but how would it have altered my understanding? How would learning the legacies of all the white men honored where we schooled complicate our lessons?

Then there are the mascots. I still have a photo of me from that period that captures my spirit, at least that day, when my head was cocked to the side, my smile fixed in a contrived cool. The polo shirt I wear is my cousin's, either passed down or grabbed from his drawer and worn clandestinely. It's an ugly multicolored pattern, but at the time, I must have thought it fly. The buttons are unfastened and expose my maroon PE shirt. Unseen along my chest is the symbol of a Native in a headdress like a Buffalo nickel. This was our mascot. Imagine what knowing who Shaw was in the context of Native iconography would have done for me.

From there, I attended Pierre A. Capdau Junior High School in Gentilly. Pierre Auguste Capdau was one of the original governors on the board of the Choctaw Club, a group that was fashioned after the Tammany Hall political machine in New York with the ultimate goal of securing collective power—white power. Through its influence, it was able to define the rules of Jim Crow in New Orleans.

I spent a year at Capdau before transferring to Slidell Junior High School, and later Slidell High School. John Slidell, the school's namesake, is the most notorious of the men whose names loomed over my education. He was a U.S. senator and eventual diplomat who served at the behest of President James Knox Polk in America's efforts to annex Mexico. After Louisiana

seceded from the Union, he worked in defense of the Confederacy, lobbying for France's support in Paris, desiring money to bolster the Confederates' cotton trade and legitimize their sovereignty on an international stage.

Had I stayed in New Orleans, I would have likely attended one of its famed parochial schools—Brother Martin, St. Augustine, Jesuit, or De La Salle—but if money was tight and public school was what we could afford, I probably would have gone to one of the McDonoghs, maybe McDonogh 35, the first high school for Black students in the city.

Upon his death in 1850, John McDonogh, a slaveowner, donated half of his estate for the development of free schools in New Orleans and Baltimore with the express stipulation that the schoolchildren visit his gravesite annually and adorn it with flowers. The $2 million he gave, $40 million in today's valuation, naturally spawned a tradition.

This event became known as John McDonogh Day and evolved into an annual ceremony conducted at the base of his monument, which was erected in 1898. The segregated procession began with the white students participating in the pageantry first, while the Black students waited for hours sweating in the May humidity for their chance to acknowledge the benevolent slaveholder. Black students, teachers, and administrators began to boycott the ceremony in 1954, when they could participate in the humiliation no more.

More than thirty schools once bore his name in New Orleans, but today only seven remain and even fewer still celebrate the holiday. There is a video, however, of a ceremony from 2019

available online that opens with a group of disinterested children walking toward their seats. The mayor of Gretna—the city that sprang up around his plantation—approaches a podium and gleefully welcomes the tradition of honoring McDonogh.

A year later, his monument was toppled, and another bust of his likeness erected elsewhere in the city was thrown in the Mississippi. Today, the statue is housed in a city warehouse and a decorative urn is set to replace his former pedestal. But in 2017, when I saw it in Lafayette Square, I was appalled at the self-aggrandized spectacle. Along the statue's pedestal, a schoolboy reached up to place a bouquet of flowers at McDonogh's chest while a schoolgirl held the boy's other hand to ensure his safety. The bust itself was dressed elegantly, the lapels of his frock coat large and spread wide to accentuate a necktie knotted in a massive bow. His face was thin with sharp angles along the bridge of his nose and jawline. Straight ahead he looked through puffy eyes, his expression stoic and composed with an aristocratic air. Picture a distant ancestor of Hugh Grant.

The beseeching image of the poor children disturbed me most because it put forth a false narrative of charity. Yet these white children were miseducated, likely unaware that McDonogh's contract earmarked support for freed children of color too. This history went unacknowledged, as well as the fact that he still considered children who toiled in bondage less than human, making them ineligible for the handout. The truth is, McDonogh's gift was nothing more than a transfer of stolen wealth, stripped from the hands of laborers who would reap none of the benefits.

———

SCHOOLS ARE MORE THAN their namesakes, of course. Buildings don't define the people who shape and occupy space. Formative experiences in classrooms with thoughtful classmates and teachers often surpass the trauma coded in the names. Through these experiences, we are given tools to make sense of our relationships to the world. Which brings me back to UNO.

There, I formally embraced reading and writing as a vocation. I enrolled as a business major, interested in economics and being less broke. But after my freshman English course, I shifted to literature.

This was a formative stage in my life when I read voraciously without the suggestion of a syllabus. Historical novels about figures from the Renaissance in the back of my college algebra class. Memoirs about race and redemption sprawled out on the quad. Anything that pulsed on the page made me yearn for the comfort I found in words.

In one class, I reread *Jane Eyre*, having first encountered it in high school. I didn't particularly connect to it then, but at UNO, it found me at a time when I was open to the revelatory experience of engaging with someone else's soul, addicted to the feeling of inhabiting someone's thoughts and motivations, whether an author's or an imagined persona's. I suddenly saw myself in the pages of the novel, rediscovering it as a tale about a ward of the state who suffers from neglect and heartache.

But no one else seemed to be having the same experience. True, it's a long book written in Victorian English that suffers

from lengthy quotidian passages, not to mention overtly racist ideas. After a few weeks, the professor and I were the only ones engaged in discussion. We didn't, however, talk about the racism.

When the course ended, I visited her office and we spoke around the awkwardness of the discussions. She voiced her displeasure with my classmates and suggested I join the honor's program or—and she said this matter-of-factly—transfer to another institution. She recognized that I deserved better, and I did, like all students who want to learn in spaces with more committed classmates.

I set my sights on Morehouse. I wanted a Blacker experience and picked the best place I could drive to and still feel like I went away for school. This is no dig to my friends and family who went to other HBCUs in the South. Shout out to Xavier, Dillard, Grambling, Southern, Jackson State, Alabama State, FAMU, Tuskegee, Howard, Hampton, North Carolina A&T, Spelman, Clark, Morris Brown, and other institutions where my friends and family schooled. But the allure of Dr. King, Morehouse's most famous alumnus, was hard to resist.

It was a strange, uncertain time for me. I had moved away from my grandmother, my first teacher, and I had no larger connections to Morehouse. I didn't know any alums personally. I had arrived on campus with a distant cousin from Mississippi who was also interested in transferring. Together we drove up in his family's Cadillac Seville to tour the campus. At some point during the tour, the guide told us that all first-year students were required to live on campus, including transfers. The cost of

room and board amounted to an additional ten grand I didn't have, and without saying it, he told me that my experience would be different if I couldn't afford it. Maybe Morehouse wasn't for me.

I heard what he said but didn't listen and scraped my way there. The desire for a better education in a Black space was too overwhelming. What I lacked in funds I supplemented with faith, which gave me the courage to trust God's will.

My cousin bailed and never transferred, so I rented a room off campus, a thirty-minute highway drive away. I don't regret the pain and alienation I felt that first semester. Eventually, I learned to adapt, but it wasn't easy. The challenge of acclimating presented itself when I walked into my first class wearing my blue uniform shirt from the Finish Line. Every head turned toward me in judgment. Later that day, a Spelmanite laughed in my face in the cafeteria when I told her I was the assistant manager. My confidence and position of authority should have made me more attractive, I reasoned, but it did the exact opposite. She didn't work and was from a faraway place called Delaware. I never wore my uniform to campus again.

Eventually, I met lifelong friends, but those first few semesters I found myself on campus lingering on the lawns, taking in the buildings and statues, embracing what it meant to be there. The two most conspicuous works of art reside in front of King Chapel on an elevated area of the campus, from which you can see the bulk of its buildings. An obelisk ringed with flags houses the crypt of Howard Thurman, the valedictorian of Morehouse's class of 1923 and arguably its most celebrated theologian not named Martin Luther King Jr. Thurman's words, written in *Jesus*

and the Disinherited, would become guiding principles for many activists during the Civil Rights Movement, including King, who embraced its nonviolent appeals while leading the Montgomery bus boycott.

The other work of art is a statue of Dr. King himself. He is memorialized in midspeech with a furrowed, impassioned countenance, his mouth agape as his lips curl around one of his moving speeches. He assumes a forceful stance, his forefinger extended from his right arm and raised at eye level, indicating the certainty of his direction.

I don't know how many times I stopped to gaze at him or how many times I simply walked past, but to be on campus is to be aware of his omnipresence. He is the source of the aura that pervades Morehouse, an aura that demands a commitment to deep mediation and study in the way of the ministers. Just beyond him, in the grandeur of the chapel where the six-thousand-pipe organ remains one of the largest in the South, I would stroll through the gallery encircling the wings of the auditorium and be inspired by oil paintings of notable figures from America and beyond. Every week I would find myself there for Crown Forum, a lecture series that students were required to attend with the aim of reinforcing the aspirational expectations set before us. Business casual attire was mandatory. Sometimes the lectures moved me, but other times I found myself uncomfortable with my ignorance of decorum and upper-middle-class sensibilities. Many of my peers knew they would be leaders in the molds of their parents, and I had no such exemplars. I wasn't born into a rich family from Delaware.

I was most comfortable in the classroom, where my professors

seemed to care about me as much as they cared about my academic performance. This is not to say I loved them all, but the few that I didn't were outliers. Some of my classes only had a handful of students, and together we would engage deeply with texts for hours.

Because I had already earned a bunch of credits from UNO, I was eager to dive into the culture and enroll in upper-level courses to accelerate my matriculation, but the chair of the history department, a man born in Liberia, thwarted my plans. I had met with him to get his approval of the *A* I had earned in the History of Western Civilization, but as he reviewed my transcript, he lingered longer than I thought necessary and rebuffed my request directly: "Young man, the history of the world didn't begin in Europe." With the incoming freshmen, I would have to take World History taught from the Africans' perspective, and I was pissed, more concerned with my grade than what he was actually saying. Were it not for his sincerity, I don't think I would have been open to the blessing, especially since I didn't appreciate it at the time. Thus began my unlearning of white supremacist culture.

There were other moments when I was offered correctives to my whitewashed education. I found Baldwin, queer identities, and the slave narratives, each a sweeping epic of survival and divinity. I once again engaged with *Jane Eyre*, this time through *Wide Sargasso Sea*, a novel written as its counternarrative. That madwoman confined to the attic in Brontë's novel could be read through the context of the transatlantic slave trade in Jean Rhys's interpretation. Bertha wasn't a woman prone to hysteria as a symptom of her womanness. Rather, she was trapped in a

foreign land, forced into a transactional relationship due to slavery. I even found white writers whom I came to love: Didion, Emerson, Milton, Shakespeare, Faulkner, and others. How I came to them, though—through a lens that didn't overlook how they handled race—made all the difference.

So much of what I experienced at Morehouse was unimaginable as a student in New Orleans, and when I reflect on my time there, I often find myself learning new lessons. While I was strolling the campus trying to find myself in the spirit of the men honored on its grounds, I was unknowingly engaging with the work of Ed Dwight, the first Black candidate for NASA's astronaut program. Unfortunately, or fortunately, depending on how you view the trajectory of his career, Dwight was never selected to become an astronaut, a decision he believed reflected the racial politics of the times. But this failure led him to other endeavors. He returned to the arts, his first love. In 1977, he earned an MFA from the University of Denver and embarked on a career in which he produced 129 sculptures and over 18,000 gallery pieces. His work is housed in museum collections throughout the country, and his sculptures have been commissioned by countless organizations including the Congressional Black Caucus, the NAACP, the United Negro College Fund, the National Urban League, and the John Hope Franklin Center. The focus of his art lies in the Black experience from slavery to civil rights to the present, and he remains one of the most important American sculptors.

Dwight sculpted the statue of Dr. King in front of King's Chapel and another of Benjamin Mays, the sixth president of Morehouse who mentored King and gave the eulogy at his fun-

eral. "To be honored by being requested to give the eulogy at the funeral of Dr. Martin Luther King Jr. is like being asked to eulogize a deceased son," he opened. Upon his death, Mays's remains were entombed on the campus where his statue, dressed in a graduation gown, urges its students to strive.

These details only increase my love for Morehouse. The legacies of the people and structures and physical space continue to amaze and uplift. This is the import of setting and place, how our lives are often unconsciously shaped by unseen sculptors of the physical and divine.

THE DAY KATRINA MADE landfall was the first day of my third year teaching English at Southside Academy, a high school in Cherry Hill, Baltimore. I stayed up all night watching the Weather Channel and suffered through the next day, wondering about the safety of my family. I had moved to Baltimore from Atlanta a few weeks after I graduated from Morehouse to begin a program at Morgan State University, an HBCU, which paid for my master's in education on the condition that I teach for five years in the public school system.

That first year remains the hardest of my career. The neighborhood was situated in the southernmost part of the city in an area separated by an inlet of the Patapsco River, home to the largest public housing complex in the city. This was the era of *The Wire*, the HBO series that accurately captured the state of the city and school system during my tenure. Addiction and poverty were ubiquitous.

The principal was stern and filled the room with a tall, dom-

ineering presence. She was also from Cherry Hill and wanted the best for its students, many of whom she had personal connections to. No matter how hard I tried, I couldn't meet her standards. My students were difficult to reach, and every day it seemed like I was getting written up, another memo placed in my file joining the stack that could justify my termination. I didn't make it any easier with my Morehouse mystique dripping from me like I was better than them. Sure, I thought about quitting the day a student charged at me in the hallway and disrupted the school day, but I had no other options.

It was my fault anyway. I had made an offhand comment to what I had perceived as disrespect and reminded him that I wasn't his father, in the way that we let each other know we've crossed the line. "I don't know who you think you're talking to, but I'm not your friend, your mother, or your father . . ." He didn't let me say another word and flipped his desk and ran toward me standing in the doorway. We were waiting to move to an assembly or some other event, and the teacher whom I was talking to struggled to restrain him as the commotion spilled into the hallway. All the doors to the other classrooms flew open, and the hallway became our arena. His dad was in jail, I learned later, and I was the asshole.

There were other days when I collapsed on my couch after work and would wake up in the same clothes the next day without lesson plans. During this period, I remained committed to writing and enrolled in a composition course in addition to my education classes, but after a few weeks, I flamed out. I had to take the course again a few years later, when Katrina had me fearing the worst. If I wanted to graduate, I couldn't with an *F*

on my transcript, so there I was, chasing my dream, floundering in a state of crisis.

The first class assignment asked me to describe who I was, and at the time, I listed a bunch of descriptors in what read like a prose poem that ended with the portrait of a despairing soul, unsure of his family's survival. I've always thought what I wrote that first day must have ingratiated me to the professor, because later in the semester she offered me a chance to write what would become my first byline, a biography of John Biggers. Biggers is arguably the most important African American muralist ever, and he is also the founder of the art program at Texas Southern University, another HBCU, where he mentored many notable artists still working today.

So let me break this down: because I attended Morgan, I got a job at a challenging school, which jeopardized my degree and made me repeat a course, which led to my first publication, which happened to be about an amazing artist, all while I lived in Baltimore, the other city that benefited from John Mc-Donogh's theft, and none of this would have been possible without my first teacher.

When I think about teachers, I always see my grandmother as one of those called to serve as models and sources of information, those who offer directions to the right books and demonstrate the discipline required to learn and grow. My maternal grandmother, of all the people who noticed my advanced aptitude as a child, fed me books and encouraged me to write. When our joint efforts were awarded first place in a citywide essay contest during my time at Shaw, our relationship became firmly

established. I was the writer, she the editor, and we went on like this till her death, exchanging letters and books and ideas. Throughout it all, she was teaching me scripture and perspective, always motivating with affirmations.

Our greatest exchange was the story of her evacuation after Katrina. While I was in a Baltimore classroom writing about the pain of not knowing if she survived, she was documenting it all in her head to give to me. Eighteen handwritten pages of her rescue from her attic with her mother and son; the night they spent on the overpass as people died in front of them; the trauma of seeing a woman set another woman's baby on fire in a Houston shelter; the despair that followed. As the years have passed and my emotions have become less raw, I've come to appreciate the gesture as another one of her teaching tools.

It was a crafted reflection with dramatic narration and a spiritual ending. The audience, I've come to realize after years of confusion, was always me. When she told me she wanted me to do something with it, I thought it deserved to be shared with the world, until I realized it was mine alone to read as a testament to the value of documenting one's life, even if its impact only reaches a single soul.

As a teacher, since my first post in Baltimore, I've always sought to be of similar service through my love of language and the arts, and I have gone on to teach hundreds of students in various settings, in high schools, libraries, community colleges, reentry programs, graduate schools, and other spaces.

The first place where I assumed the title of professor was Boricua College, a nontraditional school that was created by and

for the advancement of Puerto Ricans and Latinos. Nearly 80 percent of its students are adults who live in the three communities where each of its four campuses are situated—Washington Heights, Williamsburg, and the Bronx.

I had earned two master's degrees by the time I applied for a position, the latter of which was in creative writing, so I assumed I was interviewing for a vacancy in the English department. But the dean of one of the Williamsburg campuses was desperate and needed an art teacher a few days before the semester, and before I knew it, I was assigned an art history course.

"You see this master's of fine arts," he said, pointing to my resume, "this is all that matters. Here's the textbook," and he handed me the revised sixth edition of the *History of Art*, edited by H. W. Janson and his son. "Keep it light. Show lots of images. Don't lecture too much," he said.

I was confident in my teaching ability after five years as a high school teacher in Baltimore and Brooklyn, my skills having been sharpened by scores of challenging situations, convinced that as long as I had books, I could teach any subject. While I had demonstrated the ability to instruct in multiple disciplines and had experience instructing adults, my students at Boricua—mostly older than me, some as old as my parents and grandparents—soon convinced me of my arrogance.

To prepare for the semester, I studied the textbook and sat with the ancient world, the Greek and Roman eras, the Renaissance, and modernism. During class, I encouraged students to consider the symbolism of the works, the artists and their medi-

ums, the significance of the work's location and purpose—any and everything that I thought could bolster their appreciation. Sometimes their responses were simple preferences of color and subject matter, while most were moved by the religious iconography of the Renaissance and Middle Ages.

But I felt ineffective, a novice without sufficient strategies to engage them in art. Some students still struggled with literacy, and for the few who were proficient, the readings proved too dense and academic. It didn't help that the book was over a thousand pages and weighed more than ten pounds.

Then I began to offer extra credit. They could visit a museum and describe their experience to the class, or they could attend the class trip to the Metropolitan Museum of Art that I had organized.

More of them came to the Met than I had expected, some with their partners and children, and together we walked through the sculpture garden where, to my surprise, some identified the different types of columns on display, a distinction that I had taught them mnemonically. Doric columns are *dull* compared to the more *intricate* Ionics, which are not as *complex* in facets as the Corinthians. Some even recognized artists we had discussed, and most walked with me through the ancient Egyptian collection, where the entrance makes you feel like you are entering the tombs of a pyramid.

When we returned to class the following week, I was touched by how transformative it was, as many confessed that they had never been to a museum, some still shocked that the admission price was suggested. Nearly all of them said the trip was the best

part of the semester, and the experience taught me that no percentage of right answers can quantify the reward of learning how to engage with art and glean its value.

In all my capacities, whether I was formally the teacher or student, I can point to a moment, a lesson, a pupil, or a peer whose influence remains. There are far too many to describe, but for each I am grateful, even and most especially in those moments when the insistence of white supremacy made me uncomfortable, when the dehumanizing texts I was forced to read, written by supposed masters, made me question my worth, when the exchanges with teachers whose biases prevented them from seeing my talents caused me to shrink.

These are my lessons, but what about yours?

Think of the educational settings that have been most formative in your life, whether you occupied them as a student or instructor. These spaces can also include those outside formal school settings. Identify a teacher, classmate, or experience that stands out from your time there. Reflect on your feelings about this person or experience by writing a few paragraphs.

After you have done this, research the founders of these spaces, the namesakes, the origins of its mascots and insignias. If the books you seek have been banned, you're on the right track. Don't let bureaucracies dictate your consumption.

Use what you have learned to question your relationship with white supremacy. How does understanding what and where you learned shape who you are today? Are you maintaining the laws of white supremacy, or are you working to deconstruct them? (Hint: no one is innocent; often we assume white supremacist behaviors and ideas subconsciously.)

You can respond to the questions however you like. Write a poem, song, essay, or play. Make a drawing, painting, or sculpture. Take a picture, shoot a film, or create any other form of visual art. Every creative expression is acceptable. Most importantly, for this is how you'll be judged in the end, share your findings with everyone you love.

"HAVE YOU SEEN OUR SISTERS?"

You may or may not have heard about the Dakota 38.

—Layli Long Soldier

My favorite monument that still honors white supremacists in New Orleans—and when I say "favorite," I mean conceptually—is the statue of the city's founder, Jean-Baptiste Le Moyne de Bienville. Foot traffic is steady along the small triangular park on Decatur Street where it stands, the Riverfront and Jackson Square—maybe the most visited sites in the city—only a few blocks away. But when I stopped to gaze at the monument on a sunny afternoon, no one else seemed to notice it.

Its complexity set it apart from the others, for captured there along with Bienville's image were two other figures, a Native American man in a headdress and a priest in full papal attire, each on his own pedestal facing a different direction. This three-in-one quality, rendered in an impressionist style, conjures three

narratives best understood when woven together, and I pieced the puzzle as I circled its base over and over.

The first time I had seen Indigenous people portrayed unsympathetically was when I traveled to the Dominican Republic on spring break as a college senior. Curious about what lay in the capital, I traded one of my sunbathing afternoons for an exploration of the Zona Colonial in Santo Domingo, where a towering monument commemorates the island's "discovery" by Christopher Columbus.

Cast in bronze, wearing a long, flowing robe that puffs at the elbows, Columbus stretches his left arm toward the horizon as his forefinger points north, indicating the direction of the New World. This is odd, of course, considering the DR is decidedly south of Spain. His stance could also indicate another point of departure, however, as his voyages throughout the New World were myriad. His right hand clutches a mooring, and a sword swings at his waist to the left. Along the square, pyramidal plinth, an Indigenous woman wearing a headdress and loincloth extends upward in a contorted position to write: "The illustrious and enlightened Christopher Columbus." According to legend, the woman is Anacaona, a Taino who was the first Native American to learn how to read and write. After her village was burned, she was hanged in a public square in Santo Domingo, and her presence, gazing up in awe at Columbus, fails to account for the eventual slaughter of her people. Jutting from the pedestal's edges are menacing beakheads, each ready to ram into another vessel, and on the other surfaces rest large palm branches as symbols of victory and conquest. A gift from the French in 1887, the statue seems to underscore the mythology of victors.

The Native American man in the Bienville monument sits on its second tier, one leg folded under the other, his arm braced tightly against his chest. A peace pipe, finished with five feathers, rests on his shoulder. The position seems unnatural and strange, especially the tension that defines his expression. It doesn't indicate suffering or captivity, but it doesn't indicate joy either. Somberly, his chin droops toward his chest, his close-eyed depiction conveying a stoic resignation. Why was he here, I wondered, trapped in this sordid tale of imperialism? Shouldn't the terror he endured be shielded from public view?

I shifted my gaze to the priest, whose statue is said to capture Father Anastase Douay, the Frenchman who had first traveled to Louisiana on the expedition of Cavelier de La Salle. Later, he would accompany Pierre Le Moyne d'Iberville, Bienville's older brother. Atop Douay's head is the customary zucchetto, and around his waist the cincture that tied his robe falls in three knots, symbolizing poverty, chastity, and obedience. Rosary beads hang from his sleeve, and he appears to be studying from an open book, presumably the Bible.

I turned back to Bienville, his figure styled in the typical attire of the seventeenth-century elite—a waistcoat, cravat, breeches, and stockings raised to the knee. Nothing is remarkable about his depiction. His hair, most likely a wig, falls to his shoulders. You could have convinced me his was the image of Thomas Jefferson or George Washington, his face nondescript and European. With a book lodged at his hip, his left hand balances his weight on a staff. It seems he was equal parts scholar and explorer, one versed in the Native tongues and steeped in the white man's greed.

Hidden under his cloak is the image of a serpent that snakes around his torso, the tattoo emblematic of his complicated views of Indianization, or the practice by which one adopts the customs of Native American culture. If he were to rule the land formerly occupied by Natives, he reasoned, he would have to embrace their way of life, especially if they were to trust a twenty-one-year-old, the age at which he was first appointed governor of the Louisiana territory. An outsider born in Montreal, Bienville successfully ingratiated himself to the region's Native peoples and served four terms as governor, effectively branding him the "Father of Louisiana." While the Europeans of his time considered tattoos sinful, Bienville was of the New World and did whatever he deemed appropriate to secure his position, which of course included violence. To this end, he led battles against the Natchez and Chickasaw on behalf of the Choctaw, who had helped him colonize New Orleans. And as for our direct ancestors, he enforced a strict doctrine for enslaved Africans called the Code Noir.

First devised and implemented in the French Caribbean colonies in 1685, the Black Codes were a list of fifty-four articles that outlined the acceptable conduct and punishment of enslaved Africans. Jews were excluded from the Louisiana property. Catholicism was the only acceptable religion. Marriage between Blacks and whites was prohibited. Enslaved Africans belonging to different masters were prohibited from congregating in groups. Execution was the punishment for anyone who struck his master and left a bruise or open wound. Theft of livestock or food was punishable by death, lashing, or branding of the fleur-de-lis. Runaways were punished on an escalating scale.

The first attempt cost the ears, the second the hamstrings, and the third one's life.

These codes make no appearance in the statue's inscription:

JEAN BAPTISTE LE MOYNE

DE BIENVILLE

BORN MONTREAL FEBRUARY 23, 1680

DIED PARIS MARCH 7, 1767

FOUNDER

OF

NEW ORLEANS

1717

WITH HOMAGE OF

LOUISIANA · CANADA · FRANCE

My great-grandmother—the one who was rescued after Katrina with her daughter, my grandmother—seemed to know that she would never see me again the last time we spoke, this the day after I saw Bienville and the anonymous Native American man in stone, their relationship consecrated by the priest.

She and I were never close. Throughout my youth, I kept a distance, and she never seemed to mind. After all, I had come along after she had lived a full life. She had mothered three children, each who had their own, who had had their own, which meant she had more than enough distractions to prevent her from bothering with me. I don't know if Mama, as we called her, or Mama Nancy, knew why I was home, if she knew why I was spending time with the monuments that rose in her lifetime

to scare her into subservience. I just listened as she told me one story after another, her faculties sharp, her memories lucid. Her eyes never left mine, and it was like I was experiencing her for the first time. She was ninety-six then, a few months before she would celebrate her last birthday.

She told me about sitting on the porch with her grandmother, a Cherokee woman who wore long plaits and liked to smoke a pipe as she went on about her life on the reservation and the ways of the world, about how to avoid becoming one of those common women who let men do with them as they pleased.

"Irvin," she said, "you got to hold your head up to any white man. Don't be afraid. Stand flat-footed and tell any of 'em that need to be told," and then she paused for emphasis. "I might be afraid of a bear or snake maybe, but a *human being*, not me, honey." So satisfied was she with the absolute certainty of her words, her smile unrelenting.

She told me about meeting Joe Louis, how handsome he was before she claimed he was dumb as dirt, laughing with her whole body.

The conversation, which was really an uninterrupted monologue, eventually took a turn when she arrived at the story of her sister's death. There was a dance at the Rhythm Club in Natchez, but she was sick, and her father told her to stay home. God bless the common cold or whatever she suffered from, because it saved her life. When word spread about the fire, she went down there to look for her sister and described a scene of dead bodies splayed out everywhere, the smell of burned flesh something she wishes she could escape. I had heard parts of this story before but never with such detail, and I returned her gaze with disbelief.

Then we arrived at her grandfather. He had set out one night

from Natchez to another Mississippi town, and they found his battered body on the side of the road, discarded like trash. "Can you believe it? For five dollars? That's all he had, and to think I never got to know the man!" She was shouting, her emotion raw and strange. I had seen her angry before when she was her ornery self, but now I was seeing her injured, on the verge of tears. She paused and looked away, her face traveling somewhere distant, and I realized for the first time that she had never healed from the loss, from the accumulation of losses.

She returned from where her mind drifted, repeating her lifelong stance. "That's why I don't care if they're a white baby in the cradle, I hate 'em," she said, smiling, shrugging her shoulders as if to say, *Yeah, I said it*. "Pastor Brandon used to always tell me that hatred would destroy me," and she paused as if ready to offer a concession that never came.

Often, I was repulsed by her stance on white folk, but this time it seemed that I was hearing something I had missed. The ease with which she recalled the minute details of her story became a performance, the exact years and locations and descriptions of the people from her past just sitting there on her tongue.

She charted her life through a series of tragedies. Her mother, dead from scarlet fever and insufficient health care, another casualty of white supremacy. Her grandmother followed, then her sister, and then her grandfather, all within the span of her teenage years. And that was just the experience of *her* family. Who knows the other losses suffered by friends and acquaintances? She survived Jim Crow and saw our leaders assassinated. Hate wasn't an abstraction; it was as real to her as a second skin.

Sometimes, when we were watching the news in the break

between her beloved soap operas, when we learned of another local official caught in a scandal, she would interrupt the reporting and scream "Lying crackers" or "Them crackers ain't never been right" or "That's why you can't trust them crackers."

I didn't know any white people then except for a few teachers and the brother and sister who were the only white students at my elementary school. I didn't have anyone in mind who deserved my defense, but I never liked the energy of hatred. I've always preferred the grace and demure way my grandmother, her daughter, would address uncomfortable situations. But how should you respond to the overwhelming evidence of racism in your life, its fingerprints all over you? Should you grin and bear it forever?

If given the opportunity, Mama Nancy would happily accept that task of putting someone in their place. But now, after reflecting on our final conversation, I'm left reconsidering my previous positions on her questionable aphorisms. "My mother would always tell me that you shouldn't go around acting as if you're better than anyone," she would say, "but the truth is, you are. Some people are just beneath you, baby. No matter what, you got to always hold your head high and be proud of who you are." For years, I never knew how to tell who I was better than, and eventually, at least consciously, I stopped comparing myself to others.

In the immediate wake of our meeting, I left knowing that my great-great-great-grandfather was disappeared and that my lineage includes Native American ancestry. I purchased a DNA test to confirm Mama Nancy's story of her grandmother, but the results didn't provide the evidence. I still believe her. Many of us

do. Passed on through generations as myth to disavow the systematic rape of our mothers by white men, Native ancestry rewrites our history.

These realizations were no comfort to the questions they inspired, and I went looking for answers. The New Orleans I knew was changing. So much of it seemed unfamiliar and inviting. Disgraced heroes were falling just as I was erecting a new temple for Mama in my mind, an altar where I wanted to offer supplications for all that she endured.

The questions kept coming. Why did Jackson and Bienville and the other racists remain? Didn't Obama decree that Jackson's image be removed from the twenty-dollar bill and replaced by Harriet Tubman's? Yet somehow I still found him in my wallet, tucked away between records of who I am and everything I value.

If Jackson had cleared the land of Native Americans after the Louisiana Purchase to expand slavery and the country's borders, I figured I should go looking for answers where the country's most celebrated white supremacists loom large over the landscape, where their permanence seems just as assured as Jackson's image in front of St. Louis Cathedral.

Mount Rushmore is to America as Jackson Square is to New Orleans, both symbols of the country's celebration of white supremacy and its tendency to mythologize its origin. Both willfully disregard the Native American experience. And both may never be blasted from their granite canvases.

A year later, I would pack my questions and trace the Mississippi River as if driven on foot from the land, past Natchez to the Missouri River to the Cheyenne, and overland to the Black Hills. I wanted to know how others cope with the audacity of

white supremacy, its presence thick and palpable, always there, towering over the fleeting moments that compose our lives.

ON THE LAST day of the Second Annual Indigenous Writers' Festival, I entered a hotel ballroom as the keynote speaker read from her work. I had debated whether to go since I had already missed the other panels and readings. My trip had been full, spanning two weeks exploring the region. I also hate being late. But a spirit, maybe the subject of a legend that I was just learning, urged me to reconsider my relationship to time.

The speaker read from a lectern, and I shuffled to an empty seat in the back. A quick scan revealed my singular presence. I was the only man and the only non–Native American occupying space in a celebration for Native American women. Immediately, I felt out of place and flipped through the program to hide my discomfort. LeAnne Howe, a Choctaw author, was the speaker, but the program didn't identify what she read. Not long into her reading did the scene emerge as she assumed the perspective of one of the thirty-eight Dakota men lynched the day after Christmas in 1862. I had never heard the story of the largest mass execution in U.S. history and couldn't believe what I was hearing. What had I walked into?

> In Dakhóta land, they are pulling down the last of our dead,
> Bodies of men and women hanged by a rope of lies.
>
> When I was a human being,
> I would sing the air thick with Dakhóta songs.

December 26, 1862.
In one hundred and fifty years, the citizens of Mankato
will shiver,
Asking why their ancestors hanged thirty-eight Dakhóta
Indians over a handful of hens' eggs.

When I look at your world, I weep
Because in the end, even your life is a captivity account.
Maybe we are all captives of one sort or the other. . . .

Later, I learned the book was called *Savage Conversations*, a
drama told in three scenes and following three characters: Mary
Todd Lincoln; Savage Indian, one of the thirty-eight Dakota
men hanged; and The Rope, both a man *and* the image of a
hangman's noose used in the execution. In the years after her
husband's assassination, Mary Todd Lincoln had become ad-
dicted to opiates and claimed that a man, Savage Indian, had
entered her room every night to sew her eyes open and slash her
face and scalp, a charge for which she was tried for insanity in
an Illinois courtroom and committed to Bellevue Place Sanitar-
ium, the central setting of the play. Years earlier, President Lin-
coln had ordered the execution of the Dakota men, attended by
four thousand cheering settlers, and Howe imagines the mass
execution as the source of the visions that continued to haunt
his widow.

After the reading, another woman sang a song in her Native
tongue to honor the land of her ancestors. I didn't understand the
words, but the passion through which she sang in a closed-eyed
trance said enough. Everyone rose and formed a circle, and I

lingered along its edge, plotting my exit. *I shouldn't be here in this space of mourning*, I kept saying to myself just as another woman pulled me forward, and I joined hands with the others as I circled the space in prayer for the Native American women who haven't made it home. I thought of my ancestor's advice to Mama as I shut my eyes and reached for the sublime, but I couldn't shake feeling like a trespasser.

It's hard to describe what I felt at that moment due to the limitations of language, how my understandings immediately shifted as I felt so many spirits in the space, in the embrace of women who continued to pull me forward.

Eventually, someone invited me to the poetry reading at Racing Magpie, a nearby multipurpose center that served as a gathering site for Native American communities where artists rented studio space and sold their wares. When I arrived, the show hadn't started, and I surveyed the space and studied the paintings lining the walls in the interim. A collection of red dresses and clothing caught my attention.

"HAVE YOU SEEN OUR SISTERS?" read one T-shirt. "UNRESOLVED: CASE CLOSED OR MURDER?" read a flyer pinned to a dress. Another said "$21,000 REWARD" for information about a woman last seen in 2017, a picture of her Chevy Silverado under an image of her beautiful smile.

I felt overcome as the reading began, starting with a prayer and an offering to the Lakota ancestors. Each reader performed a poem or two and filled the space with tears, laughter, and applause. It was an intimate gathering. Everyone knew each other, and I could sense they had been looking forward to the event for

some time, each longing to hear what the others had brought to share. And as I write these words, I'm not sure I can ever repay their generosity. The gift was the perfect coda to my exploration, although this Western framing relies too heavily on linear time. For many cultures, endings are beginnings, the divisions of human experience less rigid, and I began to see myself in the circle of their circumstance.

This reflexive realization was not absent of ignorance, however. After the reading, possessed by a spirit of kinship and lubricated by glasses of red wine, I told the site's director that I had a Cherokee ancestor, and he paused before telling me how the suggestion offends. He said it frankly, without injurious intent, and I made space for the lesson. Most Americans have Native blood, he said, which was to say that kinship is beside the point.

Many of us, especially in New Orleans, claim Native ancestry. And even if we don't, we feel like they are a part of us still. The father of my childhood friend was a Mardi Gras Indian. He lived next door, and often I would linger in his basement inspecting the colorful headdresses and costumes that he wore on Super Sunday, the beadwork and feathers and sequins just as meticulous and beautiful as the traditional clothing I had seen in South Dakota, except our Indians incorporated African iconography in their attire, their costumes like huge West African spirit dolls.

Legend has it that Mardi Gras Indians learned the ways of Native life after escaping to Native American camps during slavery, where they were cared for and developed community. And in the spirit of celebrating their connections, Mardi Gras

Indians created their own traditions, inspired by war ceremonies, in which they fused battles with carnival pageantry. At first these battles were violent, but over time they became more about the costumes, or suits, as they were called. The tribe with the prettiest suits emerged victorious. The tradition continues today, as a statue of Allison "Tootie" Montana, who was called the "Chief of Chiefs" and who was responsible for ending the violence between the tribes, stands in Louis Armstrong Park, in Congo Square, in the Tremé neighborhood of New Orleans, where enslaved Africans congregated freely for ceremony and dance, and where our relationship to Native culture is concretized.

I wanted to stay there longer to learn more about Native art and literature and contemporary life, but the event soon ended. People began filing out, and I rifled through the clothes for sale and found something for my wife, a purple dress adorned with gold spears that felt silky and well crafted. I walked along the walls again, stopping to embed my favorite paintings deeper into memory before I made it to the door.

A FRIEND AND EARTH SCIENCE teacher from Maryland flew out for a couple of days to join me. He had arranged for us to speak with someone at Mount Rushmore to learn about the ecology of the memorial so that he could share the findings with his students. It was overcast and rainy on the day of our visit, and we waited inside a viewing area for our guide. The space was lined with displays and infographics of each president and stories about the principal architect, Gutzon Borglum.

Earn CASH & STAMPS: This is a One-Time-Pay Product Program you could earn over & over. You are paid directly.

Directions: 1. Fill in the coupon below. 2. Choose your package. 3. Make 4 copies of this entire page. 4. Wrap up 20 new "Forever Stamps" along with your MONEY ORDER in the amount of the product package you have chosen. 5. Priority mail to EACH DEALER & Admin listed on this page. **If paying by Cash App, please mail each Dealer and Admin 20 Forever Stamps with this form completed.** *Must mail* this form to receive your product package.

9103 Woodmore Centre Dr. #21
Lanham, MD 20706

CashApp : $TyeceJohnson05

Mail payment to ADMIN:
Tolar Internet Group
15105-D John J. Delaney Dr. #21
Charlotte, NC 28277
Cash App $KellyTolar

* IF PAYING BY CASH APP, YOU STILL NEED TO
MAIL THIS FORM TO ALL DEALERS ABOVE! *

Print Neatly

START HERE

Name: _____

Address: _____

City: _____ State: _____ Zip: _____

CashApp ID $ _____ Email: _____ Phone: _____

Choose Your Product Package *BONUS* ~ $250 PACKAGE GETS 300 PRINT & MAIL (any mailer) CO-OP ADVERTISING

	
$250 + 20 Forever Stamps to each Dealer & Admin:	You Get Membership, Ad Copy, 100 Leads, 100 Color Prints, 300 Prin
$100 + 20 Forever Stamps to each Dealer & Admin:	You Get Membership, Ad Copy, 50 Leads, 50 Color Prints, 100 Print
$50 + 20 Forever Stamps to each Dealer & Admin:	You Get Membership, Ad Copy, 25 Leads, 25 Color Prints, 50 Print &
$20 + 20 Forever Stamps to each Dealer & Admin:	You Get Membership, Email Ad Copy Only. You can still earn on all p

Copyright@TIG. DISCLAIMER: You are making a PRODUCT PURCHASE of a Mega Mailer Membership......

I perused a few displays and migrated to the gift shop, which was stocked with things you would expect—American flags, magnets, and cheap replicas of the monument. Coming upon the bookshelves, I flipped through a children's book about life during the American Revolution, and the only mention of Black people was a short statement about Phillis Wheatley, who was "brought to America from Africa." Nothing about her enslavement or the conflicts waged against Native nations. Pissed, I closed the book, unsurprised.

The guide introduced herself as the chief of interpretation and education at the Mount Rushmore National Memorial.

"So," she opened, "what do you want to know?"

"Tell us about the wildlife that live here," said my friend.

"Well, there are mountain goats and mule deer and numerous bird species that are thriving and often seen here along the grounds, although today doesn't seem to be the best to venture out. Ultimately, our goal is to try to reduce our footprint while preserving the space for its original inhabitants."

"What about the effects of acid rain?" my friend asked.

"As you may know, when carbons are released in the atmosphere, they cause our rainwater to become acidic, but these small amounts are not enough to dramatically alter the monument, as it takes hundreds of years for granite to recede an inch, which means the memorial will remain intact long after we are dead and gone."

"Can you tell us about the sculpting process?" I asked.

"Good question," she said. "One of the more interesting stories about the monument are all the adjustments that were made while carving it. You can't really see it today, but—"

"Excuse me," a white man interrupted. "Do you know when we will be able to see the monument?"

We all looked out the windows to see dense cloud cover obscuring the faces.

"I'm sorry, but there is nothing we can do about the weather. Maybe tomorrow will be clearer," the guide responded sympathetically.

"What was I saying?" She turned to us again.

"The adjustments," I said.

"Yes, well, the mountain wasn't easy to carve, especially since it's made of many minerals, all which made it difficult to adhere to the sculptor's original vision. Jefferson was particularly challenging, which is why his face is angled up and out of plane with the others. Many have also remarked how his image doesn't really look like him. The same goes for Washington—"

"Excuse me," someone else cut in. "Is there somewhere else where we can view the monument?"

"I'm sorry, but this is the only view available," she said and walked backward toward a wall to move away from the crowd.

"Their faces," I prompted, noting a quizzical expression on her face.

"Yes, Lincoln's is probably the most defined and recognizable, but even then, the original goal of sculpting their torsos was scrapped due to funding. The sculptor died before it was completed and left the task to his son. The whole enterprise took sixteen years and ended in a hurry, as you can see from the blasted rubble that remains at its base."

I peered out at the stones piled in a messy stack.

"While they might not be aesthetically pleasing, moving them

at this point would further disrupt the delicate ecosystem, which leads me to the measures we're taking here to limit—"

"Excuse me," a white woman interrupted. "How long do we have to wait to see the monument?"

"I'm sorry, ma'am, but we can't predict the weather," she said before turning back to see our smirks. "I get it," she continued. "People travel for hundreds of miles to see the memorial, and some only have a few hours to spare, but I'm not sure what they expect us to do."

"Magic," I said, and my friend laughed. She restrained a smile.

"You know," she continued, "you two are just the type of people we need here, as interpreters, I mean, to help people understand their experience."

It was a kind suggestion that meant they needed more Black people on staff. She was surprised, I'm sure, that on the other side of her emails were curious Black men, and when she offered us a job, I felt her biases shift. These are the same biases that retreat when I tell white folks that I'm a professor, or a writer, or anything else that doesn't align with their racist beliefs. Still, I considered the possibilities of the position. I would lean into my Blackness as I told visitors that Borglum chose these presidents to represent America's history—Washington for our foundation, Jefferson for our westward expansion as negotiator of the Louisiana Purchase, Roosevelt for our economic expansion as the architect of the Panama Canal, and Lincoln as the unifier of our country in the aftermath of the Civil War.

But I would also tell them that Washington and Jefferson owned more than six hundred humans, that Roosevelt supported

the destruction of Native culture, and that Lincoln had "freed the slaves" while ordering the execution of thirty-eight Native men in Mankato. I would tell them that Borglum was a white supremacist who had carved the world's largest monument to the Confederacy on Georgia's Stone Mountain, that he was a scam artist with questionable sculpting skills who viewed the Rushmore commission as a money grab to settle his debts. I would tell them that the mountain was named after a New York lawyer of little significance who laid claim to it while prospecting the land. I would tell them that the Lakota used the site for medicine and prayer.

Eventually, the clouds passed, and we were able to see their faces, which were wet as if streaked with tears, the stones stained along their cheeks. As we gazed at the image, their legacies darting about my mind, I remembered what day it was. Juneteenth wasn't yet a federal holiday, but it was still significant to us. We had actually wanted to visit a day earlier, but our guide wasn't available, and fittingly, the stars and rain clouds seemed to align. *Fuck these dudes,* I said to myself. Even if their faces cloud the landscape for centuries, fuck all the lies they represent.

THE NEXT DAY, I took my friend to see Crazy Horse. We separated at the entrance so that he could have his own experience while I strolled the Indian Museum of North America again to reinforce everything I was learning. After thirty minutes or so, I found him weeping in a space called the Wall of Windows at the end of the welcome center. The room was the nearest to the monument, and the views it provided were breathtaking, unobstructed

through its floor-to-ceiling windows. The steepled roof and benches lining the walls made the space feel even more sacred.

A gallery of portraits along the other side of the room had triggered him. Each had been painted by David Humphreys Miller, a white man from Ohio who at sixteen had traveled west to learn more about Native life and culture, specifically about the Battle of Greasy Grass, the Native name for what is taught to most Americans as the Battle of the Little Bighorn.

Miller had first arrived at the Pine Ridge Reservation in 1930, where he spoke with survivors of the conflict. Later, he would go on to other reservations in the Dakotas, Montana, Nebraska, Wyoming, and Oklahoma, speaking to elders about their experience. Eventually, he learned fourteen Native languages and was adopted into sixteen families. He was even given the name Chief Iron White Man by Black Elk, who had adopted him as his son. While Natives of this generation were wary of photographs and portraits, fearing they captured irretrievable parts of their spirits in the frames, they still consented to his requests. What remains are seventy-two portraits of the survivors, each captured in old age, their faces set against white backgrounds, each in a headdress or tribal necklace or with long plaits that dangle freely in the white space. Some are captured in profile, others straight on. At the display case in front of the wall, each of their stories is told—their names, where they were from, and how they characterized the battle.

Joseph White Cow Bull was twenty-eight when he defended his homeland, recounting: "I woke up hungry and went to a nearby tipi to ask an old woman for food. As I ate, she said, 'Today attackers are coming.'" He had exchanged fire with one of

the troop leaders and had seen him fall from his horse into the river. He couldn't say if the man he killed had been Custer, or Long Hair, as they called him, but he was proud still.

I'm not sure if my friend had been moved to tears by this account or another, but as he flipped from one story to another, glancing back and forth from the wall to the page, he was overcome with emotion. The Native skepticism of portraiture may not have been unwarranted, because Miller certainly captured their spirit, each portrait vibrant and realistic, their faces grooved with countless wrinkles like mazes that formed expressions full of wisdom and pride. Searching their faces for everything they'd experienced could have spanned hours.

We then made our way up the mountain. Twice a year during the Volksmarch, which takes place in June and October, the public can climb the mountain for free by hiking the gravel trails to the top, where you can view Crazy Horse's nine-story-high face and stand along the space where his arm will extend into the horizon. All other treks can be purchased for a donation to the memorial, which at the time of our visit was $105. With a guide we rode up in a Jeep, past grazing cows and pigs to the nape of his neck where we walked the rest of the way to his face.

"Here are your hard hats," said the guide, a middle-aged white woman dressed for an expedition. "The mountain is a construction site, after all. I'm sure I don't have to tell you this, but please avoid touching the cranes and machinery."

The walk up from behind Crazy Horse's face felt like a great reveal, the wind crisp and flaying the collar of my jean jacket. As he slowly came into sight, I was struck by his beauty, the

mineral compounds serving as the perfect medium. His tan skin is flecked with garnet and feldspar, giving it a reddish color, with traces of mica, beryl, and pyrite making it glint like gold. Thin stripes of black from the tourmaline finish it with what seems like war paint.

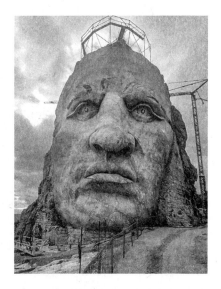

"The views are incredible," I said eventually, as I turned away from his face and scanned the vistas. It was partly cloudy

Crazy Horse Memorial,
Crazy Horse, South Dakota, 2018

and chilly, but the sun burst through just enough to make the weather tolerable.

"They really are," said our guide. "I'm always left in awe every time I'm here."

"How often do you come up?" asked my friend.

"A few times a week, which is really good for us because the donation goes directly to carving the mountain. We just bought a new machine that's going to allow us to dig more precise holes. When Korczak first started, he would spend half a day lugging up jackhammers and chisels, and thankfully, the process is much more efficient and safe. When you get home, you'll get a detailed breakdown of what we used your donation for today, and you'll get regular updates thereafter. All donations are completely tax-deductible."

"That's awesome," said my friend.

"We think so, especially since we don't receive any government funding."

"Why's that?" he continued.

"It's complicated, especially in South Dakota, but ultimately, it was Korczak's stance to refuse government support. We do get some pretty significant donations from anonymous donors, though, and from people who leave us portions of their wills."

"Any celebrities visit?" my friend asked.

"Gene Simmons came up with a film crew a few years back, but I can't think of anyone else. Bill Clinton is the only president to have visited the memorial, but mostly our guests are locals or people who came here after visiting Mount Rushmore."

"We were there yesterday, but it's wild how so many people might never hear about this, let alone visit."

"True, but we hope things are changing."

"Yeah, I heard that y'all are renaming Harney Peak," I said.

"Yes, that's the highest peak east of the Rocky Mountains. We're standing on the second. That one was named after a brutal general who slaughtered Native women and children," she said soberly. "Changing the name was long overdue."

"Why do people behave so badly?" my friend asked and walked toward the mountain's edge.

The guide seemed to have missed his rhetorical tone and paused for a moment, her face searching for the right words as if preparing to explain racism to a child.

"I don't know. I don't know why things are the way they are," she said almost to herself, and the space between us filled with the silence of her sadness, save for the wind, which rattled one of

the chain-link fences. "Well, I'll give you fellows some space. Let me know if you need anything else," she said and stepped aside.

We took pictures in front of Crazy Horse's face, pausing for a moment to reflect between shots. So much had happened in this part of the world, and from my vantage, it seemed I could see it all, the Black Hills in every direction, the sense of history everywhere, the future staring through Crazy Horse's eyes. At the current pace, the monument won't be completed in our lifetimes, but when I come back, if I ever come back, it will be different, and visitors may never be able to stand where I stood.

Of all my experiences in those two weeks, standing along Crazy Horse's arm is a moment that I will always cherish. It was as if I could see the past and future at once, gazing out at the stretches of land that were still untouched, channeling the spiritual residue of the region, thinking of the millions of Native nations and bison that had populated the land, wondering what the coming generations will think of Crazy Horse. It was as if I had been transported to the porch of my distant ancestor, where she puffed clouds of tobacco smoke to the rhythm of her sorrows. *Grandmother,* I would say, *I've made it home.*

"WHAT DO YOU THINK of the monument, as a Native, I mean?" I had asked an artist whose work was featured in the Gift from Mother Earth Art Show, the Crazy Horse Memorial's annual showcase of Native and Western-style art.

Her paintings and drawings felt psychedelic, full of bright colors, with Native American women rendered with green and

blue hair, their faces and bodies wavy, caught in motion. I was particularly moved by a small drawing of a Native American woman with bright yellow skin, her face forlorn, and I picked it up for closer inspection. Along her arms and face, fissures threatened to reduce her to a pile of rubble like she was made of stone. Her heart was visible in her torso, translucent and revealing a blue mass decorated with yellow stars, evoking the American flag. From her aorta, blue and red drops dripped into a lake at the bottom of the frame. Coiled around her arm, a two-headed snake was poised to bite a flower growing from one of the heart's valves. The other snake hung limp in death. In her other hand she held an eagle feather and flower aloft, and just below her bent elbow, a Native woman in a small boat held a bowl to catch the remnants of the figure's crumbling arm.

The artist turned to scan the space around us to make sure no one was in earshot before she leaned in.

"I might get in trouble for saying this," she began. "Because there are people here who might not like what I'm about to say, but some of us think we shouldn't desecrate our holy lands. Just because they did doesn't mean we have to. I mean, is this really going to change what they did to us and Crazy Horse? *And*," she emphasized, "the artist was a fucking racist. Why should a white man depict our pain?"

"I had no idea," I said, grateful for her honesty. "I read somewhere that Crazy Horse's finger-pointing is disrespectful and not in line with Native values. He probably wouldn't have wanted his image on a mountain either."

"Exactly!" she said. We spoke in hushed tones about her activism and art and the Rosebud Reservation, where she lived,

before I purchased the drawing of the crumbling Native American woman she called *Mother Earth*.

BEFORE I LEFT for the Pine Ridge Reservation, I ate the continental breakfast at my hotel like I had every morning of my stay. But this morning, a white boy, maybe twelve, sat with his family at a table across the room with a sweater emblazoned with a bald eagle in its center, the sleeves patterned like Confederate flags. What a way to set the tone for the day. Go looking for white supremacy, find it everywhere. Go looking for nothing, find white supremacy everywhere. Look, white supremacy everywhere.

As I approached the reservation, I couldn't tell the difference between it and the rest of South Dakota. The fields of green were still mostly undeveloped. The roads were fine. There were more trailers and rusted junkers in the front yards of the homes, but I didn't encounter bands of Natives searching for stalled-out victims like a white bartender had suggested in Rapid City. Honestly, it reminded me of Mississippi with its few stoplights and a handful of gas stations in disrepair.

My first stop was the Heritage Center to see the Fiftieth Annual Red Cloud Art Show. The exhibit began in 1969 with the goal of showcasing the wide-ranging talents of Native artists, and it remains the longest-running art show of its kind located on a reservation. Since its inception, the Heritage Center's permanent collection has grown to over ten thousand pieces of contemporary Native art and historical Lakota items.

There wasn't a single piece that didn't move me. I was cap-

tivated by the fusion of contemporary ideas and abstractions with touchstones of Native life. Everything was impressive, shockingly so. Not that I didn't think the works could be so good, but I was shocked because I had little frame of reference. Much of what I had seen of Native art was produced by non-Natives. The colors, the media, the scale—everything seemed to offer a fresh perspective. I was particularly struck by the work of Bryan Parker, a member of the Muscogee Creek, Choctaw, and Apache tribes. One of his pieces, titled *There's a Kind of Hush*, captures a Native man in quarter profile with a mask of blue paint beginning at his nose and extending up toward his forehead. He is dressed in multipatterned clothes, one of his lapels emblazoned with different-colored horses. On the other lapel sits a huge monarch butterfly. The background is a landscape dominated by rolling hills and a setting sun among cumulus clouds and stars painted as angled crosses. What makes it special are the different patterns and textures employed. Parker had used acrylic, colored pencil, coffee, and spray paint on illustration board to treat every object differently. A dreamy African collage comes to mind, yet the colors and patterns are distinctly Native, layers of browns and purples and yellows and oranges and blues. And his eyes, shielded behind a blue mask, evoke a serene, mystical tone, at once an invitation to pray, mourn, or prepare for war. Had I the means and were it not already sold, I would have purchased it on the spot.

There were others, too many to catalog, with a few that especially resonated with me. Many of the paintings had used ledger paper as a canvas, and I had never seen such art. One painting by Gerald Yellowhawk titled *Chicago Waste* stood out. It de-

picts a scene of three Natives, one in headdress, the others in tribal clothing, seated across from a white man in a top hat and suit with its coattails splayed across the floor, his hand holding a quill over a document. In the background, an industrial cityscape is seen through arched window bays, low-rise buildings and smokestacks shadowy in the setting sun. The sun's position suggests the length of time the group has been assembled and the end of Native life as once known. Two of the Native figures are slumped over the table, as if drunk on the empty ink bottles that lay beside them. The Native man in the headdress seems amused by something and reaches forward for the quill, as if ready to sign. The ledger paper is oriented in landscape, and to the left of the scene, words and numbers are written at what would have been the top of the page. The symbolism seems obvious, conjuring the Chicago Treaty of 1833, which effectively stripped Native Americans of their lands in Wisconsin, Illinois, and Michigan, driving them west of the Mississippi River. Perhaps the man is pointing west in bemused disbelief. The irony of the ledger paper, official government issue, like the parchments on which rations were dispersed and treaties drafted, makes the depiction even more incisive.

Later, when I spoke to the director of Racing Magpie, he would tell me more about the practice of ledger art. When Native peoples were imprisoned during the Indian Wars, often they were given discarded ledger paper and painting materials by government officials, which sparked an entire genre of art that formerly would have been composed on rawhides. They were interested in preservation, not so much in the Western concept of art and aesthetics, so that their battles, hunts, and spiritual visions could

be passed on to the next generations. But their slaughter and imprisonment gave ledger art new importance. The practice, which began in the late nineteenth century, continues today.

AT THE SITE OF WOUNDED KNEE, where hundreds of defenseless Natives were slaughtered, most of them women and children, I paid my respects to the dead. Twenty Army officers were awarded the Medal of Honor after the assault, which is twice as many as the number of Army officers who were awarded for the wars in Afghanistan and Iraq combined.

Afterward, I drove to the nearby campus of Oglala Lakota College. The vision of the institution is to "rebuild the Lakota Nation through education," and its mission is "to educate students for professional and vocational employment opportunities in Lakota country." I read these words in the college's brochures and let them guide me as I perused the space full of photographs and paintings and artifacts.

I focused on the images and tried to grasp a semblance of their lives. There was a mural of the Sioux Nations, including parts of North and South Dakota, Wyoming, and Nebraska, replete with small icons of animals and warriors and sacred lands and rivers and Army officers and railroad tracks with steam engines, the whole history of their lives as if marked on a board game. There was an image of the seven Lakota Council Fires, the individual tribes that make up the Sioux Nations. There were photographs of their lives before the white man and those of their captivity, one featuring a Native man with a ball and chain slung over his shoulder.

By this time, I was overwhelmed with all I had seen, all the images of dashed hopes set against the brilliance of their creative expressions. It was time for me to go, and I grabbed a few brochures detailing the college's annual report and scholarship endowment campaign.

According to a 2012 census report, the two reservations that the college serves, the Cheyenne River Indian Reservation and the Pine Ridge Reservation, ranked first and third as the poorest counties in America with poverty rates north of 50 percent.

But its students still thrive despite their poverty. Pictured on graduation day in their nurse uniforms and in their places of employment, they are celebratory, smiling with promise and pride. Each of their profiles echoes the same sentiment of gratitude for the familial atmosphere where they were taught more than what was outlined on their syllabi, where their problems were met with love and patience, where they were pushed to succeed because the reward was collective. Without fail, each described a goal to give back to their communities via their training and service. Like Boricua and Morehouse and Morgan State and all the spaces designed to uplift its own, the value of an education filtered through your own worldview is hard to quantify.

TEN FEET FROM THE ENTRANCE of the Prairie Edge Trading Company and Galleries, on the corner of Main Street and Sixth in Rapid City, a bronze statue of a Native elder captures her braiding the hair of a young Native girl, her granddaughter or other member of her tribe, I presumed. The elder beams with a closed-mouth smile as she attends to the girl's hair. Both figures

are draped in buckskin cloaks, their dresses ornate and decorative, visible from the waist up. The day I happened upon them, someone had laid a bouquet of wildflowers and fern stems along the elder's wrist so that it appeared she would weave them into the girl's hair.

I paused for a moment and took in the sweet sentiment before I entered the store. It was by far the most impressive store selling Native goods, art, and artifacts that I had seen in the Black Hills. It occupied nearly an entire city block and was full of jewelry, clothes, rugs, herbs, and mementos. On the second floor, a gallery of paintings and sculptures occupied the space, and I recognized some of the artists. Ledger art featured prominently, and one captured generations of a Native family superimposed over a replica of the Declaration of Independence as they stand in ceremonial dress, their faces forward, heads high and gazes full of pride.

I was drawn to the massive star quilts until I looked at the tags. The prices were steep, but that wasn't the issue; many of them were made in China or India or the Philippines or other sweatshop locations and made me question the authenticity of everything else.

I was about to abandon the store when I stopped to survey an artist painting a landscape. He was an older Native American man with long silver hair pulled into a ponytail, and I picked up one of the flyers to figure out who he was. A former staff sergeant in the Air Force and graduate of the American Academy of Art in Chicago, he had had his work displayed in shows and galleries across the country, including more than a hundred murals, one of which is on display at Denver International Airport.

The painting he was working on, though half-finished, was as

impressive as his résumé, the clouds and bright sky rendered in precise brushstrokes above an open field.

"This is really powerful," I said eventually.

"Thank you," he responded. "So, what brings you to Rapid City?" he asked with a smile.

"I came here to see the Crazy Horse memorial and other Native sites in the region. Writing a book. Tell me, what do you think of the project?"

"Well, if you ask ten Indians what they think, you'll get fifteen different answers," he joked. "Personally, I think it's all about money."

"What do you mean? You don't think they're doing any good there?"

"Depends on how you define 'good.'" He reached for a binder and flipped through its pages, each a print or portrait of his work protected in plastic film, until he arrived at a cutout of an article. The headline read: "Millions to Crazy Horse project could be better spent." It was an op-ed by a writer of Algonquin descent who manages a tourist blog about the Black Hills.

I read the first few lines: "Amazing. Five million dollars is coming to a project that has been in development for sixty years and only half-completed. I think most people would agree that it will take another hundred years to complete the project."

"That's a hard argument to counter," I said, shocked at the painter's readiness. "Can I ask why you carry the article around with you?"

"For people like you," he said as he met my eyes.

For people like me? What did he mean by people like me? Seekers? Outsiders? The uninitiated?

"You don't think Native imagery is important on such a large scale? I mean, the statue right outside, with the Native woman and girl, it gave me such a warm feeling before I walked in here. Shouldn't that be the goal?"

"Of course I do. What matters more is who's doing the work and how. That statue outside wasn't always there. It used to be an image of a Native on his knees in chains while an officer was releasing him, but the moment was confusing. Many didn't know how to read it. Was he releasing him or actually hauling him off to jail? Crazy Horse was absolutely important to our legacy, but who shapes it matters because they will determine what it ultimately means."

Twice a year, the Crazy Horse Memorial hosts Night Blasts that let guests witness synchronized explosions strung along the mountain. The purpose of the blasts is twofold, in that it allows the public to see the monument take shape and to commemorate a significant event in Lakota history. The blast I attended recognized the Battle of the Little Bighorn, curiously not called the Battle of Greasy Grass on the memorial's summer events calendar, and to honor the matriarch of the mountain, Ruth Ziolkowski, Korczak's wife, who had passed away four years earlier.

Guests sat along the same benches where I had watched a family of hoop dancers on my first visit, except this time the scene was dark, the mood hushed and electric. It was packed to capacity. In the center of the veranda, a lectern and microphone waited for the program to start.

The first speaker was a daughter of Ziolkowski, dressed smartly in a simple two-piece suit. "Thank you for being here to honor my mother," she began, and I struggled not to see her as a

thief. How could she in good conscience make this moment about her mother, who hadn't lost generations to war and famine? Who cares about another dead white woman in the land of the Lakota?

The next speaker was enrolled in the University and Medical Training Center for the North American Indian housed on the site. She was nervous, her voice shaky as she recounted the events of 142 years ago, when her ancestors had driven back the white man for the final time, when after the conflict Crazy Horse was captured and stabbed in the back by U.S. soldiers while held in custody. I marveled at the mastery of white supremacy, the devil of many names, conversant in all languages, his perversions their own intricate works of art. The student was stuck in the waste of centuries past, trying to claw her way out and flee from the outstretched hand of whiteness.

Before, after, and during the same space of my trauma, white supremacy captured imaginations the world over. The enemy of the Lakota and the Black American is the same, but as the outsider, I wondered if it were my place to stand and tap the young student on her shoulder and offer a few words to say on behalf of the surreal moment. "Tell them you don't want their money," I would have whisper-screamed in her ear. "Oglala Lakota College wants and needs you."

The dynamite detonated along the curved column of the monument like fiery dominoes that shot into the night sky. When it stopped, the crowd cheered for minutes, and I couldn't say why. Were they cheering for Ruth? Crazy Horse? The Native students? For them all? Multiple things can be true at once, I know, like creation myths that embrace the legends of other gods. Still, I wanted to feel more certain about my experience, the Native

world, and where I fit in it all. I wanted a sign from a spirit, an otherwise natural event occurring unexpectedly, a miracle, an answer to all the questions. I wanted to hear the smoky voice of my great-great-great grandmother.

AT THE SITE of the Rhythm Club fire in Natchez, a plaque was erected to honor the lives of those who perished. Of the 209 who died, most of them were Black, many of them burned beyond recognition. In 2010, a museum opened on the site to commemorate what remains the fourth-deadliest fire in the country.

Along the plaque, my great-aunt's name is listed, right below where Mama's name could have been, and in the space of its absence, my life emerged. It's a troubling feeling to gaze upon a statue or memorial and see yourself depicted in absence, like looking at a mirror that doesn't return your reflection. This is what I see and don't see in Mount Rushmore and Andrew Jackson and even Crazy Horse. Because no image remains of Crazy Horse, the sculptors relied on the recollections of those who knew him best to reconstruct his expression. So, like the depiction of his stoic face staring bravely in the direction of white men who stole everything from him and his family, we can only imagine the truth of our lives when we go looking, when we spy what isn't there.

CAPTAIN
BLACKMAN

Who is it that opposes you in carrying out the law? The
police department itself.

—Malcolm X

O n the day of his father's funeral, the birth of his youn-
gest sibling, and his nineteenth birthday, James Bald-
win was troubled by the debris and destruction of a
riot that had left Harlem in disarray. The riot started with the
shooting of a Black soldier. He didn't die, but his presumed
death incited the masses nonetheless. Before it happened, Bald-
win had noticed the people of Harlem huddled on the stoops
and corners of the neighborhood, most of them silent, brooding
over some impending doom. Church ladies and sex workers,
hustlers and preachers, young and old, all concerned about their
loved ones in the Army. The collective worriers he knew told
him that they were more concerned about their loved ones' secu-
rity in the South, where they were stationed before being shipped

overseas to the arenas of World War II. If they died on the battlefield and not in a noose, he sensed their deaths "would come with honor and without the complicity of their countrymen."

I hadn't read *Notes of a Native Son* and didn't feel the support of my community when I joined the Marines as an eighteen-year-old college student. The world wasn't at war, although the U.S. had dispatched troops to Iraq and Kosovo. The wars in Afghanistan, Yemen, and Iraq were only a few years away. I had completed my first year at UNO and decided to join the Marine Corps Reserves, not due to some fervent patriotism, but because I was broke and lacked guidance. I couldn't depend on my parents and grandparents who struggled to support themselves, let alone me, an able-bodied eighteen-year-old. My ten-hours-a-week, ten-dollars-an-hour work-study job wasn't enough. So, I went to the local recruiting office to enlist.

"DOOPUS" WAS WHAT THEY called him, a portmanteau of doofus and his last name. The title wasn't completely off the mark. A tall, portly bespectacled kid prone to speaking in non sequiturs, he often waddled down the hallways of our high school to a chorus of jeers from our classmates. Yet, in our high school French class, I befriended Jason. While he was undoubtedly awkward, I thought he was a good-natured person who, like most teenagers, struggled to overcome his insecurities. We would often talk at length about our upcoming football games, girls, and his desire to attend the United States Military Academy at West Point.

Throughout my years in high school, however, our conversa-

tions never occurred outside of a football field or a classroom. I never visited his house. He never came to mine. So, when he called me shortly after my visit to a recruiting office, with an assured, unwavering tone, I was duly alarmed. How did he get my phone number, and where did he get his manhood? Faintly jealous of his transformation, I listened to him detail the merits of the Marine Corps. "It's a great opportunity," he argued. "At least see what we have to offer."

The recruiter failed to meet my expectations. A Marine was supposed to be a square-jawed, chiseled specimen, a model of impervious fortitude. Instead, his face was a plump mound of uncooked dough. His eyes didn't gaze resolutely like those of a seasoned soldier who had witnessed unspeakable atrocities. His shone with the flickering optimism of a salesman, and as I looked at his pictures on the wall behind his desk, him smiling in his Desert Storm combat gear, the desert's landscape in the background, I couldn't help thinking that he seemed to have had a good time in Iraq.

I had tons of questions, and Doughface didn't flinch, smiling through them with ease, as if he knew they were coming. Still, I continued to voice my apprehensions like a skeptical customer. But he was unflappable, and as I sat there, losing ground, I wished for my father's way with words, his ability to wear managers and salespeople down in pursuit of a discount. But his pitch worked, and asking Uncle Sam for help became too appealing of an option.

"Can I complete basic training in the summer, before the upcoming fall semester begins?" I asked with confidence.

"Sure. Just come down to the office on Saturday, and you can

do some PT with the other recruits in the area," he replied, certain that he had me ensnared.

I didn't fit in with the other recruits. Although I remembered many of their faces from high school, I found them immature and aimless. Many of them had entered the workforce right out of school and struggled to find gainful employment. Others viewed the military as their last resort in a host of unsuccessful schemes. Few had considered going to school once they finished their commitment. None were enrolled in college like me.

Naturally, these differences began to define us when we trained. Each Saturday, when we ran a mile and a half, their faces soon discolored until they were keeled over, their bodies heaving last night's liquor. *How foolish*, I thought. Even when we played pickup games on those cool Saturday mornings, it became quite evident that I was far more athletic. No matter the sport, the outcome of the game always hinged on my performance as I fought off double- and triple-teams, and while I enjoyed a certain sense of satisfaction during those games, I would always realize, shortly after, that my opponents were still the second- and third-string players from my high school.

Hovering at the edges of those games and ahead of the pack during our runs, Doughface would stealthily whisper to me, "You know, you are a natural leader. I can see you leading a whole platoon of men. You're the type of soldier the Marine Corps needs."

THE HOTEL ROOM WAS SMALL, the beds firm. Outside, the cold air was a stark contrast to the fevered anxiety that had en-

gulfed the room. I was assembled there for the evening with a group of teenage boys for our impending processing and official entry into the Marine Corps the next morning. All the faces were foreign, but their stories were the same. The Black boys were there to escape the penal system and "stay out of trouble," while most of the white boys were following in the footsteps of their grandfathers, uncles, fathers, or brothers. There were a few upper-middle-class anomalies, white recruits who had lofty political aspirations and were only enlisting as a perfunctory step toward their goal. Then, there was me, still wondering whether a few hundred dollars a month was worth my commitment.

My roommate was a thin Black boy, whose "trouble," I thought, must have stemmed from his associations, for he struck me as no more than an impressionable teenager. I could tell he was nervous as he went on about the detoxifier he had purchased a week before. "This shit works," he proclaimed to the others who had eventually entered our room and began to detail their own cleansing methods. When the conversations waned and everyone retreated to their rooms, I lay in my bed and attempted to calm myself and fall asleep.

The processing day was then my longest on record. We rose at five in the morning, and through checkpoints and clearance stations, we were released onto a military base and ushered into a bright, blue room just beyond a grand marble-floor entrance. On the wall facing us, a huge American flag served as the backdrop to a raised stage. We were positioned in rows that stretched across the entire room, and when we settled, a man emerged dressed in a Marine Corps uniform to issue a proclamation that we recited in unison. Pledging my allegiance to the United States and vowing

to uphold the integrity, legacy, and work of a Marine, I began to feel a sharp sense of uncertainty. *What am I getting myself into?* I thought, craning my neck around the room to see if I could glimpse on anyone's face what I felt in my chest.

The events that followed only heightened my sympathy for prisoners. I couldn't help feeling worthless as we were shuttled from station to station to be fingerprinted, drug-tested, blood-tested, stripped naked, and made to perform dehumanizing exercises. We duckwalked to prove we weren't flat-footed and bent over with our hands touching the floor so that our anuses could be spread and inspected. The worst of it was the waiting. At each station, I waited for what seemed like hours for my chance at humiliation, while my fear gradually increased.

At approximately four o'clock, I finally saw the finish line. The last station was the place where you officially sign your name on your commitment papers and accept your MOS: military occupation specialty. Doughface had told me to answer no to all the questions and everything would be fine, and it wasn't long before I found myself in front of the questioner.

He was unlike the other Marines manning the stations before. His attractive face was crowned with a hairstyle that was more flattering than the buzz cuts of his colleagues. His demeanor was also striking, exuding an air of professional privilege as if he had never seen a battlefield. None of the colloquial exchanges were said either. He just asked me to sit and promptly began his line of questioning. Tensely, I looked into his steely face and answered each question, trying to steady my quivering voice.

"I have 'Military Policeman' listed here as your MOS. Is that correct?" he asked flatly.

"Well, yes, but my recruiter said that I could change that later, so . . ." I uttered timidly.

"That's fine. Your ASVAB scores indicate that you qualify for special operatives and intelligence as well. Would you be interested in those fields?"

"Yeah," I answered, wondering why Doughface had kept those jobs from me.

"Fine, there are some other questions I need to ask you, then," he went on. "Have you ever committed an act of terrorism. Have you ever committed a crime? Have you ever used any illegal substance?"

"No . . . no . . . Well, I did—"

"Before you finish, let me inform you that if you answer yes to any of these questions you are ineligible for these occupations. Lying on a federal document is a crime punishable with fines and possible jail time, so consider your answers carefully."

"Well, no, then. I mean, yes . . . in high school I . . . But no, he told me to say no to everything."

"Who said this?" he asked indignantly.

"No one," I said, cracking. "I mean, you're telling me that I have to be an MP if I say yes to this, but if I say no, then everything's fine?"

"Young man, I'm asking you to tell the truth."

At this moment, my pent-up fear and confusion and exhaustion caused my head to spin. What was I doing? Doughface lied to me. Why is this guy so tough? All I have to do is lie.

I had smoked weed in high school like most people I knew, but unlike them, I was actually ashamed of it. My father smoked, and he and I butted heads so frequently that I vowed to distance myself from all his behaviors. I would not become him. I was also so committed to sports that I worked out all the time and rebuffed the offers from my friends, who had started to spiral in their consumption. But after the football season of my senior year, I wasn't recruited, the girl I was in love with moved to London, and I fell into a depression, no doubt influenced by the natural anxiety that troubles teenagers destined to leave the nest.

During my last semester of high school, my friends welcomed me with open arms into their circle of smokers, and I nearly failed all my classes and didn't graduate. I even got suspended, a first for me, for openly disrespecting my French teacher, a Black man whom I actually liked. One poor decision after another marked my days, and everything seemed to be falling apart.

But those troubles were behind me, and now I had a decision to make. The minutes that passed seemed like hours as I sat there before I confessed, on the verge of tears, "I can't do this."

I rode home in the military van with Doughface. No words were shared, his face tinged red from frustration and mine relaxed in relief. I had escaped the military but not the South, at least not yet.

When I look back on my eighteen-year-old self, I'm amazed at my arrogance, naivete, and desperation. With a simple signature, my life would have taken a dramatically different course. If I was the unquestioning type and did as I was told, I would have become a military policeman, which means that I would have likely joined law enforcement as a civilian. It seems wild to

even consider, knowing what I know now, having read Baldwin and others who describe an America that has been ungrateful to our sacrifice, from slavery to fighting in its wars to the present. Even more unbelievable is becoming what I fear. I have crossed into my forties and have survived several near-death experiences, but I still find myself catching my breath around police officers and my heart pulses faster than I would like. How could I ever be a cop?

ON SEPTEMBER 15, 1983, Michael Stewart was arrested at three in the morning on the First Avenue train station platform while waiting for the L back to Brooklyn. He was detained and escorted out of the station when, according to police accounts, he fell face-first on the pavement and became uncontrollably violent. To restrain him, the police hog-tied and beat him unconscious. When he was sent to Bellevue Hospital thirty minutes later, he was brain-dead and had suffered injuries consistent with strangulation. He died after thirteen days in a coma. Before he was charged with resisting arrest and possession of marijuana, his wails were heard by students in their dorm rooms nearby.

"What did I do? What did I do?" a student recalls hearing him scream before he was kicked and beaten, before he was thrown, lifeless, into the back of a squad car.

The six officers indicted for his murder were acquitted. All were white.

I was two years old at the time of his death and didn't know the circumstances of his life. I had read his name along with

others at the end of the credits of *Do the Right Thing*, but a serious study and understanding of the film didn't come until college, nearly twenty years after his death, about the same time I was introduced to Jean-Michel Basquiat, my favorite artist and an outspoken voice against the evils of white supremacy.

As birthday presents, my wife has taken me to several Basquiat shows. One year she took me to the exhibition at the Brant Foundation, where I saw the largest number of his works ever displayed in one space, a show that spanned his entire career. I have seen his paintings at the Brooklyn Museum, galleries throughout New York, and in other spaces throughout my travels, but nothing I thought would compare to this one, where close to seventy of his pieces were displayed across four floors, where the highest-valued, largest pieces were given enough space along the walls to amaze. I posed next to his *Untitled* (1981) skull, which sold for $110.5 million in 2017, certain that I would never see a better show focused on his work.

For another birthday, my wife took me to a show that changed my mind. *King Pleasure*, curated by Basquiat's sisters and family, captured him through a level of intimacy that only they could access. Home videos and his early sketches as a boy were displayed alongside a map of the places he had lived and frequented in Brooklyn. His childhood home was even re-created, along with his studio as they found it after his death. How they illustrated his life with so much nuance and care moved me more than I had expected.

I have a habit of getting too emotional about my passions; films and art and songs often bring me to tears when I engage with them while in a pensive mood, when I'm contemplating

something larger than self. In this space, it happened again when I read the explanation of his signature crown:

ROYALTY

The crown emblem is ubiquitous in Jean-Michel's work. He wanted to make sure the world knew he was recognizing Black kings and queens who defined his world history. And it also signals to us that he himself was a king—sharing a powerful lesson and [an] enduring exhortation for people of color. Many personal Black heroes can be found throughout his paintings and drawings. From jazz musicians and singers to sports heroes, they were immortalized in much of his works. Charlie Parker, the jazz legend, was a particular favorite of Jean-Michel's—our brother loved his music, which is apparent by the number of works he painted in Parker's memory.

I had long since known the significance of Basquiat's crown, but for some reason, maybe because I was surrounded by reflections on his life as told through the perspectives of people who knew him best, I felt overwhelmed by my encounter with his genius. My eyes swelled with tears as I mourned him. He loved us so much that he centered us in everything, even as the art world consumed him alive. He had reached the highest highs,

but his gifts were never enough for his critics, and the lack of universal embrace no doubt fueled his addiction and led to his overdose. I can't be sure, but he must have viewed the slights as both personal and as slights to us, the weight of which was probably too much to bear.

Although our tickets were timed to control the flow of patrons, the show was cramped, and I moved quickly into the next room to avoid becoming a spectacle. My direct line of sight fell on a large painting of three figures, each black with white and yellow lines scribbled into their frames to outline their bodies. The smallest figure stands between the others, whose raised hands hold blue batons about to crash down on what appears to be a boy. The boy's eyes are Xs, and his mouth, an oval with vertical lines, suggests anguish. In each of his hands, he clutches an indistinct blue object that could be a gun or graffiti pen. The larger figures are policemen, mouths full of smiling teeth as they grab the boy's shoulders to apply as much force as they can. Above the boy's head are stars that float into a yellow background.

There was no wall text to contextualize *Jailbirds* (1983), but when I surveyed the space, I realized the room was centered around the title of one of Basquiat's other paintings, *Irony of Negro Policeman* (1981). This painting wasn't in the room, but I remembered it from the Brant Foundation's show. It featured a squat officer dressed in blue, his face slightly demonic, his eyes ringed with red circles. Just above the officer's left foot, the word "PAW" is written above "(LEFT)," which is struck through, drawing attention to what appears to be the beginning of another partially written letter. The genius, as is evident in many

of his paintings that feature crossed-out words, is that the words suggest multiple meanings at once. The hands and feet of the officer appear claw-like, a beast *and* a PAWN sacrificed in the chess game of white supremacy.

I returned my gaze to *Jailbirds* and saw another painting, *Defacement* (1983), which once headlined a show inspired by the death of Michael Stewart. I didn't make it to the show, regrettably, but I remembered the reviews and the image of Basquiat's homage to the fallen artist. Painted on the wall of Keith Haring's studio, the scene is the same as the one depicted in *Jailbirds*, with two officers bludgeoning a dark figure. *Defacement* is much smaller, however, and seems like an unfinished proof of *Jailbirds* that was completed in the immediate days after Stewart's death, when Basquiat reportedly said to his friends, "It could have been me." *Defacement* seemed to be the product of an emotional release that was never intended to be displayed publicly or on the scale of *Jailbirds*, a piece that seems to have emerged when his senses were more controlled.

Michael Stewart was to Basquiat what Philando Castile was to me. Stewart was an art student at Pratt Institute, the school a block away from my apartment, and he, like Basquiat, wore locs and had dabbled in graffiti, the art form that had first introduced the world to Basquiat.

As I stood there gazing at the canvas, piecing together the connections, I reflected on the irony that I had almost become a cop. Would fate have led me to tragic outcomes like it has for the Black men who wore the shield?

Imagine if I had joined the Marine Corps Reserves thinking it would only be a two-weeks-a-year, one-weekend-a-month

commitment, but it was extended to active duty like the hundreds of thousands of National Guard and Reserve soldiers whose deployment amounted to nearly 45 percent of the total forces sent to Iraq and Afghanistan. Imagine that I was killed in Fallujah or Kabul and joined the 18 percent of "part-time" soldiers who became causalities.

Now imagine that I survived and completed my eight-year commitment to the military, after which I found a job on a police force and settled into a suburban, middle-class life.

Imagine that despite the racism I endured from my colleagues, I maintained my commitment to the force and demonstrated integrity when I reported one of my colleagues for excessive force for kicking a mentally ill suspect in the head. Imagine that I was fired for making the complaint and was characterized as a rogue officer prone to making false accusations. Imagine the depression that consumed me in the aftermath when I lost my livelihood and my relationships to my partner and family. Imagine my mental state as I drafted a manifesto detailing how I had devolved and become unrecognizable to the people who knew me best. Imagine the empty vindication I felt after murdering the daughter of the former captain who portrayed me poorly in my trial against the force. Imagine how I felt when I killed others with the same tactics that I learned on the force and in the military. Imagine how I felt knowing that my life would end in a hail of gunfire as flames engulfed my body. Imagine that I was Christopher Dorner.

Now scrap that image, and imagine me as another officer who followed the orders of my superior despite my unspoken misgivings. Imagine that I had joined the force with the explicit

goal of countering the racism that pervades precincts. Imagine that I wanted to show my community that Black officers could actually protect and serve without abuse. Imagine my disorientation when on my third shift as an officer, I had to call for backup because I couldn't get a Black male suspect in the back of my patrol car, and my training officer arrived on the scene, the same training officer who had extended the length of my training because I was too indecisive, the same officer who was ex-military and who had served nineteen years on the force. Imagine the heat I felt radiating from the suspect's back as I held him down while my training officer placed his knee on the suspect's neck. Imagine me agreeing with him when we refused to roll the suspect on his side at the request of one of the other officers on the scene. Imagine the nothingness I felt as I searched the man's neck for a pulse. Imagine what my days will look like when I spend three years in jail for assisting in his execution. Imagine that I was Alex Kueng.

Of course, all Black law enforcement officers don't meet tragic ends. My cousin, who is two years younger than me, just retired from the Navy, and he never saw combat. He has even encouraged his two sons to enlist, and frequently, maybe too frequently, he brags about his pension. Another cousin is married to a police officer in Houston, and there are countless other success stories, including many who became artists. See Jacob Lawrence, Romare Bearden, Charles White, John Biggers, Ed Dwight, and others.

Black soldiers have even assumed significant roles in all of America's conflicts, from Crispus Attucks to the present. John A. Williams, who served in the Navy during World War II,

illuminates these contributions in his 1972 novel *Captain Black-man*. Abraham Blackman, the novel's protagonist, is wounded in a mission and drifts in and out of a coma as he hallucinates about the Black soldier's role in the American Revolution, the Battle of New Orleans, the Civil War, the Indian Wars, the Spanish-American War, and both World Wars.

In the chapter in which Blackman imagines himself in the Battle of New Orleans, he meets Andrew Jackson, who has declared martial law to commandeer all weapons in the city and compel every able-bodied man to serve in a militia. Fresh off his victory in the Creek War, which drove Creek Nations out of Georgia and Alabama, Jackson solicited help from wherever he could, appealing to both free Blacks and those enslaved. Militiamen, farmers, Natives, pirates, and Blacks eventually joined together in arms to defeat the British brigades, although the British outnumbered them two to one. By some accounts, Black men made up nearly half the American forces.

In the account Williams imagines, Jackson makes his plea to the free Blacks alone:

> As sons of freedom, you are now called upon to defend
> our most inestimable blessing. As Americans, your coun-
> try looks with confidence to her adopted children, for a
> valorous support, as a faithful return for the advantages
> enjoyed under her mild and equitable government. As
> fathers, husbands and brothers, you are summoned to
> rally round the standard of the Eagle, to defend all
> which is dear in existence. Your country, although call-
> ing for your exertions, does not wish you to engage in

her cause, without amply remunerating you for the services rendered. Your intelligent minds are not to be led away by false representations.—Your love of honor would cause you to despise the man who should attempt to deceive you. In the sincerity of a soldier, and the language of truth I address you. To every noble hearted, generous, freeman of color, volunteering to serve during the present contest with Great Britain, and no longer, there will be paid the same bounty in money and lands, now received by the white soldiers [. . .] in money, and 160 acres of land. The noncommissioned officers and privates will also be entitled to the same monthly pay and daily rations, and clothes furnished to any American soldier.

When the war was won, Williams imagines his protagonist and his Black compatriots secured in their positions as landowners, "asking white men for nothing and giving nothing in return."

But the truth reads differently, as recollected in *The Narrative of James Roberts, a Soldier Under Gen. Washington in the Revolutionary War, and Under Gen. Jackson at the Battle of New Orleans, in the War of 1812: "a Battle Which Cost Me a Limb, Some Blood, and Almost My Life."* Roberts was born on the Eastern Shore of Maryland and was later sold down south to New Orleans after being denied his freedom, which was promised to him after his service in the Revolutionary War. According to Roberts, when the War of 1812 spread to New Orleans, Jackson directly solicited the service of the enslaved and had arrived at his master's plantation to enlist five hundred men, all

of whom he had handpicked. Once he had selected his would-be soldiers, he addressed them as such: "Had you not as soon go into the battle and fight, as to stay here in the cotton-field, dying and never die? If you will go, and the battle is fought and the victory gained on Israel's side, you shall be free."

Upon hearing Jackson's words, Roberts describes his unbridled elation at being chosen to fight. "This short speech seemed to us like divine revelation, and it filled our souls with buoyant expectations. Hardships, of whatever kind or however severe, vanished into vapor at the sound of freedom, and I made Jackson this reply: that, in hope of freedom we would 'run through a troop and leap over a wall;' that I had as well go there and die for an old sheep as for a lamb."

After the men received combat training, they marched from their base in Natchez to New Orleans, where they would quickly defeat the British. Roberts lost a finger in the battle but didn't mind trading it for freedom. The men were celebrated in a procession throughout the city, after which they were told to return to their masters. Many protested, but Jackson brought them to a bar and let them drink freely through the night to placate them. Roberts declined to drink and demanded what he had been twice denied. He writes:

> At that moment I cocked my gun; but there being no priming in it, I bit off a piece of cartridge, and, going to prime it, I for the first time discovered it was not loaded. Had my gun been loaded, doubtless Jackson would have been a dead man in a moment. There was no fear in my

soul, at that time, of anything, neither man, death, nor mortal. The war-blood was up. I had just two days before cut off the heads of six brave Englishmen, and Jackson's life, at that moment, appeared no more to me than theirs. It was well for him that he took the precaution to have our guns unloaded when in the ammunition house. His guilty conscience smote him, and told him he was doing us a great piece of injustice, in promising us, by the most solemn protestation, that we should be free if the victory were gained. I would then have shot him dead a thousand times, if that could have been done. My soul was stirred in me, and maddened to desperation, to think that we had placed our lives in such imminent peril, through the persuasions of such false-heartedness, and now told to go back home to our masters!

Roberts entered into that murderous space that we are all capable of, the moment when the world has become too much and reason is disregarded for vengeance. Had these men not fought so valiantly, the country, as it is currently constituted, may have never expanded west.

IN A GENTRIFYING neighborhood of the Ninth Ward called the Bywater, situated along the banks of the Mississippi less than four miles from the battlefield where Black soldiers fought the British, a victory arch stands out of place. Atop the arch, the crown reads:

ERECTED A.D. 1919 BY THE PEOPLE OF THIS THE NINTH
WARD IN HONOR OF ITS CITIZENS WHO WERE ENLISTED
IN COMBATIVE SERVICE AND IN MEMORY OF THOSE WHO
MADE THE SUPREME SACRIFICE FOR THE TRIUMPH OF
RIGHT OVER MIGHT IN THE GREAT WORLD WAR

The makings of a nest hang from the center of the arch just below the outstretched wings of a granite eagle. Along the columns and cornice, weeds have sprouted through the seams of the structure, the bronze tablets hammered onto the columns heavily oxidized. Each tablet lists the names of the white men killed in action, the white men who died in service, the name of a single Red Cross nurse, and the white men who survived. On the backside of the arch, the one facing away from the street, the columns bear two other tablets, which honor the "colored" men who died and those who survived.

When I first visited the site, an empty beer bottle tucked into a brown paper bag rested on one of the rear ledges. A chain-link fence separated the arch from the fields and the complex of Frederick Douglass High School. The arch was originally the centerpiece of Macarty Square, a park situated along St. Claude Avenue, before it was moved to the edge of the square, before the neighborhood's development engulfed the park.

When I last saw it, after having just visited my family's house on Andry Street, a middle-aged white couple jogged past it, the

woman commenting how odd it was to see it here. They didn't stop to inspect it and didn't see me sitting in a car across the street with my windows down.

And she was right. It is strange to see such a memorial honoring veterans while enshrining our segregated past. The "colored" men were honored, at least, which I'm sure was viewed as a show of respect for them despite the racism they endured when they came home. This acknowledgment exceeds what James Roberts describes as the unjust treatment of the "some sixty or seventy" Black soldiers who perished in the Battle of New Orleans, their names and circumstances never accounted for, which, in his words, "deserves the deepest reprehension."

Still, the arch stands, though it seems better placed within the complex of the National WWII Museum. There, several buildings—containing a restaurant, hotel, education center, theater, and various exhibits—immerse you within the period of the war and its conflicts in the European and Pacific arenas. Planes, jeeps, motorcycles, boats, guns, missiles, uniforms, a submarine, and other artifacts are displayed throughout. There is even a 4-D experience that transports you to pivotal scenes of the war, complete with faux smoke, explosions, and moving seats like you are strapped into a roller coaster.

In one gallery, titled *United but Unequal*, the museum addresses the role of Black soldiers and civilians who supported the war effort at home, along with the contributions of other minorities, including Japanese and Native Americans. While the space is small compared to expanse of the museum, it doesn't shy away from the unvarnished truth. A placard reads:

READY TO FIGHT

Many military leaders believed African Americans were incapable of performing complex military jobs and that they would fail in combat. Consequently, they were assigned to segregated support units commanded by white officers. Despite racial discrimination, 1.2 million African Americans served in the military. Their contributions raised hopes for a more tolerant and unified nation, but the government refused to integrate African Americans in the military in wartime, even after so many had fought for democracy. This failure fueled the Civil Rights Movement, which would intensify after the war.

As the casualties mounted, Black soldiers became infantrymen, pilots, tankers, medics, and other occupations. For those back home, President Franklin D. Roosevelt's Executive Order 8802 banned racial discrimination in defense industries, spurring employment opportunities. The museum notes that while some Black Americans were welcomed, "others became victims of racial violence and rioting." To promote the federal action, the War Manpower Commission, an agency charged with balancing the infrastructure of the war's labor needs, produced posters and other propaganda to bring the country together.

One poster features two men assembling a piece of machinery

together, the Black man gripping a wrench, his white counterpart guiding a riveter. The men are captured in grayscale and at the bottom of the poster it reads "UNITED WE WIN." At the top of the image, the vivid red, white, and blue of the American flag capture the gaze.

In the same space, a photograph shows a smiling Black soldier raising his hand to form a V with his index and middle fingers. Before it became a symbol of peace and the subculture of the 1960s, the V stood for victory, and when raised by Black soldiers, it meant something even more hopeful, representing what became known as the Double V campaign. Victory over the Axis Powers would mean victory at home. It would give birth to a truer freedom, one that we have been seeking our entire time in America.

Of course, the Double Victory campaign failed, and this freedom won't manifest unless we keep fighting.

Despite Andrew Jackson's advice to the slavers, whose property he returned after the war, the enslaved Black men who had fought so courageously under his leadership kept answering the call. To these slavers he said:

> Never suffer negroes to have arms; if you do, they will take the country. Suffer them to have no kind of weapons over ten inches long. Never allow them to have a piece of paper with any writing on it whatever. You must examine your slaves very closely, for the time is coming when the slave will get light; and if ever his mind is enlightened on the subject of freedom, you cannot keep him. One slave bought from the East will ruin a

multitude of those raised here. Before a slave of mine should go free, I would put him in a barn and burn him alive. Gentlemen, take me at my word; for if you do not, you will be sorry for it before many years. Never arm another set of colored people. We have fooled them now, but never trust them again; they will not be fooled again with this example before them.

We have been fooled again and again, although "fool" may not be the most accurate assessment. Rather, we have weighed our options and often choose to take up arms with a clear-eyed optimism, knowing that while we have been deceived countless times, hope remains a valuable currency. No matter the wars that define the times we live in, faith tells us that the original promises might be kept.

Maybe I was the fool the day I walked away from the Marines—a coward, even—guided by a youthful pessimism grounded in ignorance. Maybe I wasn't.

Six

A DAY IN THE
LIFE OF CHAINS

I promise if you hear
Of me dead anywhere near
A cop, then that cop killed me.

—Jericho Brown

Hours before I was arrested, I saw *Miles Ahead*, a speculative art house film about the span of years when Miles Davis failed to produce new music, directed by and starring Don Cheadle. The scene that resonates with me the most is a flashback wherein Miles exits a club to smoke a cigarette between sets. After a few drags, a cop orders him to move along. A heated exchange ensues. Miles tells him he's the man on the marquee, but the cop assaults him with his stick nonetheless.

After the film, I ate at an Italian restaurant on Metropolitan Avenue in Brooklyn with my then girlfriend, now my wife. Like extras in a bad movie, we were the only couple of color. The meal was quick, expensive, and unremarkable. I drove my usual route home and prepared to make a left onto Driggs, which

would have brought me directly to Bed-Stuy through Williamsburg. The light was green, and a cop, traveling east in the other direction, paused and flashed his lights, granting me the right of way. This ordinarily would have been a kind gesture if he hadn't turned directly after me. Two blocks later, he hit the sirens.

"License and registration," he demanded at my door. "I need you to roll all your windows down, sir," he said, as he and his partner shined their flashlights throughout the car.

"Here you go," I said, handing over the documents along with my CUNY ID. "I'm a professor, by the way."

The strategy of revealing my employment as a public servant had worked many times before, some letting me go in recognition of our shared commitment to the city, not to mention our source of income.

"I'll tell you what," he said. "I pulled you over because your tint is too dark, but let me run your name and if nothing comes up, I'll let you go."

By then I had been pulled over many times in New York and wasn't surprised or any less annoyed. The charade was all too familiar.

Sure, officer. You can run my name, officer. I'm not a criminal, officer. I'll wait here patiently, officer. Thank you, officer.

My wife told me to relax.

"Someone should give his ass a ticket," I said. "His fucking headlight's out."

"Relax," she said again, and I replayed all the other times that I had been pulled over and detained. For a taillight, headlight, illegal tint, speeding when I wasn't, improper lane change, and I'm sure for other reasons I can't remember.

Once, when I was traveling to D.C. from Brooklyn late one night, a cop pulled me over for speeding. Maybe I was, but when he came back from running my license, he was more concerned about my vehicle's registration. My car was listed as black, indicated by the initials "BK" instead of the color that it clearly was, blue, which meant that the initials should have been "BL." He asked me to step out of the car, and we waited on the shoulder of the B-W Parkway for another officer to arrive so he could check the car's serial numbers. Awkwardly, I tried to explain that I had never noticed the error. I knew he didn't believe me. It was definitely a dope boy's car, a late-model electric-blue Acura with dark tint and low-profile trim that ran along the underside of the doors and hood. I hadn't altered its condition from the day I bought it at the dealership. I was more drawn to its low mileage and immaculate interior than its exterior appearance.

I thought of all these run-ins until it became clear that it was taking too long for the officer to return. *Had* I done something? I began to wonder.

"I need you to step out of the car, sir."

"What? What did I do?"

"There's a warrant for your arrest. Step out of the car, sir," he said again, and my wife began to cry.

"What did I do?" I asked again in disbelief as he hungrily searched every pocket of my heavy coat. It was an unseasonably cold evening in April, a few days before my thirty-fifth birthday. "What did I do?" I demanded once more.

"Sir, I can't tell you until we get to the precinct."

"What?! So, you're telling me that I have to spend the night in jail, and you can't tell me why."

"Sir, you're resisting arrest!" he boomed, and I saw Miles again, bleeding on the asphalt. In the officer's eyes, I saw a flickering flame, ready to consume everything in its path. His tone confirmed the rest. Burly and bald, he shifted into a fighter's stance, and instantly, I felt the weight of the moment. I saw Michael Brown and Eric Garner and Sandra Bland. This was three months before we would witness Philando's execution.

"Does he need anything?" my wife asked as she climbed over the armrest, crying more profusely now.

"No," said the cop. "Take all his valuables."

I handed her my watch and wallet.

When he turned me around to cuff me, I noticed we had drawn the attention of the white faces staring from their brownstone stoops. An oversize beanie slouched loosely on my head and I wore a collared shirt buttoned to the neck. Looking at their faces inspecting mine, I realized that I would have fit in nicely with the neighborhood's newest residents except, of course, for my skin.

"I'm not a criminal. I'm not a criminal. I'm not a criminal," I repeated through clenched teeth as we drove away, the older cop seated beside me in the back.

"Sir, it's not about being a criminal!" yelled the burly one.

We rode the rest of the way in silence, the cuffs pinching my wrists when potholes rattled the suspension.

We arrived at the 90th Precinct, a few blocks from the Broadway stop on the G train, a stop that I frequented when I taught writing at the Graham Avenue campus of Boricua College. The older cop took me straight to the holding cells, where a Black man, maybe in his twenties, was being processed, and I watched him as I waited. He had a fresh fade and wore stylish clothes

over a fit frame, the tongues of his ACGs flopping as he turned to be photographed.

"What they get you on?" he asked after he had been processed and placed in my cell.

"I don't even know, man. They haven't told me, said there was a warrant for my arrest."

"Oh, you good then. They didn't catch you with nothing, you good. Probably a citation. You gon' get released tonight," he said with a smile. "They caught me with some cash, said they saw me do a hand-to-hand, but cash ain't enough to charge me. You feel me? They got the other dude out there but whatever he had on him, on *him*." He stood and slowly paced the cell. "They tryin' to jam me up cuz they know I'm on parole," he continued, turning back to me. "But I been working. I'm a personal trainer. I got pay stubs. No arrests . . . I'm good."

His arresting officer returned and pulled him from the cage for his phone call, handing him a cell phone while he stood off to the side.

"Step out of the cell," my arresting officer said when he returned. "Take off your belt. Remove your shoelaces." And like that, I was initiated into the criminal justice system.

When we were done, he placed me back in a cell. Then the burly one returned.

"Okay, what number do you want me to dial?" he asked through the bars.

"Can't I make my own call? The dude before me did. Cop let him out and he sat right there," I said, pointing to a desk chair.

"Look, this is how this is going to go: You tell me the number and I dial. Simple as that."

131

"Fine."

I gave him my wife's number and he held the phone up to the bars when it rang. She was frantic, but I calmly logged her into my email account and dictated a response to my department's secretary.

"Anything else?" she asked.

"I don't know," I said. "This guy's giving me a hard time, so—"

"What?!" he interrupted. "I'm giving you hard a time? You think because you're a professor I'm supposed to give you special treatment? You're done!"

Then he hung up the phone and stormed off. I was enraged for what seemed like forever before he returned with a sheepish grin.

"You won't believe this," he said. "Your warrant is for an outstanding bike ticket." His tone suggested that he wanted me to overlook everything he had said and done before.

"You mean to tell me that you arrested me for a bike ticket that I already disputed?"

"You ever live on Classon Ave.?"

"Yes."

"You must have not received the notices."

"And you arrested me for this?" I said, astonished. "I bet if I was a white boy, you would have let me go."

"Oh, now it's about race!" he said, growing defensive. "Don't give me that shit."

"You arrested me! For what?!"

His face tightened as he sought an answer he couldn't find or would rather not share.

"Fuck you!" I screamed at his back when he stormed off, clip-

ping the last word almost instinctively, afraid that he may have heard an invitation to assault me.

Thus began my night in jail. I thought of that bike ticket, how the cops had sped up to stop in front of me as I keyed open the door to my place, how I had turned around in alarm and asked the officers if everything was okay. I was guilty of riding my bike on the sidewalk for maybe twenty yards as I left the street and rode past the bodega on the corner to my door. I saw myself cussing out the officers, obvious rookies who in their youth didn't know how to restrain me. I had laid into them and questioned their incompetence and overreach of the law. I thought about how ridiculous everything had seemed now. I had been pulled over many times since the incident and no other officer had ever mentioned a warrant. But what really made my head hurt was the understanding that my current address, the one that I had publicly claimed on my license, was available to them, and if it wasn't, it was evident there was a gross breakdown in the city's communication. If I had really committed a crime, they would certainly come find me.

"You know, we don't even issue bike tickets anymore," said the attending officer as if he were listening to my thoughts.

I chuckled in disbelief and resigned myself to my circumstances. While the officers chatted about their long commutes and pay grades, I thought about what I had planned to teach the next day.

I was in the middle of my poetry unit and was going to discuss the figurative language employed in "We Wear the Mask," Paul Laurence Dunbar's reflection on the collective plight of African Americans who feel they must conceal their distress from

the world. Dunbar was the son of enslaved Africans and knew the horrors of slavery firsthand. Through the poem, he illustrated the emotional intelligence that our ancestors used to cope with the absurdity that complicated their days. I had taught it many times before, and almost instinctively, I began to recite the verses that I could remember in my head.

> We wear the mask that grins and lies,
> It hides our cheeks and shades our eyes,—
> This debt we pay to human guile;
> With torn and bleeding hearts we smile,
> And mouth with myriad subtleties.
>
> Why should the world be over-wise,
> In counting all our tears and sighs?
> Nay, let them only see us, while
>> We wear the mask.
>
> We smile, but, O great Christ, our cries
> To thee from tortured souls arise.
> We sing, but oh the clay is vile
> Beneath our feet, and long the mile;
> But let the world dream otherwise,
>> We wear the mask!

The long history of oppression hadn't defeated our ancestors, and I found comfort in their strength. I wouldn't be broken by these bars.

Soon enough, others were placed in the cell with me. The

first, a Latino man, was barely out of his teens. Even though there were only two of us in there, he sidled up to me so close that his thigh pressed against mine.

"You smoke bud?" he asked, and I looked at him confused, wondering if his question was some sort of joke.

"Nah, man," I lied, having come to appreciate the medicinal benefits of cannabis as an adult, but that was none of his business.

"I can get whatever you need," he continued.

He had gone to a GameStop to return a controller. The store was apparently closed, but the door had been left ajar, so he went in and took what he wanted from the shelves, not realizing that his movements were captured on surveillance cameras. They caught him the next day when he went back to complete the return, and as he shared the circumstances of his arrest, I thought of how foolish he sounded, how completely unaware he was of himself and his predicament.

When he told me to extend my body across the length of the bench so that I could sleep without anyone sitting next to me, I took his advice and stretched out, if for no other reason than to end the conversation. He slid to the other side of the cell then and spoke to a young woman.

"What you here for, Ma?" he asked, and she detailed the story of a lover's quarrel.

Through sobs, she explained that her boyfriend had taken her phone and wouldn't return it. He had taunted her and ran with it between the courtyards of their projects until she had had enough.

"He said I stabbed him, but I didn't."

"You too cute for that, Ma," said the gamer.

"And I'm pregnant with his baby," she managed through tears.

"You hungry, Ma?" he asked, moving to hand a few bills to the attending officer. "Get a couple bags of chips and a honey bun."

My anger eventually receded and became a profound sadness, not necessarily for myself, for I sensed that that my arrest wouldn't gravely impact the course of my life. I was saddened for the people locked up with me who seemed trapped in a system that feeds insatiably on Black and Brown lives. I saw myself again in the South Bronx, where I had taught young men and women at a reentry program years before I became a professor.

At close to three in the morning, we were transported to central booking by a pair of tired, disengaged officers. When we arrived, we were shuttled from cage to cage for further processing. My irises were scanned and entered into a database before I was thrust into a narrow cell where a data clerk confirmed my identity and address. Then I was placed in a cell with eight other men ranging from their teens to their fifties. One man was groaning uncontrollably, his body convulsing as he violently scratched his forearms. I tried to sleep sitting up, but every time I felt myself drift off, he seemed to unleash a disembodied wail that echoed throughout the cell.

I awoke the last time to the sounds of guards sliding bananas and peanut butter and jelly sandwiches through the bars. Then they chained and shuttled us to another cell that was packed with more men awaiting bench trial. Some had been waiting all weekend.

There was a teenager arrested for fighting with his brother,

men arrested for public urination, public intoxication, weapons charges, violation of parole, possession of controlled substances, and I'm sure for other offenses they didn't share. Together we talked about the Knicks and the lottery numbers and our arrests, all while the man continued to groan as drool fell from his mouth.

"I be tweaking like that when I be on them Percs," said a teenager, laughing as he lay supine on the concrete floor.

There were only two white faces, one a young man who wore an expression of shock and terror, his eyes wide and unblinking. The other was an older man whose demeanor was relaxed and unconcerned, an attitude that seemed to suggest the life of a career criminal. He had been accused of stealing a Home Depot truck and was caught when he went back to the store the next day, a crime that some of the guys had heard reported in the news.

Before we were called into the courtroom, we were summoned by a lawyer from the Legal Aid Society who reviewed our cases in a small room attached to the cells, accessed through a thick steel door. I had indeed been cited for illegal tint along with my outstanding warrant, but both would likely be dismissed via a conditional discharge, meaning my record would be sealed if I had no further police contact for six months. While I appreciated her confidence, I explained that I needed my charges dismissed immediately because I was in the process of being hired as a full-time professor, that the arrest could jeopardize my livelihood.

I didn't share that I had worked as an adjunct professor for six years at Hunter and City Tech and Medgar Evers and Boricua, that I had gone through multiple interviews at Queensborough,

that my prospects were high. I concealed all my anxieties and calmly asked if she could ask for more. I left the room hopeful but worried.

Would all I had worked for be thrown away over a bike ticket?

As men came and went from the cell to the courtroom, I realized that those who returned were to be remanded to Rikers Island. While I wasn't worried about this fate, the energy in the cell began to shift, and I empathized with the men who were facing it. Surely I would go home. I had never been arrested and had a clean record, but this wasn't the case for the gamer, who upon entering the cell again paced around with tears in his eyes.

Bang.

He reared his head back and violently slammed it into one of the steel doors.

Bang.

The mood in the cell darkened. The jokes ceased. The guy who sat next to me would be remanded too, and he stared at the floor vacantly. My name was called shortly thereafter, and I almost leapt from my seat.

The judge who presided over my case was a middle-aged Asian man, who, at the reading of my charges glanced up at me and expressed what appeared to be a mix of exasperation and shame. I read an apology on his face. The proceedings lasted no more than five minutes and lacked any drama. My lawyer detailed my circumstances as a pending hire and asked the judge to grant an immediate dismissal, to which he consented without hesitation.

I left the courtroom with a dollar in quarters given to me by the young man booked on the hand-to-hand and a MetroCard

given to me by the court. I was exhausted and needed to use the bathroom as I waited for the train at Borough Hall. Standing there, I surveyed the station and caught the eye of a middle-aged Latino man who had been jailed with me. He had passed the time in what was either a drunken stupor or a Buddha-like state of serenity. We hadn't exchanged pleasantries, but when he saw me, he smiled as if he sensed I needed the affection. I wiped my eyes to hide my tears. Thankfully, the ride to my wife's job was only a few stops away.

"They think they can break me. They think they can break me," I said again and again as I sobbed in her arms. I didn't want to cry and was surprised that I couldn't stop, but eventually, as she swept my face with her palms, I embraced the release. I wanted to square up with the burly officer and loosen a few of his teeth with my fists, to show him that I'm a man worthy of respect, but I felt abused and shattered instead.

It took me awhile to revisit Williamsburg, maybe months, the trauma of my experience too piercing to endure. I've overcome my anger at the thought that the officers preyed on me like an animal, that they prodded me to incriminate myself without reading me my rights, that my case was a waste of time and money.

I'm more upset by my mind's urge to forget, a defense that feels natural and appropriate sometimes. But if I do, if I succumb to what's easy, I stand to lose much more in the process. I must always remember what happened to me to remember what it means to be a Black man in America. There are no markers to indicate the time and place of my arrest, no plaques outlining the officers' names and their ranks, no visible image of what transpired on that April evening, but in my mind's eye, I see it as

I always will. I see the place where I learned what it's like to spend a day in chains.

EVERY MORNING, years earlier, I commuted ninety minutes via a train to another train to a bus to 170th Street and Third Avenue in the Bronx to teach young people reading and arithmetic in preparation for their GEDs. These young folks lived in neighborhoods with the highest rates of poverty and incarceration in the city. They ranged from eighteen to twenty-four and either had served time, were on probation or parole, had been convicted of a misdemeanor, had been arrested, or had had some other police contact.

The participants who had the most severe deficits were the people I got to know best. These were students who struggled to comprehend multiple-paragraph passages, write coherent sentences, and memorize the multiplication table. Earning a diploma was at least six months to a year ahead of them, and that's if they remained focused and continued to stack skills.

It was a tough job because of all the challenges they faced. There were plenty of days when I struggled to keep them engaged, to get them to focus for more than thirty minutes on a task, but I kept showing up for the few students who recognized the value in seeking what they lacked.

There were so many students who stood out, so many who will always live in my memories. Some who completed the program and joined the staff, some who went on to college, and some who never escaped the streets.

There was one I'll call Jada, a thin, cagey person who I could

tell had lived a hard life, the skittish profile of the abused fitting her too perfectly. She would pop off at anyone who made her feel threatened, and because of this, I didn't try to get too close.

One day, after she got yet another math problem wrong, she exploded, and I needed to regain control of the room. Delicately but firmly, I broke the news. "You won't get this overnight," I said. "You gotta keep working, but you can't behave like this." She stormed out.

The next day we spoke before class, and as I explained how I would give her extra work once she mastered a skill, gradually she became more at ease. From then on, she worked quietly with purpose. Months after she left my class, she returned to tell me she earned her diploma, and we embraced, briefly.

There was another tall, handsome young man who may have been the most natural leader I came across. He was quiet, sat in the back, and never gave me any trouble. The other students, most of whom were immature and easily distracted, seemed to revere him. He always seemed poised and in control. He was well on his way to earning a GED, but then his brother was shot, and I never saw him again.

There was another young man—I'll call him Johnny, one of my favorites—who was always ready with a joke. He could assume multiple voices and had an infectious laugh. He easily defused tension with humor, but he could barely read and write. Still, he attempted everything I asked. Often, he would nod off in the middle of my lessons, and I suspected opiates. His tooth enamel had decayed and stained his smile, formed of jagged, misshapen teeth. I liked him, but I knew education was the least of his problems.

For those who completed the program, I think of how proud they were on graduation day, their rehabilitation signifying so much for their family members and loved ones in attendance. I always hoped it stuck, that they didn't make the same decisions that had led them to us initially.

But I know it's not that simple. Overwhelming evidence of structural racism is woven into the systems that shape their lives. The Housing Authority, the Department of Education, the Food and Drug Administration, the Department of Transportation, the Department of Health, the prison-industrial complex, each guided by laws and policies that devalue their lives.

Of all the laws that have been written against us—and there have been many—it's hard to argue that any ruling has been more damaging to our community than the precedent set by *Plessy v. Ferguson*. The "separate but equal" edict established in the 7–1 decision focused on the freedoms of a mixed-race New Orleanian, Homer Plessy, who was charged with trespassing in the whites-only section of a train. Among the justices in the majority opinion was another Louisianian, Associate Justice Edward Douglass White, who eventually rose to chief justice of the Supreme Court.

A statue honoring his legacy was removed in 2020, three years after I saw it in front of the Louisiana State Supreme Courthouse in New Orleans, a few blocks from Jackson Square. The bronze statue stood grandly in front of its steps, his likeness rendered in judicial robes, pleated and parted about the neck to reveal a double-breasted suit and tie. Clutched against his chest was what I presumed to be a volume of court cases, the book huge and nearly the size of his torso. His head was slightly

raised, his eyes studying something. A supposed model of objectivity, his gaze was slack and resolute, his pudgy jowls offering no emotion.

If anyone were suited to welcome you into the halls of justice in Louisiana, it makes sense that it would be White. He studied law at Tulane and became a state senator, an associate justice of the Louisiana Supreme Court, and a U.S. senator before his appointment to the Supreme Court. He was also the only Louisianian to serve until Amy Coney Barrett, who joined the bench weeks before the statue's removal.

It also makes sense considering he was the son of slavers, sugar planters from Thibodaux who used their wealth and influence to rise in politics. His father became the tenth governor of Louisiana. White also fought for the Confederacy, and he was among the hordes of white supremacists who attempted to overthrow the state government at Liberty Place in 1874, effectively ending the state's Reconstruction era. In other words, of course an unapologetic racist would be the one to greet you at the entrance to Louisiana's highest court.

The statue was relocated from the courthouse steps to one of its inner chambers in the wave of monument topplings after George Floyd's murder. That it remained standing for so long could be seen as a nod to White's final years, when he seemed to walk back his agreement with *Plessy*. In 1915, White wrote the majority opinion of *Guinn v. United States* and *Myers v. Anderson*, which struck down grandfather clauses in Oklahoma and Maryland that were drafted upon the "separate but equal" standard he had set. In the majority opinion of the *Guinn* decision,

he called grandfather clauses "repugnant" to the right to vote for all Americans.

This corrective in conscience came too late, however, and failed to prevent states from instituting other measures, like poll taxes, to disenfranchise Black voters. The path he paved through his actions and decisions led to the War on Drugs, mandatory minimums, three-strike sentencing, Rockefeller laws, and more, each doing its part to swell the prison population like a distended belly hungry for our lives. In the end, he did his part to cultivate the policies that undergird white supremacy.

MONTHS AFTER WHITE'S STATUE was relocated, I went to the site where yet another woman had been callously murdered as a consequence of these directives. Up the Mississippi to the Ohio River I went looking, to a place where the French claimed another city for its empire and called it Louisville in honor of Louis XVI.

I spent a couple of hours walking through downtown in search of a meal, strolling past abandoned storefronts, vacated restaurants, and office spaces for lease. My path crossed a showcase of jewelry and beauty products sold by Black women, and I paused, thinking of my wife, my mother, and anyone who might appreciate the gift, but I kept it moving, eager to meet the Black woman who had drawn me there.

When I entered the Speed Art Museum, I had an unobstructed line of sight to Breonna Taylor, like she was waiting for me at the back door of a long shotgun home in New Orleans. As I moved through the galleries of the *Promise, Witness, and Re-*

membrance exhibition—inspired by her life and others killed in the war—I anticipated our meeting, wondering what she would say as I drew closer to her with each step.

The words "We the People," drawn by Nari Ward, occupied an entire wall in the first gallery, displayed as a droopy calligraphy of colorful shoelaces. Inspecting them up close, I realized they dangled freely from hundreds of tiny holes drilled into the wall like an incredible game of connect the dots. A few well-placed tugs could easily dismantle the tangle of threads, which I know is true of what the words signify. Flawed in its foundation, the image makes you remember that the promise of America came with conditions. The metaphor of a nation tripping over its laces as it marches forward is too obvious, suffering one injury after another—sprained ankle, scuffed knee, broken wrist—minor setbacks for the white masses that amount to devastating losses for we the (not) people, or three-fifths people, or whatever other calculus they've devised to strip away our humanity.

The wall text described the artworks in the room as "representations of a nation and its promise," and I scanned the gallery until my gaze landed on two flags flanking the entrance. Each appeared to be replications of the American flag without its red and white stripes, just the blue space of endless stars hung from poles braced high upon the wall. I felt my body recoil, my eyes widen, when I read the description. Created by Hank Willis Thomas, the flags are part of his Fallen Stars series, which memorializes the lives of those killed by gun violence in 2019 and 2020. I looked to the flags again and saw how they pooled into expansive folds, as if burrowing into the floor, the depths of

our family's trauma defined as a never-ending abyss. *How many stars will populate the next?* I wondered.

At the other end of the room, I inspected an untitled bust of a Black soldier sculpted by Ed Hamilton. The soldier wears an empty expression, his face a mass of goatee and cheekbones. He is neither victorious nor somber, but steady, his eyes shielded beneath a Union Army forage cap. He is one of our great-grandfathers, one of the more than two hundred thousand Black men who fought for the Union, and I made it a priority to see him in D.C., where Hamilton erected his entire frame as the first monument to honor his fight for our freedom.

I turned to the neon sign on the adjacent wall. "Nov. 4, 2020." I didn't need to read the wall text to know that this was the day after the election. I remembered the uncertainty of the moment, how in the aftermath I felt uneasy about the results with so many ballots left to be counted and the loser contesting the outcome before it was certified. Glenn Ligon fittingly titled it *Aftermath*, nodding to all the turmoil brought on by Trumpism and the hope that we would someday see the end of Covid and its variants. I remembered that two months after this date, a retired servicewoman was shot while trying to breach the Capitol, her death the result of a confused patriotism animated in a world wherein whiteness possesses unconditional impunity, somewhere beyond the rule of law that kills us over loose cigarettes, counterfeit currency, bootleg CDs, wide nostrils, and other myths ascribed to Blackness.

Onward I proceeded and saw her come closer into focus.

The next room was larger and filled with more photographs and paintings focused on the themes evoked by the word "wit-

ness." In the center of the room, towering installations reached for and hung from the ceiling where a sentence ran along the walls like a ticker: "THERE ARE BLACK PEOPLE IN THE FUTURE." It ran on, unpunctuated and clipped, becoming a declaration, question, and incantation at once. Imagined in 2012 by Alisha B. Wormsley, the sentence was first displayed on a billboard in a gentrifying neighborhood in Pittsburgh and has since been re-purposed in cities across the country with Wormsley's blessing.

I focused my gaze on eight bass drums, varying in size and color, that rose in a stack toward the ceiling. Positioned horizon-tally, one drumhead served as a canvas for a pastoral lake scene, two were affixed with mufflers, and two others were marked with logos and insignias of different bands. Each honors the Silent Protest Parade in 1917, when W. E. B. Du Bois and the NAACP, alongside other protesters, marched down Fifth Avenue in New York City to raise awareness about the spate of lynchings terrorizing our communities. Its title, *Muffled Drums*, comes from the *New York Times* description of the pro-cession as a mass of eight thousand protesters "marching to the beat of muffled drums," which inspired its creator, Terry Adkins, in 2003.

I saw the same fight in the photographs along the nearest wall, images of young people screaming into megaphones, marching through the streets of Louisville, demanding justice for Breonna. Some are composed in gray scale, others pulse with color, and all capture the tension and despair of the war. Police in riot gear assault a protester. A pair of women console each other in an embrace. A mass of protesters raise placards and signs at Jefferson Square. An Afroed woman raises a fist toward

a blurred background of the police. Produced in 2020, each image was captured by local artists in the days and weeks after her murder.

My eyes drew nearer to hers as I moved forward.

The song I heard upon entering a darkened theater brought me to church. It was familiar, but I couldn't place this version and let it wash over me as I surveyed the space. A black-and-white film played on a wall in one direction, and paintings and installations lined the others. A chorus of women's voices sang:

I'm gonna stay on the battlefield
I'm gonna stay on the battlefield
I'm gonna stay on the battlefield, till I die . . .

Sonia Sanchez performed a poem about Black death, overlaying the song in her signature cadence. My heart beat faster to the rhythm, my head nodding ever so slightly to what felt like hip-hop. In the center of the room, I found a seat on one of the benches and waited for the film to loop to the beginning. Images of shrines and flowers and votive candles occupied the frames, working together to reveal a funeral through handcrafted remembrances. My eyes watered. Mourners filed into a church, and soon it became clear that the service was for Rev. Clementa Pinckney and eight of his congregants who were killed as they gathered for prayer and study.

Quickly, I wiped my tears away.

I saw the women who taught me hymnals and scripture, the church ladies on the program and in the choir who passed out slices of pound cake after service. I saw their hats on Women's

Day, big and ornate with lace and flowers and sequins glinting in the columns of light shooting through stained glass. I saw the women who populate the memories of every Sunday of my youth and felt their spirit.

I tried harder not to cry.

I saw the men of faith, the pastors and deacons, the prayer warriors, the men who drove the van for the sick and shut-in, and I mourned. I saw my aunts and uncles, my grandmothers, my cousins, my entire family. I saw my mother last, seated somewhere in a church that coming Sunday, and I wiped my eyes with my palms to stop the flood.

I rose slowly and collected myself.

A portrait of a boy across the room gripped my attention, his skin contoured in remarkable shades of black. Kerry James Marshall captured the boy in stoic silence, his eyes full of fatigue, half-open, half-closed. He wears a mint-green T-shirt that slouches at the neck to reveal a thin gold chain and pendant that declares his initials: "BB." Splattered with swirls and unmeasured brushstrokes that drip down the canvas, the background frames his face in a dreamscape of youthful innocence. The portrait is part of a series of paintings inspired by the orphaned characters in *Peter Pan*, whereby the Neverland of the narrative becomes America, and Black boys never age due to the systems of oppression constricting their lives.

The song continued to loop in my ears:

I'm gonna treat everybody right
I'm gonna treat everybody right
I'm gonna treat everybody right, till I die . . .

Jarvis came to mind, a childhood friend who was born ten days before me. He lived around the corner from my grandmother's house in the Eighth Ward, and we spent nearly every day of our youth together. He played the trumpet like me, and together we practiced the scales in the park for hours, each trying to outdo the other, blistering our lips chasing the highest notes of "Do Whatcha Wanna."

We were inseparable until my family moved to Slidell and we lost touch. When I moved back to attend UNO, we reconnected as strangers. I was making new friends in college, and he wasn't enrolled anywhere. Every one of our childhood friends now had children of their own or had moved away. Even his uncle, who was more like a cousin because he was our age, had become distant, strung out on speedballs, a smoker's concoction of blunts mixed with weed, cocaine, and heroin.

After I transferred to Morehouse and moved to Atlanta, I learned that Jarvis died by suicide. He wasn't orphaned in the literal sense, but, like many men of our generation, born of men who were too weary or unwilling or incapable of parenting due to other means of oppression, his safety net was frayed, and he fell victim to depression and despair. Not a year goes by that I don't think of him on his birthday.

Michael Brown was honored in the installation next to *BB* in a sculpture that I had seen many times online but never in person. Nick Cave's *Unarmed*, completed in 2018, is a crest of colorful flowers woven into a memorial wreath. In its center, a raised hand could be a gun—the index finger and thumb slightly erect—or it could simply be a hand caught in the act of living, unaware of the threat it poses in rest.

By this time, I had memorized the words of what became the soundtrack of my experience and sought the wall text to learn more. "Stay on the Battlefield" by Sweet Honey in the Rock felt like a solemn sermon that ends in a climatic call to live, the perfect complement to the five-minute film by Jon-Sesrie Goff titled *A Site of Reckoning: Battlefield*. The artist was inspired by his close relationship with Rev. Pinckney and the others assembled, so close that his father, Norvel Goff Sr., served as the interim minister of the church after the tragedy.

I glanced back at the images again and felt the grief anew, thinking of all those who survived the dead before making my way to the next gallery.

I was now ready to receive her. I looked at her squarely, gleaming in the darkened space, almost levitating in another world. Slowly, I walked toward her, and after a few steps, I saw other patrons engaged in something behind me and turned. There, I saw the story of her life as told by her mother, Tamika Palmer. Captured at different ages, her words were enlarged and segmented in panels along the timeline of Breonna's life. I dropped my head into my hands as I sensed what felt like a funeral. "Stay on the Battlefield" was still audible but distant, and I fixed my gaze on her again.

I understood then that I was standing at the altar where I might offer her final words, kneel at her figure, and pray for her safe journey to the afterlife. She was as beautiful and regal as I suspected, but her skin was more striking in person. Amy Sherald suggests both life and death in Taylor's flawless complexion, her skin smooth and even but faded an ashen pewter by what I imagined is the fog traversed upon her transition to the spirit

world. She is self-assured and powerful in stance, wearing a cerulean dress that flares at the knee. Her straight-on stare is confident, the hand-on-hip pose no doubt secured by her faith in the cross dangling from her neck. This is how she lives in the life beyond, and I stood more upright to mirror her strength.

I turned again and read the story of her life. Born at 4:37 a.m. on June 5, 1993, Breonna was described by her mother as an old soul who excelled in school even after they moved to Louisville when Breonna was in high school. Two weeks before graduation, Breonna had written, "I am a strong, intelligent, beautiful black young woman who has grown so much." She planned to prove all the doubters wrong. After a brief stint at the University of Kentucky, she worked as an EMT with hopes of becoming a nurse.

Breonna was working as an emergency room technician with the goals of going back to school, buying a house, and starting a family on March 12, 2020, when she called her mother in excitement about an upcoming girl's trip. They talked about their respective days; Breonna had ended hers by watching a movie with her boyfriend. The next call came at 12:38 a.m.:

> It started with a call from Kenny. It was normal to receive a call from them at that time of day, but this call would be different. This call would be a scream for help, a cry for Bre to hold on, and a shattering of my world . . . I was more concerned with her washing her hands and staying protected at work during COVID than I was with LMPD breaking down her door, murdering her, and charging her bestie—her love, Kenny—with at-

tempted murder of one of the people who busted down her door, with no regard for the human lives on the other side of it, firing at least 32 shots, and never would I imagine being denied justice.

My daughter had yet to be born, but my son had recently celebrated a year in the world, and I struggled to hold it together, thinking of his eventual path and how devastated I would be to receive such a call.

I saw myself the previous year, the summer after Breonna's murder, after the murder of George Floyd, when protests erupted everywhere. I saw my wife discard her business suits and return to the bedside, no longer a nurse manager but just a nurse among the brave who attended to the scores of patients sick with Covid flooding her hospital. I saw her come home later and later while I cared for our infant alone. I saw myself engaged with our son, my mood absent of the anger and despair that would have surely engulfed me had I been glued to a screen.

I remembered the relief I felt when the positivity rate dipped and we found a suitable daycare. I didn't anticipate missing him, though, neglecting the force of our separation and the insecurity I would feel entrusting him with someone else. I spent that first day apart idly scrolling social media until my feed landed on a mass of white women singing "Please don't shoot" in the melody of a nursery rhyme, and I lost it, the collision of images and sentiments causing me to sob uncontrollably. I remembered wondering if I could ever protect him from the world. If he was taken from us, could I ever embody the strength of Tamika Palmer?

I stood there, rereading her words, and couldn't be sure.

I proceeded to the final gallery, down a staircase and into a bright space lined with floor-to-ceiling windows, and I saw one of the signs scattered throughout the show labeled "A Moment to Pause." This time I took heed. I searched for the bathroom so I could gaze into my reddened eyes, inhale and exhale deep, slow breaths, and splash warm water on my face.

I emerged from the bathroom still emotional but stable and fixed my sights on the last piece of the show, a neon sign created by Hank Willis Thomas in 2014, written in bubbly script that declares: "Remember Me." I let that directive guide my memories of Breonna and the show. How will I, we, America remember these times? Slowly, I retreated and walked toward the entrance, past everything I had seen, the question looming.

I returned to my Airbnb and rode the elevator up to the rooftop, my mind still swirling from the experience. I took in the panoramic views of Louisville, looking south to where I would later visit the site of Breonna's murder. The apartment complex, while newish, would be unremarkable, not unlike any other one you might find in a low-income neighborhood. There would be no markers indicating what happened, and I would share my disbelief with my father, who would ask what I expected. I would have no response, coming to the silent realization that what I saw in my mind might be too much: patterns of bullet holes dotting the apartment; glass shards and bloodstains across the walkways.

I returned to the north side and followed the river as far as I could see toward Cincinnati, where I would visit the Underground Railroad Museum situated between Paycor Stadium,

home of the Bengals, and the Great American Ball Park, home of the Reds. I would marvel at these twenty-first-century creations, an impressive array of glass, steel, and concrete, and recognize the stark difference from Louisville's depressed waterfront. Standing on the pedestrian-only Purple People Bridge that connects Ohio and Kentucky, I would see tourists pose in front of a large aluminum sign imploring all to "SING THE QUEEN CITY," a phrase that opens the last stanza of a collective poem crowdsourced from Cincinnatians in 2015. A few hundred feet behind the sign is the awning for the Underground Railroad Museum, making it the likely backdrop for the countless memories captured there.

I would stand there gazing out at the river, deep in thought, when a white man would see me seeing something else, and just as he was about to pass, he would acknowledge me with a nod and declare to his mixed-race daughter trailing him that a major war was fought here. I would wonder if he saw me seeing Margaret Garner flee to freedom across the frozen river, the real-life protagonist of Toni Morrison's *Beloved* who chose to kill her two-year-old daughter rather than have her live a life of slavery after they were apprehended by slavecatchers.

Later, I would dine at one of Cincinnati's famed restaurants for lunch. It would be packed, with a seat at the bar my only option, and when I finished and returned to where my car was parked the next street over, I would see police searching a late-model car, its hood and door ajar. A young Black man would be cuffed in the back seat of a patrol car, and a young Black woman would be cuffed in front of another. She would scream, "I ain't got nothing," while an officer patted her crotch, thinking she's

found gold. "It's a pad. I'm on my period," she would scream again. "Check it!" Her thin frame squirming in agitation, face wet with sweat, hair wild and ruffled. I would ask an onlooker what happened, and he would tell me they found a gun under the hood while others casually carry on. "Check it!" she would scream again.

I stood on the rooftop in Louisville contemplating the days ahead, still unsettled by the exhibition. I rode back down to my room and began journaling. Minutes later, someone banged loudly on the door, so loud it startled me to rush to open it before I paused and realized I should ask who's there.

"The police!"

I opened the door, terrified. Two officers, one white, one Asian, wore gaiter masks and bulletproof vests.

"Can I help you, officers?" I said uncertainly.

"We got a call about loud noise coming from this apartment," said the Asian officer.

"What? It's just me here."

"So, you haven't heard anything?"

"No."

"And it's just you?"

"Yes . . . Is there something I should be worried about?" I said, remembering I was guiltless of a crime.

"No, we must have got our numbers mixed up," said the white officer, and the tension receded from their frames.

"Sorry for the trouble. Have a nice day, sir," said the other, and they rushed away.

Hours passed before my paranoia subsided. A mix-up in numbers. A dishonest mistake inspired by a conscious or subcon-

scious hatred for my kind could have brought me even closer to Breonna, and I thought, *This can't be life.*

I'VE ALWAYS FELT LIKE I was teaching for my brother. He can't remember the number of times he's been arrested, dozens for sure, and I often found myself thinking of him when I served justice-involved youth. This is partly guilt, I know, for leaving him and my family behind in Louisiana. He is eight years younger and has lived an entirely different life. At nineteen, he had his first child; I didn't have my first until I was thirty-seven. I have three college degrees; he barely completed a semester of community college. The pain of our uneven lives is lessened when I transfer everything I've given my students onto him, when the infinite store of grace I afford them allows me to accept all of his missteps, even as I recognize the approach as an imperfect way to heal.

Still, when I saw him behind a glass partition and we spoke through a phone receiver, he in an orange jumpsuit, his hair matted and uncombed for what seemed like months, I wondered how our lives could have diverged so dramatically. How could he find himself in jail? He has never been arrested for violence or gun possession or any other serious felonies. He's dealt dope and has likely committed other crimes, but he was never charged or detained for these offenses. His principal crime, in his words, "is being Black in a white neighborhood."

After Katrina, he and my parents moved to an affluent suburb of Dallas, where they received free housing and other subsidies in the months after the storm. He, like most of the young

men in my family, excelled at sports and was the starting point guard of his high school team when his dreams of playing college and professional basketball were thwarted by the floods. Now, I'm not going to blame his downward spiral on the storm alone, but he never found his footing afterward. He even tried to return to Slidell and reenroll in high school, but the support system he needed was hundreds of miles away.

Many times, maybe too many, I've extended myself, hoping he would heed my advice. Once, during one of his disputes with the mother of four of his children, when she had kicked him out again and my parents were spent with his attitude and lack of drive, I suggested he come to Brooklyn for a change of scenery and work on getting his GED. My offer came with stipulations, however. No weed or other drugs, and he had to adhere to the educational schedule I had devised. He would read every day, and we would work on subject tests for the exam. But he didn't take to it easily, and we clashed, primarily because I felt he lacked a sense of urgency. I would get so pissed to see him scrolling Worldstar or Facebook or YouTube for hours. I can be demanding, I know, but I wanted him to understand how much education mattered in the face of all the laws and policies that were designed to keep us oppressed. "Can't you see where your life is headed?" I would admonish, and he feared the same. "I'm becoming my daddy," he would say, which meant he didn't want to end up driving a forklift for the rest of his life, relegated to a working-poor existence. Our father only did the best he could and was always present, selfless with his time and energy. But I've always thought that my brother could do better, that all children could surpass the circumstances of their parents.

We agreed on his likely outcomes if he continued down this path, but we disagreed on the solution. One positive result of being a dope boy, which of course isn't absolute, is the potential flourishing of an entrepreneurial spirit. He embodies this completely, but often it prevents him from understanding the incremental nature of success.

To counter his mindset, I made him read Malcolm Gladwell's *Outliers*, which I hoped would expand his perspective. He had never read an entire book before, and he expressed genuine gratitude for the discussions we had afterward. I always knew he was smart, and seeing the gains he made in a few weeks meant a lot.

When he returned home, he passed the GED after a few attempts and was ready to approach his life differently. But he fathered more kids, each requiring more of him, and he continued to dream too big without first establishing strong enough foundations for all the businesses he envisioned. And he kept getting arrested for a suspended license and other moving violations. "If they see you ride around all day in their neighborhood, they gonna stop you," he said to me. "At this point, they know my car, they know how I move, they know I'm an easy target." When I asked how much he owed to clear his license, he said thousands, unsure of the exact number. "Seems like I'm never gonna pay it, so that's why I'll spend a night or two in jail to remove the fines."

The saddest part, at least to me, is that I know he's not alone. By law, police have continued to profile us in the name of public safety. But as we've seen in Ferguson, Minneapolis, Memphis, New York, and other urban areas, these stop-and-frisk overpolicing strategies fail to deter crime. They do succeed, however, at

pathologizing our bodies, so that whenever we are following the law and exercising our right to legally bear arms, as was the case in Philando Castile's murder, we may still be perceived as a threat. Castile was pulled over forty-nine times in thirteen years, often for minor infractions, which led him to drive with a suspended license for years.

My brother still takes these chances, risking further citations, the seizure of his car, or worse. "If they see me with my babies, sometimes they let me go," he said. When Castile was shot, he had paid all his fines, and his license was reinstated. A child, his girlfriend's daughter, was in the back seat. The last stop was for a busted taillight—and the penalty was death. All it took was forty-nine times in thirteen years to execute his punishment. How many times, I fear, will my brother be pulled over, will we all be pulled over, before another cop exhausts their capacity for grace?

Months may pass between our interactions, but when my brother calls now, often he's in crisis and needs to borrow a few hundred dollars, and every time, no matter the circumstance, I give him what he needs if I can, as we all should when our loved one's survival is threatened, when we may be the sole witness to their humanity.

Seven

THE DEITIES OF WATER
AND CANEBRAKE

mother I need your blackness now
as the august earth needs rain.

—Audre Lorde

The first posts from Domino Park's Instagram account describe Williamsburg's newest park, located a few blocks from where I was arrested. Its feed features images of a playground, toddlers walking hand in hand, dogs in various stages of repose and activity, outdoor yoga classes, Zen gardens, soccer games, butterflies, sand volleyball courts, and sunsets silhouetting the Williamsburg Bridge. A few comment on what the space used to be, capturing the cranes and gears and storage tanks of the old sugar factory in stylized frames that evoke nostalgia. One since-deleted image, captured near the factory's brick facade, angles up the face of the building and produces a towering perspective of what it looks like to stand directly in front of it. The result is stark and foreboding. The

caption reads: "The Domino Sugar Factory at one point produced 95% of the sugar consumed in the U.S. Part of the reason we're proud to call the namesake our home!" Missing from the description is an acknowledgment of sugar's role as a driving force of the slave economy when the factory opened in 1856. Another post shows an old ad featuring a factory worker, a white woman in an industrial dress and gloves. She inspects a box of sugar in her hands as others line a conveyor belt. The caption focuses on the employees, 4,500 in total, who unloaded, purified, granulated, and packaged the product into "the iconic white and yellow bags and boxes that are still on shelves today." As if concealed by a sugary glaze, the feed is filtered so the viewer forgets what once was, mirroring the effect of sugar on the mind.

When we ingest sugar, dopamine floods the brain's reward centers, causing a euphoria so addictive that it can surpass the psychoactive pleasure we receive from sex and drugs. Its overconsumption even affects cognition, making it more difficult to learn and remember, an effect fitting for its role in the transatlantic slave trade; the pursuit of table sugar paved the path for centuries of bondage and memory loss.

Sugar is what made the slavers in and around New Orleans rich, for its emergence along the German Coast and throughout Louisiana filled a gaping void after the liberation of Haiti, once the world's largest sugar producer. It's what allowed P. G. T. Beauregard's family to send him to West Point, where he learned strategies that would earn him military distinction in imperialist conflicts waged throughout Mexico and the South in support of slavery. It's why Cuba and the rest of the Caribbean islands had such a symbiotic relationship with New Orleans, each island es-

sentially an agricultural colony purposed toward the cultivation and trade of sugar.

Jean-Nöel Destréhan, a French slaver who became wealthy on the German Coast, is credited with revolutionizing the process, generating yields America had never seen before. By dividing the labor into three groups of harvesters, transporters, and processors, he worked enslaved Africans sixteen hours a day, seven days a week, and "doubled the work of forty to fifty workers without overworking any of them," as noted in *American Uprising: The Untold Story of America's Largest Slave Revolt* by Daniel Rasmussen. Yet sugar work was grueling and earned the dreadful reputation associated with being "sold down the river," where enslaved Africans "worked longer hours, faced more brutal punishments, and lived shorter lives than any other slave society in North America." In four years of sugar harvesting, an enslaved African returned his master's original investment and produced profits that sparked the internal slave trade that exploded in the nineteenth century.

The history of America, as a result, can be traced by a path coated with sugar following the ratification of Louisiana's statehood, the invasion of Spanish Florida, the annexation of Mexico, and the systematic decimation of Native populations. These conquests more than doubled America's size and thrust the country into its position as the world's most powerful empire.

Before Domino Park was repurposed as the site of one of New York's newest architectural feats, the factory was a vehicle for slavery. Before Williamsburg became one of the most rapidly developed neighborhoods in America, Kara Walker sought to remind us of the factory's legacy.

The first few images of the feed still highlight images of Walker's *Sugar Baby*, but none mentions the word "slavery," the direct reference to the trauma lost in ellipses. The full title of Walker's "confection" reads:

> *A Subtlety or the Marvelous Sugar Baby, an Homage to the unpaid and overworked Artisans who have refined our Sweet tastes from the cane fields to the Kitchens of the New World on the Occasion of the demolition of the Domino Sugar Refining Plant.*

I saw the sculpture on the last day of the show in 2014 before it would be destroyed, before the Domino Sugar factory would be razed and the waterfront condos that look out onto Manhattan would rise in its place. I had wanted to see it earlier, but when I first tried, the line stretched for blocks, the wait over two hours.

The stench smacked you first, the acrid, sour odor still thick in the air after decades of sugar processing. Looming in the background a hundred yards from the entrance sat the sculpture, its white surface, coated with 160,000 pounds of sugar, radiating from the sun piercing through the skylights. It was massive, the biggest sculpture I had ever seen: a mammy, fashioned as a sphinx with full lips and nostrils, her head covered by a bandanna, her breasts and buttocks not just exposed but inviting, her nipples erect and ass raised in a way that said "Take me from behind." I was humbled, the way I imagine it would feel to walk before the pyramids of Giza and feel dwarfed by their size and significance on the timeline of recorded history.

The "subtlety," a term for elaborate confections once used as ornaments and placed on antebellum dinner tables, represents the culture of excess and symbol of wealth made possible through the labor of the enslaved. The factory, once the largest sugar refinery in the world, now housed a thirty-five-by-seventy-five-foot sculpture that married the tangled histories of rape and forced labor into a symbol of the women who nursed America to dominance.

Although it was the first sculpture in Walker's body of work, it fits perfectly within the scope of her signature silhouette motif, which on first glance obscures the perverse details of her antebellum narratives. Upon careful inspection, you are likely to be disturbed by images of sodomy, decapitation, fellatio, and other unseemly acts. To experience her work, then, is to be overcome with emotions that are at once visceral and alarming. I expected this much from *Sugar Baby*, desiring to be made uncomfortable but no less appreciative of her rendering of history. I didn't expect to be overcome by such an intense sadness, though, overwhelmed by an urge to look away, to cover the mammy's body and shield her from inspection. This time the message was too much to bear. Maybe Cummings, the founder of the Whitney Plantation, was right. Maybe there are some images that we should never see.

But what if Walker wanted me to look closer, to see the resin that had fused the parts of the polystyrene sculpture and imagine the weathered fissures of a marble monument, one that had withstood the decaying effects of nature to proudly honor the unceremonious role that our ancestors played in nursing white supremacists.

Maybe she sought to create the largest public sculpture New York has ever seen to honor the wishes of Charles Stedman, a North Carolina congressman, who on behalf of the Jefferson Davis Chapter of the United Daughters of the Confederacy introduced a bill in 1923 to erect a mammy on the National Mall, a few blocks from the Lincoln Memorial.

Without a shred of irony, Stedman argued before the Senate that the monument "should find a responsive echo in the hearts of the citizens of this great Republic" to commemorate the life and memory of the faithful slave. One model of the proposed statue captured a mammy holding a white child while two Black children cling to her dress. The final design that Stedman and other supporters decided on was the image of a mammy, cast within a columned fountain, sitting with an infant clung to her breast. A petition of two thousand Black women had implored Vice President Calvin Coolidge to thwart the bill.

I considered assuming Walker's voice, one that seemed to scream "Fuck You!"—the epithet evident in the archaic gesture of the mammy's left thumb jutting through her index and middle fingers. But I felt more violated than enraged. While some patrons took playful selfies that framed their smiling faces next to the sculpture in the foreground of their photos through cleverly orchestrated optical illusions, I struggled to fight back tears.

In conversations with artists and curators days after the show, I heard many of them say that Walker should have left the mammy in the past, that at the end of her career, her retrospective will be mired in vacuousness, the result of ingesting the same image over and over. I submit to some of these claims, but the power of *Sugar Baby* lies in its temporality, since the shock

and trauma it elicits was never supposed to last, as impermanent as the sculpture itself. This is the core of its brilliance. In form and execution, Walker captured the psychosis of America, how we can be drawn to empathy but only for a spell, only until something else diverts our attention. To this end, all that remains of the sculpture is part of its hand after Walker realized that peering into its face would likely be too haunting, for who in their right mind would want their yearning for sex and the rush of a few teaspoons of sugar complicated by thoughts of slavery?

DID WALKER GO TOO FAR? Is there a limit to what we should see and immediately learn about slavery? Do we need such reminders that call attention to the centuries of injustice?

These questions presuppose a blindness to the reminders that exist everywhere we look. Unpaid Black labor still has not reached the American consciousness. But consider what might happen when we learn to see the results of the transatlantic slave trade everywhere we turn, how they can be found in the origin stories of our schools, our banks, and our institutions—virtually every system that defines our society. Every American ideal can be traced back to the beginning. But like the unmarked graves of enslaved Africans in Lower Manhattan, where the epicenter of our economic engine continues to reign, it's easy to overlook the first commercial trades that brought us to these to shores.

I should tell you that this awakening can be maddening, that when you least expect the reminders to appear, they may shake you into a sadness that feels insurmountable.

In Paris, the city of love, when I and my then fiancée visited,

I had one of my most trying times. We had risen early for our exploration, the Louvre our eventual destination, and decided to walk south toward the Seine, down a pedestrian strip called rue Montorgueil, a block away from where we were staying. The street was at the center of Les Halles—the neighborhood known for its restaurants and markets established in the early nineteenth century.

But before we began our stroll in earnest, my fiancée stopped to buy allergy meds from a pharmacy, and I waited for her outside so I could get a feel for the city as it awoke from its slumber. Delivery trucks crept along the cobblestone street. Diners chewed croissants and drank espresso from café tables as they folded newspapers or stared into their devices. Tourists bounded past me, maps clutched in their hands. The energy of movement and the day's possibilities made me giddy. Graciously, I smiled, thankful to find myself in love and in Paris, wearing the mantle of a writer like my literary heroes whom I imagined had walked these same streets. Then I looked up.

Directly across from me, a relief, which read *"Au Planteur,"* was installed on the facade of a residential building in a wooden cornice topped with an ornate arch of dilapidated flowers and imperceptible symbols. Bordered by rectangular columns of equally weathered wood, each painted in shades of blue that had faded over time, the scene is tropical, set against a bright blue sky. In the foreground, large palm fronds, flowers, and young trees blooming with clusters of berries surround two figures. The first, an unshirted Black man, wears vertically striped red and white shorts, tight and cut just above the knee. Around his

neck hangs a string of brown beads. Three bangles, two around his biceps and one around his forearm, call attention to his lack of shoes. The Black man leans forward with a steaming cup to serve a white man who sits on two large sacks of unmarked goods. Clasping a pipe in one hand, the white man, dressed in a panama hat and double-breasted khaki suit, seems ready to reach for the drink with his other. Their empty gazes don't meet. At the bottom of the scene, the words *"aucune succursale"* are written in a font slightly smaller than the title. I don't speak French and couldn't translate the words then, but the painting was clearly an advertisement celebrating the spoils of the transatlantic slave trade.

I'm not sure a word exists to convey the depths of my deflation, my emotions cycling through confusion, disbelief, disappointment, sadness, and rage. Stated simply, the relief shat on my day. An image from the *Narrative of the Life of Frederick Douglass* came to mind, when Douglass begins to understand his position in the world during the struggle to determine his value after the death of his master.

Douglass had been stripped from his comfortable life in Baltimore where he had found a teacher in his third mistress and a friend in her son. He was forever changed by their separation. He learned what it meant to be a slave through passages of *The Columbian Orator*, but it wasn't until he was sent off and measured, his body divvied up into parcels to be split among the remaining heirs, that he truly understood the horrors of slavery, how it reduces man to beast. At the site of the offense, he describes the spectacle with incredulous rage:

What an assemblage! Men and women, young and old, married and single; moral and intellectual beings, in open contempt of their humanity, leveled at a blow with horses, sheep, horned cattle and swine! Horses and men-cattle and women—pigs and children—all holding the same rank in the scale of social existence; and all subjected to the same narrow inspection, to ascertain their value in gold and silver—the only standard of worth applied by slaveholders to slaves! How vividly, at that moment, did the brutalizing power of slavery flash before me!

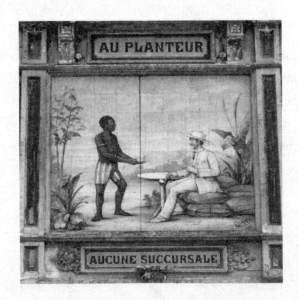

Relief seen on rue Montorgueil,
Paris, France, 2016

My eyes seemed to have seen what Douglass saw, and the alarm I experienced thrust me into a surreal contortion of space and time. But unlike Douglass, I was free from the terror of the

whip. I could forget what I saw and banish the image from my mind; except, I couldn't. For the rest of the day, I felt weighed down by a network of invisible chains as I marched toward the museum thinking that this is how they see us still.

The entrance to the Louvre lifted my spirits. In a vast court-yard of the former palace, which dates to the height of the French Renaissance, sits an awe-inspiring glass pyramid designed by I. M. Pei. Fountains and statues and two smaller pyramids sur-round the structure. Placed strategically between the large pyra-mid and the smaller ones are stone pedestals that provide optimal angles from which you can photograph yourself with the main pyramid in the background. The clash of modernity and antiquity struck me as a recasting of the past, the pyramid evocative of the great civilizations of Egypt in a rendering that seemed to validate my presence among the halls where French monarchs had debated my humanity. Through the symbolism of transparent window-panes, I had a sense of being seen and welcomed into a tradition that had denied my entry for centuries.

But after we had taken selfies standing inside the pyramid, posed in front of the Mona Lisa, and gazed at the Venus de Milo, we were exhausted. How many more images of whiteness could we endure? We knew from the outset that, with its wings and countless galleries, the palace couldn't be navigated in a sin-gle trip, so we made our way to the exit to peruse the gift shop. There, while waiting in line with a few postcards and magnets in hand, we saw the image of a seminude Black woman and turned to each other, surprised.

"Is this painting in the permanent collection?" my fiancée asked the clerk, to which she smiled and nodded.

Off we went with a three-by-two-inch magnet as our guide, searching for *Portrait of a Negress*. Up and down flights of stairs, through galleries and corridors of collections marking the achievements of Western art, we sought her gaze. "Where is this painting?" we inquired, each guard and docent and staff member offering contradictory directions, some not sure the painting was even on display, their accents thick and hard to parse. After an hour or so we contemplated giving up. But we had come too far to not see ourselves reflected in this hallowed space, I insisted, and we carried on with manic intensity, circumnavigating the section of the map where it was said to have been displayed until one attendant finally broke the news.

"Oh, that section of the museum is closed for renovations today. It'll be open again tomorrow."

We didn't have a tomorrow in Paris, as my fiancée was scheduled to fly to London and I would head on to Sicily, unfulfilled, denied the opportunity to inspect the latent sorrow in the eyes of this famous Negress.

Painted in 1800 by Marie-Guillemine Benoist, *Portrait of a Negress* was lauded for its artistic and symbolic merits. The painter, a white woman, brought the image of the other into the world of high art and saw her career skyrocket as a result. Four years later, she was commissioned to capture Napoleon's portrait. Though I would never see *Portrait of a Negress*, the portrait for which she is remembered, I had to imagine its force from the Louvre's description:

> A brilliant student of David, the artist boldly asserts
> herself here: painting black complexion was a rare exer-

cise and little taught because it was considered ungrateful. The serious look, the calm pose and the bare breast give the anonymous model the nobility of an allegory, perhaps that of slavery recently abolished.

But who is this *Negress*? What worth was she to Benoist? Perhaps Benoist was celebrating the abolition of slavery in 1794, but we'll never know for certain, nor would we ever know what became of this Negress when slavery was reinstated by Napoleon two years after Benoist completed the painting, at least that's what I thought then.

No such uncertainty exists to art historian Lisa E. Farrington, who, in "Reinventing Herself: The Black Female Nude," interprets the portrait via a Black woman's gaze:

> Despite her grace and loveliness, the seated figure, here gazing out at the viewer, can hardly be considered empowered. Rather, she sits swathed in white drapery (designed to contrast with her mahogany complexion), appearing both sad and submissive. Her hands are folded across her lap and the cloth that covers her body has been pulled aside to reveal her right breast, as if for the viewer's inspection and enjoyment. Her dark skin, seminudity, and the bandana she wears on her stately head define this African woman as Moorish erotica—a popular genre in colonial European painting that depicted Africans in Arabic costume and embodied both erotic and the exotic elements common to academic French painting of the period.

While Benoist may have been well-intended, desiring to celebrate this woman's newfound freedom and elevate her in the classical sense, perhaps the Negress made it more acceptable for the Black woman's image to be inspected and regarded as a spectacle. Six years after it appeared, Saartjie Baartman was brought from South Africa and displayed in Paris as a live nude installation that invited onlookers to marvel at her enlarged clitoris and substantial ass. To get a sense of the spectacle, one popular French publication, as noted by Farrington, captioned the sight of masses gazing upon Baartman's body satirically: "La belle Hottentote. Oh! Goddam, what roast beef; . . . Ah! How comical is nature; how strangely beautiful." Consistent with the vagaries embedded in French expression, it isn't clear if the comedy and beauty should be ascribed to the onlookers or the debased Baartman.

THE FOLLOWING WEEK, after returning to Paris from Italy, I visited the Orsay Museum, seeking relief from my swirling thoughts, desiring nothing more than a pleasant, meditative stroll through the collections.

The grandeur amazes on sight, the museum housed in an old train station that has been transformed into an architectural feat with translucent floor-to-ceiling windows between arched bays of rosettes carved into the stone walls. Each bay of windows wraps around the ceiling so that the nave becomes an awe-inspiring dome. At the entrance, a large decorous clock rests in the center of a bank of windows and evokes the baroque royal aesthetic of the French Renaissance, consistent with its famous

neighbors, the Tuileries Garden and the Louvre just across the Seine.

Divided into three levels, the museum is not as daunting as the Louvre, so I took my time strolling the galleries and grand ballrooms, until my senses were unexpectedly accosted by a towering, vivid depiction of a beheading. Painted by Henri Regnault, *Summary Execution under the Moorish Kings of Granada* was like nothing I had ever seen. From a low angle the viewer sees a pool of blood dripping down the steps from a detached head at the site of the Alhambra in Granada. The murderer's saber is still drawn as he looks away callously, his head-to-toe frame towering over the corpse. His skin is unmistakably Black, his strength evident in the thick, muscular arms, taut and veiny with the energy of motion. The warm shades of orange juxtaposed with the dark green cloak of the beheaded offer a striking contrast, but the content puzzled me in that it effectively conveyed the image of the dangerous darkie, the exotic, capricious foreigner.

A painting by Pierre Puvis de Chavannes titled *Young Black Man with Sword* unsettled me further. As its title indicates, the subject is a young Black man gripping the handle of a saber that rests on his right shoulder, the weapon extended behind him out of view. How it employs light and shadow makes it special, the landscape in the background dark and nondescript, conjuring the bleak image of a battlefield after a conflict.

But his nudity puzzled my interpretation. His legs are crossed, shielding his penis, but his lean, taut muscles are in full view, a red scarf, patterned in the Arab or African tradition, tied around his head like a bonnet. His stare is stoic and empty, peering

175

directly at the viewer. But these details failed to offer a concrete explanation.

Puvis de Chavannes, of all the artists of the period, was regarded as *the* painter of France, as he was commissioned throughout the country to depict allegorical scenes symbolic of its history and culture. Given his importance and legacy, I wondered why his treatment of the Black body had yet to be scrutinized. Shouldn't these paintings be recontextualized so viewers understand the value of Black bodies beyond aesthetics? Should Puvis de Chavannes get a pass because racist ideas defined his era? The trouble with this logic, of course, is the centuries of white supremacy you would have to excuse.

Then I came across Gustave Courbet's painting *The Origin of the World*. To the untrained eye, the message is conveyed instantly. A nude white woman lies across a bed, her legs splayed open, exposing her thick pubic hair and vulva. She is oriented vertically so that her vagina lies at the center of the frame while her face escapes inspection out of view. A bedsheet loosely wraps around her comfortable torso and reveals the supple curvature of her right breast and erect nipple. Were it not rendered so well, the image could easily fall into the pornographic, but how the brushstrokes succeed in capturing the strands of hair about her thighs, the colors of her skin, the natural lines and folds of her body, is masterful. Her languid position, slightly angled across the frame, offers two immediate readings, conjuring the image of childbirth or sex, both acts possible before or after the moment depicted.

Sex likely dominates all interpretations, for the museum's audio guide describes its function as a provocation and source of

conversation for one of its owners, a Turkish-Egyptian diplomat who often kept it hidden behind a curtain.

I was sexually triggered by the image, for sure, but when I thought about its title, I realized the painting was propagating a lie. The origin of the world began in Africa. I didn't emerge from those thighs. And while the out-of-Africa theory continues to evolve today, with some East Asian scholars advocating a more simultaneous, regional theory to human development, my world-view isn't shaped by the passage of humanity through the canals of whiteness. But this is the point. Courbet's lens is white, and he, like most of us, envisions the birth of the world reflected in his own image. This is a natural, potentially dangerous inclination, for the failure to see the world through the perspective of others has caused and continues to cause so much injury.

I was more amused than hurt, and I kept moving through the galleries until a Monet caught my attention. Claude Monet, like many of the impressionist masters, had a particular gift for capturing a landscape in brushstrokes that, when viewed up close, can be mistaken for errors, but when taken in from afar offer dreamy, transcendent interpretations. This one was no less impressive, capturing a throng of pedestrians parading down an avenue flanked by French flags hanging from residential buildings lining the street. The flags seem infinite, billowing in the breeze of a partly sunny day, and Monet renders the shadows and bursts of sunlight filtering through them with skill. I could imagine fireworks and uproarious cheers reverberating from the frame, and the celebratory energy of movement and national pride almost transported me to the setting—until I read its title: *The Rue Montorgueil in Paris, Celebration of June 30, 1878.*

"Motherfucker," I mouthed to myself.

Here was the street where I had seen the relief advertising slavery on my first day in Paris, taunting me again. The painting commemorates a day of "peace and work" designated by the French government to highlight the vitality of the national spirit in the wake of civil unrest and their defeat in the Franco-Prussian War. But somewhere in the scene, I was certain the painting also celebrated my enslavement, and I wanted to spit on it, to deface the emptiness of the French ideal and get the fuck out of there.

WHEN I RETURNED HOME to New York, I wanted to know more about my experience with art in Paris and attended a panel at the Festival Albertine moderated by Thelma Golden called "Art, Race, and Representation." The panel included French artists and scholars, along with the American painter Kehinde Wiley.

From the discussion I learned more about French artists working today, including those of the Black Francophone community, and how each wrestles with white supremacy in their work. Wiley described this as the "Frenchness about French art," which is to say how it's coded with expressions of racism and oppression.

But the context they provided wasn't enough to address a question that was still burning, and I rose to the microphone to demand an answer. I described how I saw the relief on Montorgueil and the Monet at the Orsay Museum in relation to the removal of racist monuments in New Orleans and asked: "When does the moment happen in France when people start to take

these reliefs down and understand that it's really not a good representation of us, of Africans, of humanity?"

"One way to answer the question," said the professor Nacira Guénif-Souilamas, "is to think of another option which would be to render them visible. You noticed them, but a lot of people in Paris don't. They don't even notice that Paris was built out of slavery, out of colonialism, and French humanism."

"Yes, but you can also say that there was Palais de la Porte Dorée, which became the Museum of Immigration," replied the photographer Denis Darzacq, before turning to the audience and continuing, "where you could see paintings from the colonies, and it is now dedicated to immigrants and immigration."

Guénif-Souilamas let out a chuckle and replied, "The fact [is] that what's on display there now was built on slavery and through colonization. So, you have this complete disconnection to the building and what's inside of it. . . . There should be this continuity so that this is understood as also the place where colonization took place and was on display for the French people. And this is not being done so far. You have this sense that this was the past and now is the present. But this is not how it works, there is a colonial presence in France."

The debate ended with Darzacq shaking his head and laying down the mic, a sort of gallows humor arising in the awkward space of acknowledging white supremacy's unyielding influence. What are we to do with these public spaces stained by centuries of slavery? What are we to do with the masters and their works of imperialism?

The French thought they were bringing democracy and civilization to the savages for their own good, and they sought to

prove it by displaying their works in the 1931 Paris Colonial Exhibition as a show of France's embrace of the arts throughout the world. But they failed to see the harm of their exploits, how their presence in these foreign lands had been driven by material gain.

Elsewhere, while the panelists and I were taking the French to task, Denise Murrell was crafting her dissertation research into a show that would make many formerly anonymous Black subjects in French paintings more visible. Among a host of revelations, Murrell identified the nude Black woman that my wife and I were unable to see at the Louvre, which is now called *Portrait of Madeleine*. To celebrate Murrell's findings, the Orsay Museum welcomed her show, titled *Black Models: From Géricault to Matisse*. Several paintings in the Orsay's collection were renamed and recontextualized as a result.

These types of conversations have upended the art world, as museums have begun to rethink their collections and their proximity to white supremacy, especially when it comes to their leadership, board of directors, and curators.

In New Orleans, Dismantle NOMA composed an open letter to the leadership of the New Orleans Museum of Art insisting the museum address its hiring practices, the acquisition of its collections of African and Indigenous objects, and its allocation of funds, among other demands. This reimagining of space and messaging inspired others throughout the city to go further.

In January 2022, *Sentinel (Mami Wata)* was erected at the base of Lee's pedestal as a temporary installation for six months. Created by Simone Leigh, the sculpture depicts an African deity known throughout the diaspora as Yemaya. A snake coils

around her slender nude figure, a large spoon occupying where her head would otherwise be. The sculpture was commissioned by Prospect.5, a citywide art exhibition that encouraged fifty-one artists from the U.S., the Caribbean, Africa, and Europe to reconsider the history of the New Orleans. What they produced was displayed in public spaces and galleries throughout the city.

I first saw *Sentinel* after touring the World War II Museum a block away. It was a few days after Mardi Gras and the day the officer who shot ten bullets into Breonna Taylor's apartment was acquitted for endangering the lives of her neighbors. The scene wasn't what I expected.

I strolled the base a few times before I climbed to the top tier. Beads dangled from the nearby streetcar cables and tree limbs, and as I looked down Higgins, I saw the museum with the Mississippi River Bridge in the far background and registered the image as uniquely New Orleans.

Reaching *Sentinel*, I stopped and gazed at it from multiple angles, its surface smooth and buffed to a sheen that glimmered in the receding sun. I can't say that I was a fan of it, though I admire its creator. I had seen Leigh's *Brickhouse* installed along the High Line in New York City and marveled at its brilliance, simple in subject but grand in execution, the towering presence of a Black girl in youthful plaits centered above Tenth Avenue to remind onlookers to really *see* Black women. This act of centering us has always drawn me to her work and rightfully garnered her acclaim. A version of *Sentinel* would even be displayed at the Venice Biennale, when she became the first Black woman to represent the U.S. on one of the most significant international stages. Still, something was off.

I strolled the base again as others climbed the steps. Eventually, I approached a white family of four, a married couple and their preteen sons. They were taking pictures on the other side of the pedestal facing away from *Sentinel* when I asked one of the boys if he knew what used to be here. Then the father walked up and I introduced myself and repeated the question. They were from upstate New York and relaxed a bit when I told them I live in Brooklyn. They had just flown in and their excitement to explore the city was evident. When I told them about Lee, the father paused and seemed confused. "The Confederate general," I explained, and his eyes widened in embarrassment. I could tell he still didn't grasp the full significance. I wished them a good time and thanked them for chatting with me after I agreed to take their picture.

When I returned to *Sentinel*, I watched a twentysomething Black man grip her ass with his hands, his tongue out as if ready to lick it. A young white couple had climbed the steps by then and sat just behind him, laughing as his audience.

This was my issue with the sculpture: there was no plaque or text or any indication of what it signified and its relation to the space. Of course, the symbolism is obvious. The African goddess of water situated in a city that is defined by it—by Betsy, by Katrina, by the Mississippi, by the Middle Passage. How she came to cleanse the space from the evils of white supremacy, to water the land for the coming generations, to flood the space with African ideals. Something, anything of this sort, should have been said. While I understand the artist's affinity toward abstraction, something more direct, like what she did with *Brickhouse*, seemed appropriate. And while I appreciate Leigh's

insistence that the sculpture be placed at the base and not atop the pedestal so that onlookers could engage it more closely, the final product results in a missed opportunity.

So, I figured I needed to go to Venice to see Leigh's show, *Sovereignty*, the space for which *Sentinel* was originally commissioned. Leigh had already been awarded the Golden Lion at the fifty-ninth Venice Biennale for Best Participant, marking the first time a Black woman has received the award.

Upon approach, the U.S. pavilion stood out from the others. The facade was fashioned as a West African palace, a direct reference to the 1931 Paris Expo, which also featured an architectural hut motif to showcase the artistry produced in France's colonies and the exploitation of other Western countries. While I had learned of the French's efforts to humanize its imperial subjects via the panel at the Festival Albertine, I didn't realize until I explored Leigh's work that each exhibit featured human subjects, people from all over the world displayed as if in a zoo.

Thatched roofs supported by wooden columns obscured the pavilion's palladium style, which, according to the show's brochure, is reminiscent of Thomas Jefferson's Monticello. The force of the symbolism felt surreal. The structure commanded attention from a few hundred feet away and left me in awe. It wasn't as grand in scale as *Sugar Baby*, but its message was just as powerful, and I felt my heart rate increase as the experiences merged in my imagination.

Fronting the facade was *Satellite*, a towering sculpture of a woman, her head a large disc, her skin black and smooth like the version of *Sentinel* I had seen in New Orleans. But this piece was a direct allusion to the traditional D'mba headdresses

shaped as female busts and employed by the Baga peoples of the Guinea Coast as conduits to their ancestors. It was so huge you could walk under its weight supported on thin, stilt-like legs. You would need a wide lens to capture the palace and the sculpture in a single frame, the spiritual significance and value of West African life, forcibly transported to the Americas, incomprehensible from one point of view.

This is what I wanted to feel in front of Leigh's sculpture at Harmony Circle in New Orleans: an overwhelming understanding of the presence of Black life in the physical and spiritual realms, communicated through the irreducible image of Black women, the mothers of all humanity, ready to welcome us home when we accept their position as the original source.

The galleries were sparsely populated as the closing hour approached, and the stillness of the spaces elevated the experience even further. The first gallery housed a long reflecting pool where there was a sculpture of a Black woman bent at the waist as she washed a garment on a stone. In the image, I saw my ancestors, each of my grandmothers who washed clothes for white folks so that one day I could be in a space that honored them. As their faces came into view, their voices returned to my ears, their energies enveloping me.

The work in the other galleries was equally evocative: how Leigh merged the shape and structure of kitchenware with the image of Black women who used them in their labor, how she subverted so many tropes propagated in racist imagery to suggest the beauty and strength of Black women, how she employed African iconography to underscore its ubiquity.

The original version of *Sentinel* was massive and extended to-

ward a domed ceiling, the sculpture nearly the height of Robert E. Lee's former pedestal, at least it seemed so in the space it was housed, as if its monumental presence was intended to make you feel insignificant and incapable of moving past her. She, too, couldn't be captured in a single frame, and I stood there for a moment, allowing myself to situate her in the memory of my mothers, each who had stood watch over us to do what they could to protect us from the evils of the world, even when we weren't aware.

I thought of the white supremacists on Jeff Davis who foolishly guarded Dreux and a fading tradition. They were no match for Leigh's imagination, and for all the Black women who embodied her stance in the flesh. I thought of my mother and our relationship, how she doesn't fit comfortably within the prevailing archetype of a housewife who made sure dinner was served at the same time every day, who attended parent-teacher conferences, and who straightened my tie before I left for school dances. My mother loved me through her work, as she spent every night on the clock to ensure our survival. Sure, I missed her sometimes, and I wished she appeared in the picture of me in my football uniform, flanked by my father and little brother on senior night as I held a bouquet of flowers in her absence. But labor, I've learned, is what sustains. It's how we got here and how we will ascend.

The works in the last gallery left me speechless. Many of the sculptures resembled the bell-shaped, bellowed bottles of Mrs. Butterworth's syrup, and the pattern made me wonder about their inspiration. The brochure text highlights three references: the hut-shaped buildings of the 1931 Paris Expo; Diego Velázquez's

1656 painting *Las Meninas*, which featured the Spanish royal court, obvious beneficiaries of the pillage of Africa and the Americas; and a restaurant in Natchez called Mammy's Cupboard, which was shaped like a massive mammy whose skirt served as the principal structure through which you would enter.

Because the restaurant opened in Natchez in 1940, Mama Nancy would no doubt have seen it, if not dined at its tables. When it opened, the mammy was painted a dark shade as deep as blackface, which must have been a stark reminder of the way this country perceives Black women and their worth.

In that moment of clarity, everything collided, all the images I had been chasing, all the voices of the lost, all the spaces I had seen and imagined—everything was captured in Leigh's sculptures. Time collapsed. There was no before or now or later, but all of them at once, and I felt like an all-seeing god, able to anticipate the future of Black art.

As I rode back to my hotel on the waters of the Adriatic Sea, the way forward became clear. Through the teachings of the deities on the reservations and in New Orleans and Natchez and Mississippi and Monticello and the South, through the mothers who made ways out of the waters, through championing the labor and artistry of Black women, we will emerge somewhere greater.

Eight

OPEN CASKETS

———◦———

We live in a country where Americans assimilate corpses in their daily comings and goings.

—Claudia Rankine

L ike most of us, I'm intoxicated by the body, the way it moves and lies at rest, its lines and angles, the curves and shapes it assumes. This is why it remains our greatest source of art. Since the beginning, we have used our bodies as canvases, marking it with scars and the ink of animals and plants. In our first homes, in those huts and prehistoric caves, we hammered our image onto walls and altered the land to remember and honor our presence. Countless masterpieces center our portraits and frames. Through our love of dance and athletics and performance, our relationship to the body has evolved. There is nothing like seeing our legs bend and lunge in the air, the legs splayed in a perfect split, quads and calves taut and bulging as if sculpted in stone; or the beauty of sprinters, their strides stretched and churning at the speed of a blur; or the improbable flips and somersaults of gymnasts, their bodies somehow spinning in an unbroken line ten feet in the air.

But we also are enamored with the body's abuse and disfiguration. Stonings, crucifixions, beheadings, firing squads, and other public displays of death have always served as entertainment and deterrents for the masses. I am not immune. While I can't stomach mixed martial arts, how the knockouts spray blood across my screen unexpectedly as I eat breakfast with my kids, I confess I still enjoy the violent collisions that define football, the scenes replayed in the highlights after I've seen a man bludgeoned to submission.

The allure lies equally in the escape, the near capture, and the failed attempts. The stutter step and crossover elicit the same oohs and aahs from the crowds as the dead-on strike does, the ringing smack of the collision, sending the unlucky body flying, the feet dangling in the air.

Consider the danger of witnessing the destruction without your consent.

The most injurious form of the spectacle remains the lynching. I haven't watched the videos of the men and women slain by law enforcement in the recent past, uncertain of how I would respond to seeing someone killed, but millions have. I can't explain why exactly, but I sense an irrevocable harm that comes with witnessing a public death, the awe that rises as a sort of disbelief. *There's no way this ends in death,* the mind wonders before the body succumbs to the trauma. I'm convinced that the despair or joy that swells in our chests has to change us on a cellular level. Something in our understandings of humanity is rewired, and I won't risk the experience. Who knows if my mind will recover?

In the more traditional sense, the terrors enacted during Jim Crow began as private affairs, macabre ceremonies orchestrated

like works of performance art wherein the body is strung from a tree so old and majestic that one of its branches can support the weight of a man. The tree itself becomes a part of the show. The body, in a struggle for life, returns to rest with its neck unnaturally askew, the eyes bulging, the mouth foamy and agape. Clothed or naked, the body is pocked with bullet holes or stab wounds or mutilations or burned beyond recognition, the genitalia, knuckles, and kneecaps severed for souvenirs. Every part of the body may be cut from the corpse while a man with a banjo or harmonica plays "I Wish I Was in Dixie." The assembly drinks and eats in unfettered merriment, like the opening reception of a gallery show.

Eventually, the affairs became advertised. Trains ferried people to the action by the carload, and if you couldn't make it, a friend or family member could send you a postcard, the images like posters sold in gift shops, some reproduced and purchased on site.

Black activists reclaimed the images and raised awareness by printing them in Black-owned newspapers and quarterlies. Often, these images appeared in wide angles so that the victims were decentered and the crowds assembled came more into focus, their gleeful smiles and joyous attitudes forever etched in history. The details of the victims and their circumstances were not the point. Ida B. Wells and others sought instead to expose the white masses, and among them, the most prominent men and women of society—lawyers, doctors, public servants, and other professionals, each overflowing with pride, honored to claim their presence among the "justice seekers" as photographers captured their evil.

Despite the efforts of these Black activists, two or three Black Southerners died by lynching every week throughout the late

nineteenth and early twentieth centuries. Among these numbers is my great-great-great-grandfather.

But as with all things seen too frequently, the masses grew numb to the spectacle. Gone were the full-page images printed on the covers of newspapers, their only acknowledgment relegated to one-line blurbs. Even as interest dwindled, lynching was not declared a federal crime until the Civil Rights Movement.

In the decades that followed, artists returned to the images. One such artist repurposed a photograph of a lynching that was printed in *Time* magazine in 1937 and again in 1955 as part of a work she called *Accused/Blowtorch/Padlock*. In 1986, Pat Ward Williams created a conceptual piece that focused on the victim, Robert "Bootjack" McDaniels, a twenty-six-year-old who was lynched in Duck Hill, Mississippi. The mob of 220 that killed him is absent in her portrayal. Instead, one framed image of his full body tied and hanging limp from a tree is situated next to three others that are zoomed in on his body parts. Surrounding the images are scribbled questions that express Ward's rage. "Can you be black and look at this without fear?" reads one. "How can this photograph EXIST?" queries another.

The effect of such a recasting, according to scholar Amy Louise Wood, elicits "new meaning [. . .] imposed on an image through text, framing, and context, as well through the viewer's subjective positioning, all of which can potentially reposition the spectator to stimulate an affective response, not only to the lynching victim, but to those suffering in the present." Through this engagement, social justice movements can emerge, as can the triggering of sympathetic responses from white Americans, many of whom have a "hazy, distorted, or forgotten" view of the lynching.

Other artists and curators have continued to use the imagery of lynching, sometimes to critically disastrous results, producing sensationalized experiences that did more to shock than inform. In 2015, an artist re-created the scene of Michael Brown's murder at a Chicago gallery. The show was titled *Confronting Truths: Wake Up!* The work employed a life-size mannequin dressed in a white tee, khakis, and flip-flops, lying face down and surrounded by police tape and orange cones. Alphanumeric markers of bullet casings outline his body, and on a wall facing the scene a video of a crying Eartha Kitt sings "Paint Me Black Angels." The artist, Ti-Rock Moore, called it *Angelitos Negros*. Moore is white and born and raised in New Orleans. T-Rock is not her real name, as she prefers anonymity. Much of her work lies in provocation through a lens she openly recognizes as privileged. Hurricane Katrina compelled her voice, as she was inspired by the images of the displaced that flooded our screens when my family was left stranded on the overpass.

The gallery owners were Black and openly acknowledged the potential controversy, welcoming the painful dialogue in spite of the risks. Still, Moore said she regretted the piece after Michael Brown's parents came to the opening. She had asked for their consent, and his mother had agreed; his father never responded. But when they both arrived and saw the mannequin, they asked for their son's likeness to be covered and removed.

In 2017, at the Whitney Biennial, the white artist Dana Schutz displayed a painting called *Open Casket*, which re-created the scene of Emmett Till's funeral. Till's body was rendered as an abstraction, his head overly large and faceless, marked by a prominent streak of paint across the frame. The backlash was

swift. Social media debates raged, many claiming white appropriation and exploitation. How could a white artist traffic in Black death for material gain? No matter that Schutz said she would never sell the piece. Still, it inspired a protest demanding its removal and destruction. Others called the protest misguided and distracting.

In 2023, the imagery of lynching found itself at the center of a controversy gripping the fashion world. This time, the popular streetwear brand Supreme came under fire for a project that planned to use the image of a lynching on its merchandise. Spearheaded by Tremaine Emory, Supreme's first Black creative director, the image was part of a collaboration with Arthur Jafa, the widely acclaimed Black artist whose films and art remain cult classics. Emory encouraged Jafa to lend one of his artworks to the Supreme brand, specifically an image of three lynched Black men surrounded by a white mob, which was juxtaposed with an image of gang members posing with guns, their eyes obscured by black rectangles to render them anonymous.

In defense of the image, Emory claimed the message was clear: this gets you that, the lynching begets the gang. While this is a fair interpretation, the image seems to suggest more in the anonymity of the gang members and the unobscured faces of the white mob. The essential question and purpose of the piece asks the viewer to question where they should direct their gaze.

The collab was approved by the board and printed on hoodies, T-shirts, and skateboards before the project was scrapped and Emory abruptly resigned, citing the company's systemic racism as the reason for his departure. When the public got wind of the imagery, many thought it went too far. Sure, two respected

Black men were behind the idea, but because young white men make up a large contingent of the brand's customers, the criticism was harsh, including from the few Black people who worked at Supreme.

How would you respond to the sight of a white teenager walking toward you with the image of a lynching across his chest? Like many, I thought the idea was irresponsible, in spite of Emory's express desire to inspire dialogue.

Dialogue in and of itself is empty without direction. Images of lynchings are not fit for public consumption without context, especially when employed for aesthetic purposes. The most comprehensive show to explore lynching photography, *Without Sanctuary*, faced this truth after its initial opening in 2000, when the images were displayed alone and patrons left with uncertain interpretations. Fortunately, the curators adjusted and made the show more interactive and educational.

These lessons haven't altered our access to viewing lynchings, however. Social media still enables us to stream the terror on demand. News outlets still loop the image of some Black or Brown person slain by the police ad nauseam.

The latest occurrence that floods my screens is that of Jordan Neely, the unhoused Black man suffering from a mental health crisis on a New York City subway, whose last moments spent in the choke hold of an ex-Marine were captured on camera phones. Every time there is a new development in the case, a motion or legal proceeding, without fail, the videos are replayed. In them, Neely is still alive, as if by sparing us the image of what happened next, we can avoid the injury of consuming his death over and over. It's a cheap trick that fails to negate the harm.

But I don't think that imagery of lynchings should be relegated to history either. Thoughtful renderings of the practice offer moments of reflection and paths toward healing.

With my wife, I toured the National Memorial for Peace and Justice and its companion space, the Legacy Museum, in Montgomery, Alabama, a few months after it opened in 2018. The Legacy Museum was impressive, a twenty-first-century creation that incorporated forward-thinking technology and innovation. Upon entrance, the space was darkened to accentuate the holograms of enslaved Africans trapped in cells as their voices emerged from speakers above us, the surround-sound experience of ghost-like figures bearing their souls, chilling.

Everything about the experience was engaging, especially the exhibit that let us speak to incarcerated Black people in a simulated visiting room. So surreal was it to sit across from them as we listened to their circumstances, detailed through a two-way receiver as if we were in the prison with them. We were captivated, the line from slavery to mass incarceration clear and vivid.

I was moved by all the sights and sounds, especially when I came to the exit, where a large, amorphous sculpture grabbed my attention. From afar, it wasn't clear what it signified, a figure perhaps caught in the act of running or walking, the bronze surface shiny like chrome under spotlights. But when I inspected it closer, I saw the body was marked with large holes about the head and torso, an impressionist creation without a clear gender expression or face. Sanford Biggers titled it *For Michael* in 2018, and immediately I saw Michael Brown laying on the asphalt of a Ferguson Street, his body left there for too long like the victim

of a lynching, swaying for days on the limb of a poplar tree. Biggers had received clear consent from Brown's mother for his rendering, and in his interpretation the scene of death remains figurative, the gut punch not too much to bear. It was also the perfect segue to what lay ahead.

Along the walk to the memorial, we stopped at a roundabout with a neoclassical fountain at its center. Down one of the avenues that shot from its core was the image of the state capitol, it, too, styled in a neoclassical tradition mirroring our government's unyielding love of Western architecture. We took in the scene on one of the corners facing the fountain, a plaque erected in 2001 detailing the history of the location, where men in the eighteenth century went to steal and accumulate wealth.

MONTGOMERY'S SLAVE MARKETS

The city's slave market was at the Artesian Basin (Court Square). Slaves of all ages were auctioned, along with land and livestock, standing in line to be inspected. Public posters advertised sales and included gender, approximate age, first name (slaves did not have last names), skill, price, complexion and owner's name. In the 1850s, able field hands brought $1,500; skilled artisans $3,000. In 1859, the city had seven auctioneers and four slave depots: one at Market Street (Dexter Avenue) and Lawrence, another at the corner of Perry and Monroe, and two on Market between Lawrence and McDonough.

Geographically, it makes sense that Montgomery became the heart of the domestic slave trade. West were the plantations in Mississippi, Arkansas, and Louisiana; east, Georgia, Florida, and the Carolinas; and in the Upper South, Tennessee, Kentucky, Missouri, Maryland, and the Virginias.

The walk from there was quiet, eerily so. It was midday on a Friday, pre-pandemic, and no one was out. Businesses were open but empty, and it seemed we were wandering through a void, the aftermath of a time once marked by life.

The approach to the memorial was serene, a vast space of green and corrugated steel raised upon a hill, the sight from the entrance conjuring a well-manicured cemetery or a clearing in the woods where you might find someone lynched. We could see the principal exhibit in the distance, the coffin-like steel blocks suspended in air. We traced the perimeter when we entered past a multifigure sculpture that transported us to the Middle Pas-

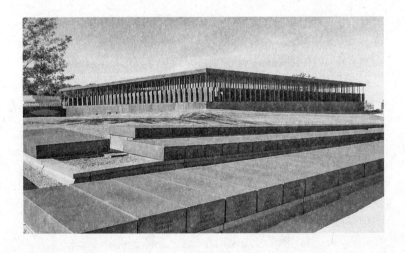

National Memorial for Peace and Justice, Montgomery, Alabama, 2018

sage, the scene evoking a state of struggle, each figure chained, reaching, squatting, or caught in a moment of terror, their mouths opened wide as if screaming.

The exhibit opens with the blocks suspended at eye level, the names of the victims and their death dates centered under the counties where they were murdered. Arranged by county, the first space seems cramped by death, the blocks almost uncomfortably hard to navigate, the distance between each just a small opening, which I suspect was by design. There is no way to avert your eyes or exit the space quickly, and in the slow, deliberate inspection, I was struck by how many were seemingly lynched with their entire families.

From there, things became more dramatic. After we left the first space, the memorial wound to a lower level, this, too, filled with the symbolic blocks, but as we moved forward, the floor sloped down so that they were hanging above us, the effect like being there when it happened, looking up at the tortured bodies. It was a lot. It felt as if they might come crashing down on us, and in a sense, they were, the weight of it all overwhelming. Lining the space are thin strips of black placards along the walls, each detailing the circumstances surrounding some of the lynched figures, the text terse and written at the bottom of the placards so that stretches of black space remain above. One reads: "Dozens of black sugar cane workers were lynched in Thibodaux, Louisiana, in 1887 for striking to protest low wages." When I think about it today, I wonder if Chief Justice Edward Douglass White had seen them die.

Toward the end of the exhibit, after we had ingested the stories and been struck by the totality of lynching, the walls became fountains, where water flowed over words that serve as peace

offerings to the lives lost: "Thousands of African Americans are unknown victims of racial terror lynchings whose deaths cannot be documented, many whose names will never be known. They are all honored here." This is only a snapshot of the breadth and work of white supremacy, and I thought of my great-great-great-grandfather and others who have been disappeared on the back roads of Southern towns, the men and women whose deaths were never captured on video.

The memorial returns outdoors, where each of the hanging blocks has been re-created and laid flat in rows, inviting further inspection. These were intended to be gifted to the counties and municipalities where the spectacles occurred, so that present-day Americans can engage with the past. The counties simply have to claim them. More than an isolated memorial, the site seeks to reach people where they are and install these works of art in the spaces where Black people hung so crudely.

There were other sculptures dotting the grounds, each inspired by the periods of terror that have marked our time here. But more than a space of sadness, the memorial ends with a long Toni Morrison quote emblazoned on a wall:

> . . . AND O MY PEOPLE, OUT YONDER,
> HEAR ME, THEY DO NOT LOVE YOUR NECK
> UNNOOSED AND STRAIGHT.
> SO LOVE YOUR NECK; PUT A HAND ON IT,
> GRACE IT, STROKE IT AND HOLD IT UP.

AND ALL YOUR INSIDE PARTS THAT THEY'D JUST
AS SOON SLOP FOR HOGS, YOU GOT TO LOVE THEM.
THE DARK, DARK LIVER—LOVE IT, LOVE IT,
AND THE BEAT AND BEATING HEART, LOVE THAT TOO.
MORE THAN EYES OR FEET. MORE THAN LUNGS
THAT HAVE YET TO DRAW FREE AIR.
MORE THAN YOUR LIFE-HOLDING WOMB
AND YOUR LIFE-GIVING PRIVATE PARTS,
HEAR ME NOW, LOVE YOUR HEART.
FOR THIS IS THE PRIZE.

The call for self-love conjured the blessings of the poets and sculptors and creatives who contributed to the space, their words and works scattered throughout the grounds. I positioned myself next to Morrison's words to pose for a picture before we left holding our hearts.

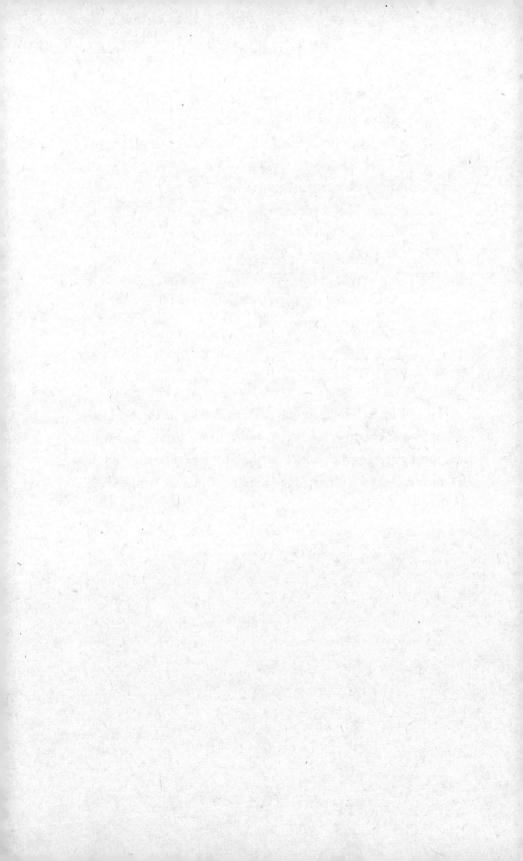

Nine

RETOLD IN PRESENT TENSE

---·◈·---

I have created nothing really beautiful, really lasting, but if I
can inspire one of these youngsters to develop the talent I
know they possess, then my monument will be in their work.

—Augusta Savage

I f the response to the murder of George Floyd is any indica-
tion, maybe we do need to see death. If this is what it takes
for us to topple racist monuments the world over, then
maybe we do need to gaze upon decapitated heads and imagine
the violence of rape to transform our times, at least for some of
us. To be clear, I haven't seen the video of his death from begin-
ning to end, and I'm not sure when or if I will. I've already seen
all I need to see. The space in my head where Black murders re-
play is full. I don't need to see the video to know George Floyd,
or Perry, as he was affectionately called by his loved ones, was a
man with a family no different from you or me. But now, in
death, he means more, elevated to an incredible symbol of ev-
erything we need to reimagine.

Across the globe, his life has inspired street art in the form of murals, abstract portraits, decals, posters, billboards, and more. The George Floyd and Anti-Racist Street Art Database has identified over 2,800 images created in the wake of his murder. Most have appeared in the U.S., but they have also been found in Mexico, Canada, Haiti, Puerto Rico, Brazil, Ireland, England, Belgium, France, Spain, Germany, Syria, Israel, Kenya, and Australia, among other locations. No doubt, many more will emerge, each purposed to recall the last movement of his limbs, the stifled cry for his mother, the pleas for mercy.

In 1890, twenty years after his death, a monument honoring Robert E. Lee was erected on Monument Avenue in Richmond, Virginia, by a mass of ten thousand who stood by and helped lift it into place. How else would their general rise in the former capitol of the Confederacy? Other men were honored along the avenue in the following decades: J. E. B. Stuart, Jefferson Davis, Stonewall Jackson, and Matthew Fontaine Maury. But now, each of their images is gone. To get a sense of the fallen Confederates, I decided to walk down Monument Avenue in the evening en route to the Virginia Museum of Fine Arts.

I began heading north on the sidewalk, amazed by the grandeur of the homes, each an impressive mix of architecture: the wide porches, porticos, and balconies of the Victorians, the steepled roofs of the Tudors, and the manicured hedges curved around the driveways of the French chateaus. I walked slowly, stopping to gaze at the razed monuments positioned in the center of the avenue, distracted by the beauty of the mansions in front of me. I proceeded

like this for a few blocks until I realized that I could take it all in if I moved to the median. This way, I had the whole avenue to myself, avoiding the joggers and pedestrians on the sidewalks.

After a few blocks, the overwhelming whiteness of the neighborhood began to make me uncomfortable, the wealth of centuries past all around me as if poured into the foundations of each estate. Sure, the monuments were gone, but the people hadn't left. This was old money, acquired by families who must have enjoyed living among the devils. Visible from their porches and bedroom windows, they could easily remain insulated within their versions of history.

I found myself ashamed that I was ashamed of not having access to their wealth. The neighborhood was never intended for me. I couldn't afford it financially or mentally, the price of openly enduring the trauma of slavery too much to bear. I fought these feelings until I arrived at Arthur Ashe Boulevard, where his image had been erected in 1996 as a corrective, and turned left toward the museum.

Then I felt a drizzle, then a little more, until a light rain began to soak my leather jacket in a steady downpour. Faster, I walked without an umbrella, shielded slightly by the canopy of large oaks lining the sidewalks. I opened Google Maps to see how many blocks I had left. My walk quickly became a jog, focused on avoiding puddles, my head cast downward. I jogged past the Virginia Museum of History and Culture and another smaller building, which, had I been less concerned with staying dry, I would have discovered was the headquarters of the United Daughters of the Confederacy, a simple structure flanked by cannons and flagpoles that could easily be mistaken for an insignificant municipal building.

Ahead, I could see the museum's signage, and I sped past a line of trees obstructing the full view of the building. And then, there it was, *Rumors of War*, one of the main reasons I had come. I knew it was outside, but I assumed it was in one of the museum's gardens, not positioned prominently at the entrance.

"Oh," I said in surprise, "I get it."

I had missed it when the equestrian statue was first unveiled in Times Square, but even if I had seen it, the experience wouldn't compare to this. For those who live in Richmond and have been moved by the beauty and symbolism of its monuments, I'm sure Kehinde Wiley's creation complicates their relationship with race. The statue was gorgeous, just as breathtaking as Beauregard had been under the spotlights. Except this one encouraged passersby to imagine a nation that values its origins and embraces how it came to be from a different perspective. *Listen to our creation story retold in present tense,* it seems to say. *Down went the Confederates to make space for me.*

In its image—the rider's torso twisted and turned askew—I saw my Nike boots, his hoodie too, and were it fifteen years ago and I still had locs, I would likely sport the same hairstyle, a high fade with thick dreads hanging from my crown. He, you, us—we are the conspirator, the messenger, the general riding off in a hurry to declare that our country is still at war with itself. The Confederates lost, but they failed to retreat. They have assumed other names and positions of power. See the Proud Boys, Oath Keepers, Boogaloo Bois, and others. See the chambers of Congress, statehouses, and city halls nearby.

The rain continued, but I stood there awhile taking it in from

multiple angles, smiling wide, charged and hopeful that the aura of control and freedom captured in the Black man's posture foretold the victories ahead. Maybe the war is coming to an end.

Because it was so new, the elements hadn't caused its brilliance to fade, and aided by the downpour and spotlights, it shined in a glossy shade of black, the wetness serving as a natural polish. Compared to

Virginia Museum of Fine Arts, Richmond, Virginia, 2021

the graffitied pedestals of the Confederates that I had just seen on Monument Avenue, this statue seemed unreal in its pristine condition. The line of trauma from there to here was striking, and I stood there transfixed.

Eventually, after circling the statue, stopping to appreciate it from all angles, I entered the museum and took in the breadth of the open space, sleek and modern with polished concrete floors, wide staircases, and translucent elevators. It was Friday night, an hour before closing, and only a few patrons were there, which made me feel like I was on a private tour.

I heard what sounded like a performance and turned toward a darkened room. Beyond an open doorway without signage or any indication of what lay ahead, I crossed the threshold. Immediately, I recognized the words of Claude McKay's poem "If We

Must Die." The poem's text was visible from the entrance, the sonnet written in white letters set against a black wall glowing under spotlights. The setting was eerie and foreboding, especially considering the poem's plea for a dignified death when faced with the "murderous, cowardly pack" of white men who continue to slaughter us. Nothing else was in the room except a wall plastered with an indistinct print resembling blood. Through this wall a round cutout, like a large mousehole, led to a room with three massive LCD screens and a pair of benches.

Each screen displayed a young Black man, presumably in his late twenties, set against colorful, floral backgrounds like those featured in Kehinde Wiley's portraits. The men, their faces wet and streaked with tears, were putting on clothes in slow-motion while couplets from "If We Must Die" bellowed periodically. After a few minutes, I realized the film was playing backward, and the men had actually undressed, but because the film starts with each man's bare chest exposed, the significance of the piece isn't revealed until you get to the end or the actual beginning and see the men's flamboyant attire. Dressed in blazers and vests of wild patterns—African prints designed to clash in striking combinations of blues and greens paired with oranges and teals—the men are peacocks, dandies desiring to be seen. But the real tell doesn't emerge until you see their gawdy costume jewelry composed of feathered brocades, chandelier necklaces, and bulky signet rings. One even wears a pink bandanna with the knot carefully fixed to the front. These men were queer like McKay, and their saddened eyes plead for acceptance.

"Damn," I said in recognition.

From the wall text, hidden in the shadows by the entryway, my suspicions were confirmed. Ebony G. Patterson, a Jamaican like McKay, created . . . *three kings weep* . . . with the desire "to present these bodies in a way that allowed space to demonstrate the full sense of the potential of their vulnerability." Patterson contextualized the current state of war that haunts the lives of gay Black men while alluding to 1919 and the Red Summer, when lynchings spiked throughout the country, the original inspiration for McKay's poem.

Like a call to the altar, the experience was that moment in service when the deacons and deaconesses ask you to lay your burdens at the feet of the Lord, and you sit there with nervous energy, nothing weighing on your heart, peeking through half-closed eyes to see whose pain was too much too bear. The spirit and sense of despair was the same, and when I emerged from the room, it seemed that Friday night's sermon would remain with me for some time. Black men, no matter their sexual preference or evolving pronouns, deserve our compassion. It calls to mind the murder of O'Shae Sibley, a gay Black choreographer who was stabbed in the chest at a Brooklyn gas station because he was voguing to a Beyoncé song with too much joy.

If I saw nothing else, I was convinced the curators of the VMFA got it right. Then I came across a smudged depiction of a cartoon character caught in the act of screaming, his mouth open wide, almost too exaggerated. Set against a gray background with small yellow splotches of paint, the figure seems caught in motion, falling toward some netherworld, the outline of his body streaked as if emitting steam or rushing in the wind.

Gary Simmons's *Screaming into the Ether,* made in 2020, depicts the Disney character Bosko, "a caricature based on American minstrelsy who was presented throughout American theaters in the 1930s and beyond." The placard reads: "Simmons animates him as a protagonist in the ongoing narrative of racial and social strife. His ghostly figure lingers like the residue of so many racist characters in our collective imagination and memory." About his intentions, Simmons offers that the work was born out of "hopelessness, that feeling of screaming and not being heard . . . it's a common feeling felt by a lot of folks."

This was the exact feeling I was chasing, the ability to capture and convey the overt hopelessness of Black life, and it felt like I was looking into a mirror, the reflection so surreal. I moved away from it with my head spinning, wishing I could own Simmons's work to relive the feeling, to revisit its message especially on days when the hatred for us seems unrelenting and I need the encouragement to scream louder.

UPON LEAVING THE MUSEUM, I settled on a burger spot filled with twentysomethings, and I found a seat upstairs at the end of the bar in front of a flat screen. There was a seat between me and an older man swiping an iPad, and I ordered a drink.

"Do you mind?" he asked when the bartender changed the game. I didn't, my thoughts elsewhere.

"Who's your team?" I eventually asked as I emerged from my ruminations.

"Well, I lived all over, so I can't claim one. Arizona. New Orleans. Maryland."

"How'd you end up here, then?"

"A woman," he said, smiling.

"Where is she?"

"Not here." He laughed. "We broke up some years ago. What brings you here?"

I paused and considered my response. "Monuments," I said and shared bits of my itinerary.

"That sounds really interesting and important," he said. "I get it. I'm Jewish. You know, white supremacy came for us too."

And we spent the rest of the evening commiserating, so to speak. The septuagenarian and the seeker. He offered parenting advice and told me how it was growing up in New York. He showed me his blog about political participation and esoteric civics history. Then he came to Lee.

"Now, this is just my gut telling me this, but the way they've fenced it off is racial," he said, leaning in.

"What do you mean?"

"When the weather's nice, you'll see white people up and down the medians on Monument Ave., picnicking and drinking wine and hanging out. But why is *it* fenced off and not the others? They don't want the protesters there who, mind you, weren't causing any harm."

When I had visited it in daylight hours, I thought it curious to find a Capitol police car idling on a side street, facing the plinth. The fence has stood since January 2021, with the city claiming it was erected to ensure the safe removal of the statue. But the statue didn't come down for another eight months. The fence remained. Hundreds of people had flocked there in 2020, and now it was inaccessible. So much community and healing had

happened there. So many works of art and reimaginings of space had been inspired by the site, particularly one of Floyd's face projected onto the pedestal, which graced the cover of *National Geographic*. But there were complaints about the noise and trash left behind. Some complaints were surely about race.

I thought back to the first time I had seen Lee's pedestal in New Orleans after his statue was removed. The words "Justice for Philando" had been tagged with a furious, unsteady hand that failed to keep them in plane, the declaration curving upward around the column, as if sprayed in haste. It was early morning, the day after the cop who murdered Philando Castile was acquitted, and a city employee was crouching on a scaffold, prepping to paint over his memorial. I was idling at a stoplight watching the spectacle unfold and focused my gaze on the different shades of cover-up poorly plastered along the base, each coat failing to match the weathered patina. A white man was about to paint over Philando's memory, which had painted over "Black Lives Matter," which had painted over who knows how many other words of protest in the space where a white supremacist formerly stood.

I sat there trying to make sense of what I saw even after the light turned green. When I finally lifted my foot from the brake and drove away—my mind fixed on Philando's memory—I realized his life wasn't being erased as much as the story of America was being revised.

Whatever becomes of the site on Monument Avenue will be the decision of the VMFA, which likely means that Black artists will be commissioned to line the street with another narrative of the same American story.

Erin Thompson describes the current culture shift surrounding monuments in her book *Smashing Statues*. For those in power and for those who lack it, protest movements can be equally effective, but "it is more likely that powerful protesters will be able to take advantage of the legal means offered by a system that they also control, while groups without political dominance struggle, often in vain, to get new monuments approved or old monuments removed." In New Orleans, this power has often been aligned with the white business class, but in Richmond, along came Levar Stoney.

Stoney, a Black man, became the youngest mayor of Richmond in 2017, and, inspired by Mitch Landrieu's swift action in New Orleans, he created a commission to transform Monument Avenue. In the wake of Heather Heyer's murder, a few weeks after he called for the commission, Stoney issued a stronger rebuke of his city's statues and implored the commission to work toward their removal. "Finally, Black people have some political power," he said at the time. "They're able to reconsider things that white people had considered settled. Nobody would have wished Charlottesville. Richmond will determine what Charlottesville meant."

One of the commission's recommendations was to "work with the museum community to create a permanent exhibit that takes a far deeper dive into the history of monuments and the people depicted." The commission further encouraged the museum community to invite national and international artists to reimagine Richmond. This led to the Wiley commission, but after the release of its 2018 report, the Confederates continued to stand until George Floyd was lynched.

DOWNTOWN CHARLOTTESVILLE IS MARKED by a pedestrian strip paved with bricks and lined with coffee shops, restaurants, clothing stores, a cannabis dispensary, a movie theater, and other tourist shops. When I visited, it was a chilly morning, and a group of middle school cheerleaders performed a routine in one of the open squares to an audience of their families and passersby. The scene felt like a rendering of quintessential Americana, a Norman Rockwell illustration full of patriotism in the signage and American flags dotting the walkways as parents pushed strollers and elderly couples counted their steps. There were a few vagrants disrupting the idyllic atmosphere, but this, too, was American, where somewhere, everywhere, despair lurks in the fringes.

I walked to the edge of the strip, where the entrance to a bus depot was crowded with addicts and the unhoused, their bodies sprawled out on scraps of cardboard and tattered blankets. Across from this scene, a bronze relief of three of Virginia's most famed statesmen was carved into the curved facade of a building. James Madison, Thomas Jefferson, and James Monroe each stood stoically above plaques detailing their accomplishments.

From there I walked a few blocks to the old town, where Georgian homes and municipal buildings took me back to colonial times. My destination was Number Nothing, a building situated in the curve of two perpendicular roads. Its location seemed caught between the two as if the space it occupied was unclear, or at least undocumented. Taped on a lamppost, a sheet of plain paper clarified:

IN MEMORY OF THOSE WHO WERE BOUGHT
AND SOLD HERE

Under it, a makeshift decal read "1619" with small text scribbled in the bubble-shaped numbers. Next to the pole were two sheets of paper taped to the brick pavers. One read:

HUMAN AUCTION BLOCK. ON THIS
SITE PEOPLE WERE BOUGHT AND SOLD.

The words "human" and "people" were added as corrections, written above the words "slaves" and "slave," which were struck through with red lines. Next to this, another sheet was stained with footprints but not enough to obscure the words.

SITE OF SLAVE BLOCK

Slave auctions were traumatic events that severed family and community bonds. This site, Number Nothing, was the location of H. Benson & Bros. auction house, one of

several places in Court Square where unpaid Africa-descended slave laborers were sold. This auction block's proximity to the courthouse enabled buyers and sellers of humans—regarded as property by white traffickers—to efficiently file legal papers after these transactions.

This temporary installation marks the sale of people in this area while the City of Charlottesville develops a more appropriate and permanent memorialization in consultation with descendants of enslaved people sold here.

[wording credit: Charlottesville Historic Resources Community, February 2020]

The area seemed too pristine and untouched, which made me feel like I was on some soundstage from centuries past. A few cars were parked on the side of the street, which brought me back to the present day, but something felt strange about the stillness.

Across the street there were two plaques erected on the lawns in front of the courthouse, both a vibrant blue lined with gold trim, unlike the older black-and-white markers that I had seen as I drove around earlier looking for a parking spot. The crest above the text was branded with the logo of the Community Remembrance Project, a campaign by the Equal Justice Initiative. The sign read:

LYNCHING OF JOHN HENRY JAMES

In 1898, a black man named John Henry James lived and worked in Charlottesville as an ice cream vendor. He had only been a resident of the area for five or six years before July 11th, 1898, when he was falsely accused of assaulting a white woman and arrested. The police transferred Mr. James to Staunton that evening to avoid a potential lynching, but officers escorted him back to Charlottesville the next morning by train. While en route, an armed mob of 150 white men stopped the train at Wood's Crossing in Albemarle County, and seized Mr. James. Learning of the mob's attack, a group of black men tried to stop the lynch mob but were outnumbered and forced to retreat. The white mob threw a rope over Mr. James's neck and dragged him about 40 yards away to a small locust tree. Despite his protest of innocence, the mob hanged Mr. James and riddled his body with dozens of bullets. The Richmond Planet, an African American newspaper, reported that as his body hung for many hours, hundreds more white people streamed by, cutting off pieces of his clothing, body, and the locust tree to carry away as souvenirs. The grand jury, interrupted by news of the lynching, issued a posthumous indictment, as if Mr. James were still alive. Despite the presence of the Charlottesville police chief and Albemarle County sheriff, no one was ever charged or held accountable for the murder of John Henry James.

THE EQUAL JUSTICE INITIATIVE 2019

I stood there in a daze. My thoughts cycled from colonial times to the nineteenth century to the present moment. I was grateful for the lesson but stunned by its power. As I stood there, another group walked up. They were young and tourists as well, their faces full of smiles until they began reading the words. I stepped aside and watched their white faces become uncomfortable before they carried on without reading to the end.

I walked to Market Street Park, formerly known as Lee Park, where the equestrian statue of Robert E. Lee no longer stood. Its pending removal had inspired white supremacists to visit the site as part of the Unite the Right rally in August 2017, which ended in the tragic death of Heather Heyer.

The park is raised above the street level and sits atop a hill. Fall was browning the grass, and the trees bore red and orange leaves. The park was empty and equally desolate, nothing there to indicate the site of its former occupant. The space at the apex was deadened, the dirt trampled with no signs of life, just a network of dried weeds and old mulch. I stood in the center of the dead patch and spun around, gazing at the church and library and buildings surrounding the area. It seemed like a perfect space for a park. What, if anything, will invite passersby here again? I wondered. What will bring the space back to life? Along the edge of the patch, someone had planted a set of small flowers behind a row of dying shrubs. Made of thin wires and colorful tufts of cotton as florets, they seemed out of place, except to suggest that something beautiful can emerge here anew.

The street where Heyer was murdered was a few blocks away, and as I walked there, I was struck by my memory of the scene. I had seen images and videos of the attack, the car speeding up

a hill into a crowd of protesters, but it seemed like I had been there, as I walked down a slope to the crosswalk that honored her life. A street sign marked the location as Honorary Heather Heyer Way. On both sides of the street, the brick walls were tagged with countless words of remembrance in chalk, with many phrases superimposed over others. The largest read "GONE BUT NOT FORGOTTEN" among "LOVE + ACTION = CHANGE" and "BLACK LIVES MATTER" and "WE LOVE YOU." So many hearts were scribbled there, so many people had left words of hope. Heyer hadn't been forgotten, but I wondered how long her image would remain. Rains will surely wash away the words, and the paint will eventually lose its luster. Will her life, born and killed in Charlottesville after a mere thirty-two years, be reduced to an honorary street sign?

THE LAST TIME I visited Monticello, I was just a boy, full of innocence and wonder. This time I was a man aware of my place in history and still full of wonder. How come? How does Thomas Jefferson remain so honored? The argument is easy for the Confederates. They fought against our imperfect union. Remember them in books and museums but not our public spaces. Nature and its elements deserve better. So do we. But what of the presidents, the men who owned and raped us, who were complicit in countless crimes? Of the thirteen U.S. presidents who enslaved us, Jefferson owned 607, the most of all.

These questions drove my thoughts as I returned to a place I hadn't seen in thirty years, shocked how the memories of what I had initially experienced came back to me—the formation of

the trees at the turns on the approach to the complex, the entrance signs, the stretch of pavers leading to the plantation's columned veranda—all of it resurfacing in flashes.

It was a crisp fall day in 2021 when I toured the grounds as the only person of color in a group composed of several middle-aged couples, some elderly walking with the support of canes. The guide was an older white woman, warm in her greeting and passionate about the task before her.

We went from room to room, the guide telling us of Jefferson's eccentric lifestyle as we walked past walls lined with Native American regalia, his carefully maintained study, and tables piled high with silver serving trays. The house opened up to a long boardwalk where Jefferson could appreciate the air and incredible sights. Monticello sits like the home of a god who can inspect his creation, in his case a five-thousand-acre plantation, elevated on a hill that provides unobstructed views of Charlottesville and the surrounding area. The guide directed us to a break in the treetops, where, through a seemingly perfect telescopic tunnel, the rotunda of the University of Virginia came into view. Founding the university was Jefferson's passion project in retirement, and from his plantation he could see the construction's progress. Sadly, the guide remarked, he didn't live to see it completed.

The conversation shifted to slavery, and the mood grew serious. Everyone had been respectful to our guide throughout the tour, quieting to hear her explanations and anecdotes, but this time we all seemed to lean in.

"Despite his achievements, he was a slaveowner. While he promised to free some, he never did until after his death, and

they all worked tirelessly toward his comfort. This is, perhaps, his great sin, and of our country," she said.

I stood on the lawn away from the group, but still within earshot, focused on her words and trying to imagine the lives of the people Jefferson had enslaved.

"The museum is working to paint a fuller picture of the enslaved who worked here with new installations and efforts to track all his descendants, and every year, we host a reunion for those able to make the trek. They come from all over the country and include his African American and white descendants. At this point of the tour, we always ask our guests if they suspect they were related to Jefferson."

I was still looking away, but I felt like the group had all turned toward me. And when I met the guide's questioning eyes, I said, "I mean, sure." I didn't have an inclination that this was true and said it half in jest to deflect my pain and half as an empty suggestion that somehow we're all related through our country's trauma.

The guide didn't catch my tone and excitedly offered to connect me to the right department to confirm my feigned suspicion. It seemed that I should have corrected her, but she moved right along and led us to the most recognizable image of Monticello, around the curved walkway to the back porch, finished with Doric columns and a series of steps that lead to the great lawn.

"After his death, the slaves that remained were sold at auction along these steps to settle his enormous debts. With so many projects and interests, he was always strapped for money. The Hemings and Fossetts and Gillettes and Grangers and Herns and Hubbards were all sold here. These steps are also the backdrop for the reunion photos of their descendants," she went on.

The others moved on after a few pictures, the formal part of the guided tour having ended, and I surveyed the lawn and the stately facade, wondering if Jefferson and I were in fact related.

The guide wanted to direct us to other exhibits, and we descended steps to a flattened space along the edge of the plantation. Here she described a new exhibit on Sally Hemings and showed us the kitchens where all of Jefferson's food was cooked.

I entered a room that seemed familiar, dank and cramped like a cellar. In the room's corner, a headless mannequin was dressed in the crude garments of the enslaved, and projected onto the body was a pattern of red and blue flowers. This figure represented Sally Hemings. I sat to appreciate the slideshow of texts that make up the small exhibit commemorating her life as told through the words of Madison Hemings's memoir, *Life Among the Lowly*. Madison was her son by way of Jefferson.

Of all the enslaved Africans he owned throughout this lifetime, "he freed only seven, and let three others leave Monticello," declared one slide. "They were all members of the extended Hemings family. Four were his children. Sally Hemings was 'given her time' after Jefferson's death, but never legally freed." This was the last slide of the exhibit, and I sat there until it looped to the beginning to learn how their relationship started. "In 1787, Thomas Jefferson sent for his younger daughter Maria to join him in Paris. His relatives chose Sally Hemings to accompany Maria as her maid-servant. She was 13 or 14 years old. She stayed in France for two and a half years." The entire exhibit seemed deliberately terse, creating a chilling effect. So much was left unsaid and trapped between the lines.

Again, I thought back to my first visit here as an elementary school student, about the lasting trauma of that experience. This happens to me often, when I find myself sensing the brutality of the past as I move in the present. It could be a name, an image, or a scene that pushes its way forward so that for the rest of the day I hear something, someone, wanting to be heard, so close behind me that even when I turn, they are tight upon my skin as if our bodies were fused. In this way, they become part of my experience.

IN THE BUILDING adjacent to the line for a shuttle that would take me back to the plantation for the Slavery at Monticello tour, there were a series of galleries detailing the crops and construction of the plantation. One gallery featured an exhibition called *Forefathers* by Maxine Helfman, which juxtaposed portraits of twelve of the thirteen U.S. presidents who owned enslaved Africans with portraits of contemporary African Americans. Like the works in Titus Kaphar's *Unforseen* exhibition—which situates many of the same men in portraits with the canvases rolled or hung loosely from their frames to reveal images of Black women in various stages of undress, gazing from the figurative shadows of our country's narrative—Helfman's portraits produce the same effect, except hers render each man's face as fused, through collage, with the faces of folks who look like me, distant kin to any one of the hundreds they oppressed.

As I boarded the shuttle, I prepared to reconstruct my own portrait of Jefferson. I arrived early and walked the length of the

path where slave cabins are sunken below the big house along the edge of the plantation, so that Jefferson would not be troubled by the view of the men and women he enslaved. A sign at the head of the trail provided context:

MULBERRY ROW

You are standing on Mulberry Row, the ever-changing hub of this 5,000-acre plantation, once lined with more than 25 dwellings, workshops, and sheds. Enslaved people, free black, and free and indentured white workmen lived and worked here as weavers, spinners, blacksmiths, nail-makers, carpenters, joiners, gardeners, stablemen, and domestic servants. The names of over 85 people are known. Elsewhere on the plantation, enslaved workers cultivated crops, tended livestock, drove carts, felled timber, and built fences and farm buildings.

The remains of four original structures and a few re-created ones hint at the complexity of the Monticello plantation. Imagine the sights and sounds of 200 years ago—the log, frame, and stone buildings; carts carrying firewood; the smell of wood and charcoal smoke; the noise of hammers, saws, chickens, barking dogs, and the voices of scores of people. You are walking in their footsteps.

Two groups had formed as they waited for the tour, an older, spry white couple dressed in athleisure and a pair of middle-aged Black men with their partners, two white women. Each seemed warm and open when I smiled upon approach.

"What brings you here?" I asked the older white couple.

"*How the Word Is Passed*," said the man eagerly. "We read it together and thought we had to do this tour."

One of the Black men chimed in, "Us too. We read it for a book club and figured we should make the drive."

Clint Smith's bestseller begins in New Orleans—he, too, is a native son—and explores other parts of the country as he travels to the Whitney Plantation, New York City, and Dakar, among other destinations, charting the history and racism of America. Reading it or listening to him recite it, as I did, offered an incredible education, and helped me shaped my own ideas. He had visited some of the spaces I had and was also inspired by the removal of Lee and other monuments in our hometown.

The book opens at Monticello on this same tour and illustrates Jefferson's life as a slaveholder, supported with passages from historians and others.

Soon, more people arrived, and it was by far the most diverse group of people I had seen at Monticello. During my first visit as an adult, I saw only one other Black man, but this group was young and old and composed of various ethnicities. The guide was a thin middle-aged white man who seemed excited about the turnout. It was late afternoon and the sun was beginning its descent, so we zipped up our jackets and moved in close.

He began by describing Monticello as an industrious plantation,

fashioned in the interests of maintaining Jefferson's lifestyle and as an outlet for his scientific inclinations. There were carpenters and artisans and engineers and world-class cooks who lived and worked here. The guide directed us to the nail shop, where Jefferson's enslaved adolescents worked on quotas so that he could sell their creations.

The rows of crops behind the shop were where some of the enslaved tended their own plots. Most lived closer to the tobacco fields in the distance. The cabins assembled along Mulberry Row were only re-creations of the few that lined the trail.

He told the story of Joe Fossett, one of the men freed in Jefferson's will. Joe was a skilled blacksmith who was able to buy his wife's freedom and two of their six children after Jefferson's death, but the other four were sold at auction on his back porch. Eventually he was able to buy the freedom for three of them and relocate his family to Cincinnati, where they participated in the Underground Railroad, but Peter, whose owner refused to sell, remained in bondage. Peter tried to escape twice but was caught and failed to reach his family. Imagine the scene of seeing your children sold before your eyes without knowing if you would ever see them again, the guide asked us to consider. Twenty-three years would pass before Peter was freed and reunited with his family in Ohio. The mood was somber as some lowered and shook their heads. Others stared wide-eyed in shock.

The Hemingses came into Jefferson's possession via his wife's inheritance, the guide explained. His father-in-law had been Sally's father, which means that Sally and Martha, Jefferson's late wife, were sisters. Martha had made Jefferson promise to never remarry after her death, and he kept his word. He never

married Sally—he just raped her, most likely in the room adjacent to where his eight-year-old daughter slept.

While in Paris, Jefferson met with several Enlightenment thinkers who influenced his stance on slavery, yet he still wrote that liberating enslaved Africans would be like "abandoning children." In a real sense, this was true for Sally, since she was just a child when he held her captive to be his concubine.

The guide encouraged us to visit the exhibit about her life if we hadn't already, and the tour ended. It was a valiant attempt to reconstruct the lives of those who lived here, but I wanted more. I strolled the trail again, hoping for a visitation from one of the voiceless, the stories we may never know.

I thought of the waters connecting Virginia to Louisiana, from the Chesapeake Bay to the Gulf of Mexico and the Mississippi, a route that was just as long as the Middle Passage across the Atlantic Ocean, and one that Jefferson had employed to punish four men he enslaved, men who were accused of attacking an overseer and planning a rebellion on one of his other plantations. I thought of Paris and New Orleans and the Louisiana Purchase and all the spaces he had been that shaped where I stood.

BEFORE LEAVING CHARLOTTESVILLE and Virginia, I visited the University of Virginia, the school Jefferson founded, to see the site of the memorial honoring the enslaved laborers who worked there from 1817 to 1865. The memorial is made of black granite slabs and lists four thousand names, though there are likely far more. Situated on a lawn that abuts a paved walkway, the memorial is accessible to students and visitors.

Once you enter the space, the walls curve up and reach their height at the opposite end of the entrance. From afar, the slabs look like a manmade barrier designed to channel water to its opening, a dam intended to choke the flow of a river. At the center of the memorial, a green space is ringed with a timeline of historical events.

First conceived by its student body in 2010, the memorial was completed in 2020 and begins with the following statement:

> As it enters its third century, the University of Virginia remembers the enslaved people whose labor and talents made possible the construction and operation of the Academical Village. Forced labor, incalculable suffering, and the struggle to live with dignity were the daily experience of the enslaved African Americans who shaped the institution's first half century. This memorial is erected as a permanent tribute to them.

The historical markers cycle through important moments in the university's slaveholding history. They start at the beginning in 1619, when the first enslaved Africans were recorded in Virginia. The next marker details the construction process, whereby the enslaved dug foundations, made bricks, pitched roofs, and completed other tasks. The markers go on to note that from 1776 to 1865, the period of America's inception to the end of slavery, Virginia enslaved more people than any other state.

When Jefferson died, several professors purchased members of the enslaved families that remained at Monticello.

Each marker offered a shocking perspective, but the one that angered me the most reads:

> **1856**
>
> An enslaved eleven-year-old girl is beaten unconscious by a UVA student. Claiming his right to discipline any slave, he suffers no consequences.

The spectacle of it all, the crowd it surely inspired, made me want to scream. How many people had witnessed the event? How many had watched it unfold without intervening? How many times had he struck her until she fell to the ground, clinging to life?

I reversed course to inspect the names, each written above a slash in the stones, as if they had filled in blank spaces or were underscored. There were some Herns and Gillettes, but most were without surnames. Some even listed occupations—cook and stonemason and seamstress, among others. Elsewhere, I learned the space they occupied in their family trees: grandmother and brother and son. The effect was surprising but clear. These were skillful *humans* who did their best to hold on to their familial ties.

As I examined the names, a white couple entered the memorial. I could tell they weren't students, at least not undergrads, and when they grew closer, I smiled and asked if I could trouble them.

"What brings you here?" I asked.

"We're visiting Charlottesville. Heard it was a beautiful city, and we figured we'd come before it got too cold," said the man warmly.

"Yeah, we're staying at an Airbnb nearby," offered the woman.

"It does have its charm. But why'd you stop *here*, I mean?"

"We were just walking by and saw you taking pictures," she said. "And I see why. This is a lot," she said, her eyes widening. "It's almost unbelievable."

"Well, I'm happy you stopped. It's such an important memorial and moment in history, really, when schools all over the country are reckoning with their past. Make sure you visit Monticello before you leave, and take the tour on slavery," I said. "I was just there and learned so much about Jefferson."

"That's on our list," said the man.

"Well, I don't want to take too much of your time," I said and walked away.

The word is getting out, it seemed. The spaces we share are offering more opportunities to see and understand each other, and for this, I left hopeful.

"ART MAKES BETTER HUMANS"

Some live by love thy neighbor as thyself,
others by first do no harm or take no more
than you need. What if the mightiest word is love?

—Elizabeth Alexander

E very year when I return home to New Orleans, since the toppling of the four racist monuments authorized by Landrieu in 2017, I find that something else has fallen, another street is renamed, and efforts to honor us progress. Along the Riverwalk, a newly erected plaque details the "Execution of Jean Baptiste Baudrau II," a Choctaw man, and another, the scope of the "Transatlantic Slave Trade to Louisiana."

Each time I visit, I take another stroll down Norman C. Francis, to remember and forget, to see what once was and imagine more. Dreux isn't there. Neither are Father Ryan and Gen. Pike, the other white supremacists formerly honored on Jeff Davis. Now, there are more jungle gyms and open space. Lee Circle became Harmony Circle.

Across the country, change has come. Robert E. Lee's statue in Charlottesville was melted down, beginning with his face, which was dramatically severed from the body with a blowtorch in a private ceremony attended by activists who had fought for its removal. The Mellon Foundation designated $500 million, the largest financial commitment in the foundation's history, for its Monuments Project "aimed at transforming the nation's commemorative landscape to ensure our collective histories are more completely and accurately represented."

Spaces like the Whitney Plantation, the National Memorial for Justice and Peace, and the National Museum of African American History and Culture exist to center the narratives of Black communities, with more to come. The Equal Justice Initiative has plans for a new site called the Freedom Monument Sculpture Park, where visitors will be able to imagine what it was like to arrive by boat and experience what enslaved Africans felt as they disembarked along the Alabama Riverbank in Montgomery to be sold and transported to some distant plantation by rail. The seventeen-acre park will house dozens of sculptures among other immersive installations and be completed by many of the leading Black artists working today. When I returned in 2024, the original museum had expanded to a larger space, an old cotton warehouse with more installations and artists and significance, so much so that it felt like a new, more powerful experience.

Museum staffs and curators have become more diverse, responsive to the systemic whiteness of the art world. Looted artifacts have been repatriated. Black and Brown artists have garnered more acclaim, and their works have become more

visible. Even Monticello has pledged to portray Thomas Jefferson as a slaveowner.

But while strolling along the Riverwalk in New Orleans during a recent trip, I thought of a troubling exchange I had in Venice, after I had seen the genius of Simone Leigh at the Biennale. I remembered feeling grateful to experience the array of talent from across the world, easily the most expansive show I had ever seen. By the time I left, it was well into the eve-

Artist touring their gallery after the Biennale, Venice, Italy, 2022

ning, and as I ambled toward a water taxi that would ferry me back to my hotel, a window display caught my attention.

Half a pane of the transparent glass was covered with red lipstick kisses, a hundred or more above a question written in the same hue: "AND YOU, WHAT WOULD YOU DO FOR A LIKE?" It was a clear provocation that worked, as I became curious about the art that I could glimpse behind the glass and stepped inside.

The entry room contained conceptual pieces of reclaimed objects, newspapers stuffed into translucent trash bags and shrines dedicated to the environment. As I moved through the length of the gallery, down a long hall with other conceptual works, I was struck by the artist's use of hair, synthetic braids, and wigs,

knotted and patterned in geometric shapes that were woven onto coarse fabrics. The artist was a squat Cameroonian, dressed in a colorful kaba. In accented English she explained her process: The use of hair, specifically Black hair, was a commentary on the spaces that Black women occupy within the system of patriarchy, each piece a reflection of a womanist theme. Some even used her own hair, the most visceral example, a phrase centered on a wall: "BORN LIKE THIS," the words composed of tight black curls, with flecks of gray strands, the entire piece fluffy like gnarled felt.

Her work was moving, but her perspective was even more fascinating. She had staged exhibits in New York, in Africa, and throughout Europe and was versed in art theory and the movements of the art world. But her criticism of the Biennale surprised me.

"Guess you gotta be a Black woman to win this year," she said, referencing Simone Leigh and Sonia Boyce's groundbreaking achievements, her tone more mocking than celebratory. "And all the women on display! Must be tough to be a man in the art world this year," she scoffed.

I was confused, and it must have shown, because she quickly explained that what she meant had more to do with the obvious overcorrection of women's representation and acclaim, so much so that it flattened the praise.

What about everyone else? she asked. Why weren't other countries represented in what she called "the Olympic games of art"?

"I reached out to the committee to see how to get in, to ask about the criteria and process of being selected for the Biennale,

and they just ignored me. But why were there so few African countries when we all come from the motherland?"

As she spoke, I read the posters she had plastered in the entry room, each a line or phrase translated into multiple languages that asserted the unifying nature of art. "ART MAKES BETTER HUMANS," read one, which underscored the show's title, *Fantastic Republic of Motherland*, which she employed as an acronym to ask where and how we wanted to be remembered. Another poster invited patrons to perform, sign the wall, or leave a trace of their presence with hair or online comments.

The entire experience upended how I viewed the Biennale and the art world at large. I didn't subscribe to all her critiques, sensing a measure of envy, but it didn't come off as self-serving either. She passionately believed that the division of nation-states was a farce, rooted in imperialism, and she was right.

Is there a way to champion art and artists without detriment to others? Certainly, but what she was advocating—an anarchist vision of a return to a before that never was—was equally outlandish and insightful. Can we effect lasting change through systems irreparably stained by white supremacy? How can we operate outside these systems and the mechanisms that govern them without blowing it all up?

Decades of racial progress have provided the blueprint, but these same decades haven't shrunk the wealth gap. Haiti is still a failed state, and the West African countries still ravaged by French imperialism are teetering on the brink.

As much as America is changing for the better, there are still too many causes for concern. For every monument to Harriet Tubman or Emmett Till in production, Mount Rushmore remains.

For every street, city, and state named by Native tongues, Andrew Jackson remains, and who knows when Crazy Horse will ever rise.

As I gazed out at the Mississippi, I couldn't be sure.

It's fine to tidy your house in preparation for dinner guests, but when they arrive, how will your food sustain them? The work of clearing the land of racist iconography is underway, a wonderful corrective toward the beautification of our spaces, but these efforts need more fuel. This fuel looks like real repair as a demonstration of our immeasurable capacity for love, wherein the violence and ignorance of our history are overcome, and the lasting salve is the overdue payment owed to us for our sacrifice and service to this land.

ACKNOWLEDGMENTS

Every word of this book is the product of God's grace and my family's love.

To my family: I am nothing without you. My membership in our legacy means the world to me. Everything you've shared with me, directly or indirectly, still guides my thoughts and actions. Some of you are mentioned in these pages but many of you are unnamed, although you were present for so many scenes. Thank you for the difficult conversations and your willingness to share. It was my intention to render your reflections as accurately as possible.

To my father: Thank you for never compromising who you are even when it's uncomfortable. Through your example, I've learned to view the world critically and appreciate multiple perspectives.

To my brother: I'm so proud of you for not giving up even when the world can be too much.

To my mother: I've always felt your love, but now that I have my own children, I realize the sacrifices you've made for me, and I'm so in awe of your strength and commitment to education. I remember the times when I wanted nothing more but to be at your side, and these memories still bring me joy.

To my children: Thank you for keeping Daddy on task and reminding me of what's important in life. Both of you arrived during the pandemic when none of us knew if we would survive, but your smiles and laughter and innocence carried me forward. I'm so excited to witness your growth and evolution. When you read this, I hope Daddy's words will inspire you to leave your mark on the world.

To my wife: During the final stages of editing, I realized how much you were present in so many scenes, and, initially, this gave me pause. I wondered if readers would think it weird, until I realized that our love is all-encompassing. It is such a privilege to be your partner. Right after our honeymoon, I dove headfirst into research and traveling, and you always encouraged me to keep going. It's not lost on me that we first connected through our mutual love of Toni Morrison, and when I look back on that time and compare it to where we are today, I can't believe how lucky I am. Thank you for the gift of forever.

To my friends who are more like family: Mateo Askaripour, Mikael Awake, Robert Jones Jr., David Nadelman, Gibran Mc-Donald, Joshua Pollard, Candice Iloh, Rickey Torrence, Zuri Farngalo, Kyle Hamilton, Sabrina Alli, Zachary Norris, Sydnie Mosley, Paul Hunter, Selam Negatu, Ndidi Menkiti, Kahlil Fitzgerald, and Austin Martin—each of you makes life worth living.

To my writing friends (many of you are also like family): There are too many of you to name, and when I started listing you, I had to stop after two pages. If I've ever shared space and time with you in any meaningful way, I'm so grateful for our fellowship. Thank you for showing up for me. I'm especially

grateful for my family forged through our agent. You all mean so much to me.

To my Rhode Island Writers Colony family: I think about Brook often and miss him dearly. We bonded instantly, and his departure left a lasting impact on me. I still see him as a significant catalyst for my writing life. Dianne and John, I hope to honor Brook's life in everything I do. Thank you for sharing him with us. Thank you for all your support. In lieu of listing everyone who's been a part of our community, I'll only mention those who were in my cohort, but know that I sincerely love you all. To Nana Ekua Brew-Hammond, Jason Reynolds, Kerika Fields, Crystal Boson, and Vincent Burwell, thank you for those meals and laughter and inspiration.

To my VONA and Bread Loaf community: Thank you, especially Vanessa Mártir, Grace Jahng Lee, Jason Lamb, Noreen Cargill, Lauren Francis-Sharma, Jennifer Grotz, Michael Collier, Todd Cole, C. Dale Young, Laura Goode, Uche Okonkwo, Annelies Zijderveld, Nicole Shawan Junior, Jennifer Bowen Hicks, Taymour Soomro, Junious Ward, Paul Tran, Porscha Burke, Michael Torres, Mike Alberti, Omotara James, Genevieve Beltran, S. Erin Batiste, Nick Robinson, Ingrid Rojas Contreras, and Lauren Markham.

To my classmates, teachers, and students: Thank you for allowing me to grow and learn, especially my students in Cherry Hill. Each of you will remain dear to me. I'm so proud to witness the adults you've become. Special thanks to Linda Carter, who orchestrated my first byline, and to Melvin Rahming and Delores Stephens, who prodded me forward with care.

To my colleagues everywhere I've taught: Thank you for your

support, especially my family at Queensborough Community College. I want to list you all, but your names would fill too many pages. Special thanks to Sheena Gillespie, Linda Reesman, David Humphries, Jennifer Maloy, Margot Edlin, Margaret Chin Quee, Rosita Saldivar, and Cheryl Levine for keeping us together. Extra special thanks to the members of the Black Faculty and Staff Association at QCC. You have held me down in so many ways. To my City College and St. Joseph's family, thank you, especially Michelle Valladares, Yana Joseph, Moe Liu-D'Albero, Lee Clay Johnson, Alicia Mountain, and Deborah Lily White.

To all the artists mentioned in the book: Thank you for your brilliance. Special thanks to Titus Kaphar for telling my team to pick another painting when we asked to use your work for the cover. We absolutely landed on the right one. So thankful for your genius and commitment to making space for us in the art world.

To the writers who read, blurbed, reviewed, and interviewed me for this book, thank you for spreading the word.

To the writers whose books and ideas specifically influenced how I crafted this book, thank you: Sarah M. Broom, Jesmyn Ward, Claudia Rankine, Teju Cole, Emily Raboteau, Kiese Laymon, Imani Perry, Clint Smith, Eula Biss, Jenny Odell, David Treuer, Robert Samuels, Toluse Olorunnipa, Zadie Smith, Cathy Park Hong, Edwidge Danticat, Matthew Delmont, Ibram X. Kendi, Edward E. Baptist, Ta-Nehisi Coates, Alice Walker, Nikole Hannah-Jones, Erin L. Thompson, David Mura, Nicole Fleetwood, Mitchell S. Jackson, Denise Murrell, Elizabeth Alexander, Robin Wall Kimmerer, Roger Reeves, Jericho Brown, Robin Coste Lewis, Layli Long Soldier, Michelle Alexander,

Bryan Stevenson, Rebecca Solnit, Olivia Laing, Rachel Kaadzi Ghansah, Hanif Abdurraqib, Wendy S. Walters, Karla Cornejo Villavicencio, Xochitl Gonzalez, Malcolm Gladwell, Daniel Rasmussen, Andrea Stuart, Tommy Orange, James Baldwin, Audre Lorde, Malcolm X, Ralph Ellison, John A. Williams, Toni Morrison, Ernest J. Gaines, Fanny Jackson Coppin, James Roberts, Ida B. Wells, and Fannie Lou Hamer.

To Georgia Bodnar: None of this would have been possible without your vision. I knew from our first conversation that I wanted to work with you. But as fate would have it, we dissolved our business relationship and became family. We're so grateful for you.

To Ibrahim Ahmad: Who knew that this would work so well?! I was so anxious and apprehensive about the book falling apart when we first met, but I couldn't be more appreciative of your care and expertise. In short time, I knew that we were meant to work together, and I saw our collaboration as another one of the unexpected blessings that this book has brought to my life. Thank you for managing my mania and pushing me on the page. I truly couldn't have imagined the architecture of this book without you.

To the entire team at Viking: Thank you for pouring everything into this book. Special thanks to the marketing and publicity team: Molly Fessenden, Yuleza Negron, and Alex Cruz-Jimenez; senior subsidiary rights manager Bridget Gilleran; editorial assistant Elizabeth Pham Janowski; production editorial assistant director Lavina Lee, book designer Nerylsa Dijol; and to the copy editors, booksellers, and everyone else who played a role in bringing this to the world.

To PJ Mark: From our first meeting, you've always made me feel seen, which still amazes me. It's been an incredible pleasure to work with you. I'm not sure how you do it, but you always make time. Nothing gets by you, and I appreciate all your efforts, especially your invisible labor. So grateful to be a member of your literary family.

Thank you to the Research Foundation at the City University of New York for supporting this book from its inception. Thank you to the Mellon/ACLS Community College Faculty Fellowship from the American Council of Learned Societies for supporting the research, writing, and editing of this book.

To Annie, my first writing teacher: We did it! I felt your presence so many times while writing these words, and I'm so grateful for the visitations. We all miss you dearly. This book, like everything I write, was conceived with you as my primary audience. I hope I made you proud.

Last but not least, thank you, dear reader, for spending time with these words. I hope you experience life differently hereafter. Now get to work. There's a whole world out there that deserves our care.

100 YEARS of PUBLISHING

Harold K. Guinzburg and George S. Oppenheimer founded Viking in 1925 with the intention of publishing books "with some claim to permanent importance rather than ephemeral popular interest." After merging with B. W. Huebsch, a small publisher with a distinguished catalog, Viking enjoyed almost fifty years of literary and commercial success before merging with Penguin Books in 1975.

Now an imprint of Penguin Random House, Viking specializes in bringing extraordinary works of fiction and nonfiction to a vast readership. In 2025, we celebrate one hundred years of excellence in publishing. Our centennial colophon will feature the original logo for Viking, created by the renowned American illustrator Rockwell Kent: a Viking ship that evokes enterprise, adventure, and exploration, ideas that inspired the imprint's name at its founding and continue to inspire us.

For more information on Viking's history, authors, and books, please visit penguin.com/viking.